OLIVER RATH
BERLIN BOHÈME

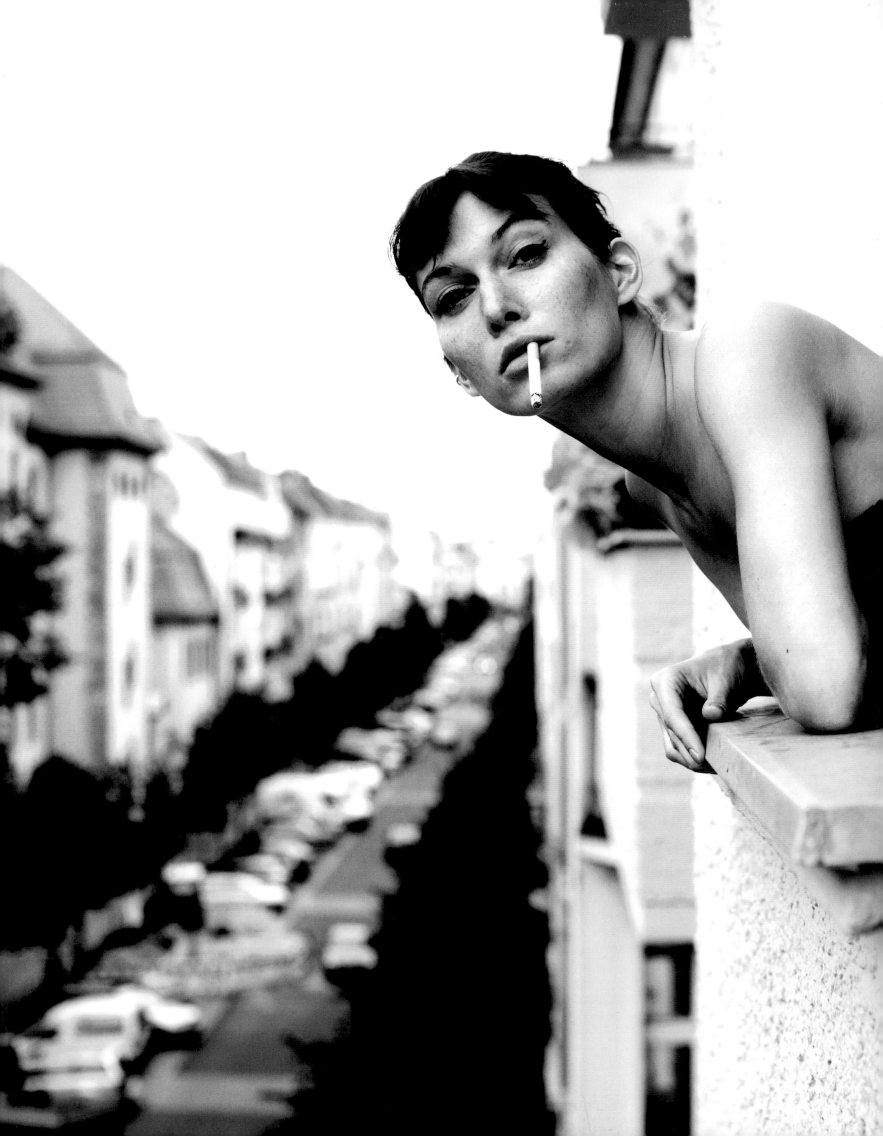

OLIVER RATH

BERLIN
bohème

EDITION Skylight

First Edition 2014
Copyright © 2014 by Edition Skylight
Photographs © Oliver Rath

EDITION SKYLIGHT
Willikonerstr. 10
CH-8618 Oetwil am See / Zürich
Switzerland

info@edition-skylight.com
www.edition-skylight.com

ISBN 978-3-03766-653-1

Bibliographic information published by
Die Deutsche Bibliothek
Die Deutsche Bibliothek lists this publication in the
Deutsche Nationalbibliografie; detailed bibliographic data are
available in the Internet at http://dnb.ddb.de.

Design: Weiß – Graphik & Buchgestaltung
Übersetzung: Tina Tröbs und Eugene Edwards

Printed in Slovenia

FOREWORD/VORWORT

When Oliver Rath asked me to write the foreword for "Berlin Bohème", his first ever publication, I was very pleased, because it allows me to bear witness to our friendship. I have known Oliver's photography for many years: he has documented not only most of my installations, but has also made me the subject of numerous portrait sessions.

These should not be understood in the classic sense, as they fluctuate between elaborate staging and total chaos. They are created in long, nighttime sessions, emphasising randomness, and always finding new forms of authenticity. This works at the level of sociological analysis, focusing on a variety of social worlds. He pursues a wide range of ideas and designs for images, and this book makes clear that not only what is depicted significantly influences our understanding of the image.

His photos are obviously accurately balanced constructions, because in today's differentiated world, it's all about finding a public stage to express the social and emotional self. Oliver Rath is a master of illusion, which, in the age of narcissistic individualism, needs a social dimension, because authenticity is always measured in staging, in pictorial representation. He condenses a lot of information and visual effects into a central statement.

Oliver's work is located on the borderline between art, design and fashion photography. In this way, he captures the feelings of a generation, playfully moving between a range of media and styles. He has found a unique language for their lives and their environments.

The (anti-) formalist gestures in Oliver Rath's images serve the radical code of his protagonists; they focus on the breaking of taboos and the crossing of boundaries, deliberately moving at the threshold of what is bearable. These provocative visual compositions violate bourgeois conventions; their high-gloss surface conceals the abysmal and secretive. This publication brings together for the first time a selection of his versatile work.

Oliver Rath's visual language characterizes our contemporary imagery and collective memory. For these reasons, it gives me great pleasure to be a part of it by writing this foreword.

Congratulations to Oli on his first publication!

Stefan Strumbel

Als Oliver Rath mich bat, für seine erste Publikation »Berlin Bohème« das Vorwort zu schreiben, hat mich das sehr gefreut, denn es zeugt von unserer Freundschaft. Ich kenne die fotografische Arbeit von Oliver seit vielen Jahren: er dokumentiert nicht nur die meisten meiner Installationen, ich war auch Motiv zahlreicher Portraitsitzungen.

Man darf sich diese Portraitsitzungen nicht im klassischen Sinne vorstellen, sie pendeln zwischen elaborierter Inszenierung, totalem Chaos, entstehen in langen Nächten und betonter Zufälligkeit und finden immer wieder neue Form der Authentizität: einer Authentizität, die sich auf der Höhe einer soziologischen Analyse unterschiedlicher sozialer Welten bewegt. Dabei verfolgt er verschiedene Bildkonzepte und dieses Buch macht deutlich, dass nicht allein das Abgebildete unser

Verstehen von Bildern wesentlich beeinflusst. Seine Fotos sind offenkundig präzise austarierte Konstruktionen, denn heute geht es in den differenzierten Lebenswelten darum, für das soziale und das emotionale Selbst eine Bühne öffentlicher Inszenierung zu finden. Oliver Rath ist ein Meister der großen Illusion, die das soziale Leben im Zeitalter des narzisstischen Individualismus braucht, denn Authentizität wird immer als Inszenierung, als bildliche Repräsentation gesetzt. Dabei verdichtet er eine Vielzahl von Informationen und visuellen Einflüssen zu einer zentralen Aussage.

Olivers Arbeiten bewegen sich an der Grenze zwischen Kunst, Design, Gestaltung und Modefotografie. Sie fangen damit das Gefühl einer Generation ein, die sich spielerisch zwischen den unterschiedlichen Medien und Stilrichtungen bewegt und eine ganz eigene Sprache für ihr Leben und ihre Umwelt gefunden hat. Der (anti-)formalistische Gestus der Bilder bedient den radikalen Kodex seiner Protagonisten: Tabubrüche und Grenzüberschreitungen, die sich bewusst an der Schwelle zum Ertragbaren bewegen, rüde Kompositionen, die gegen bürgerliche Bildkonventionen verstoßen. Unter ihrer hochglänzenden Oberfläche verbergen sie das Abgründige und Verschwiegene.

Diese Publikation versammelt nun erstmalig eine Auswahl seines vielseitigen Werkes. Seine Bildsprache prägt unsere heutige Bilderwelt, unser kollektives Gedächtnis und deshalb freut es mich umso mehr, dass ich mit meinem Vorwort Teil dessen sein darf.

Ich gratuliere Oli zu seiner ersten Publikation.

Stefan Strumbel

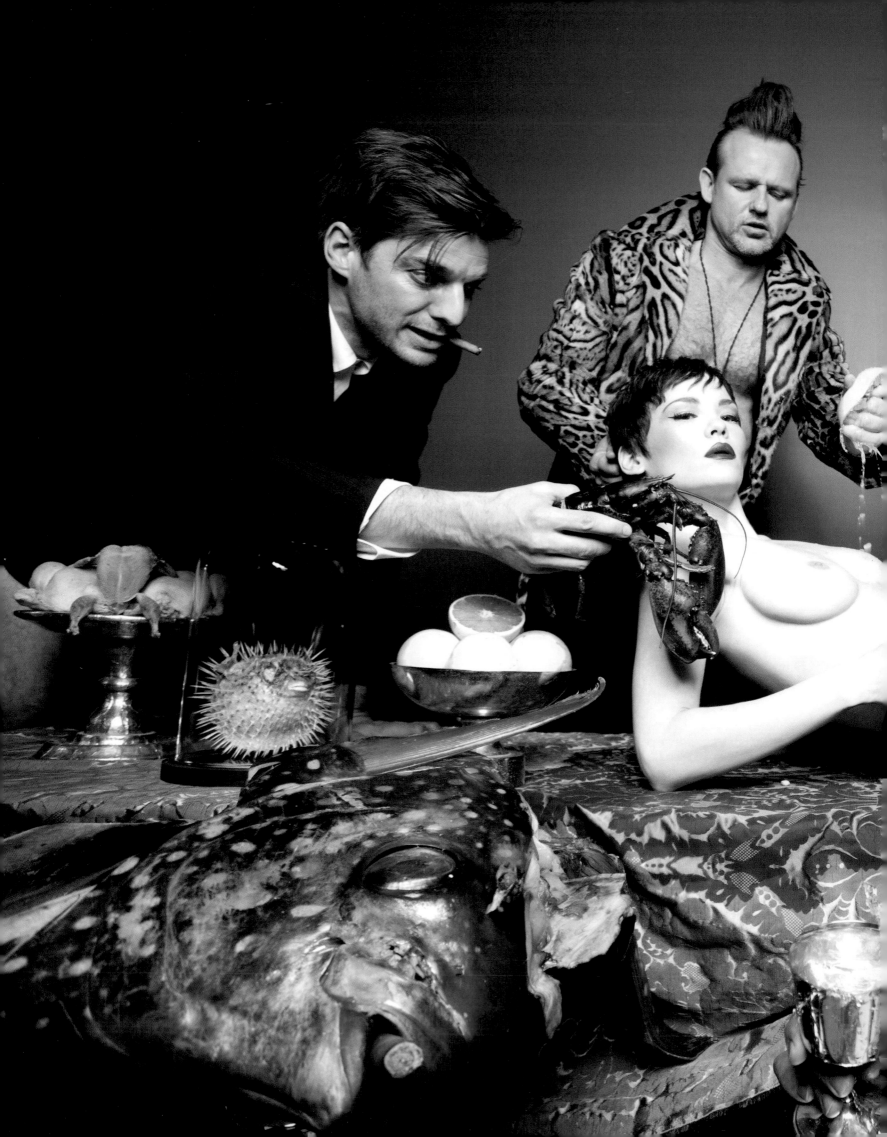

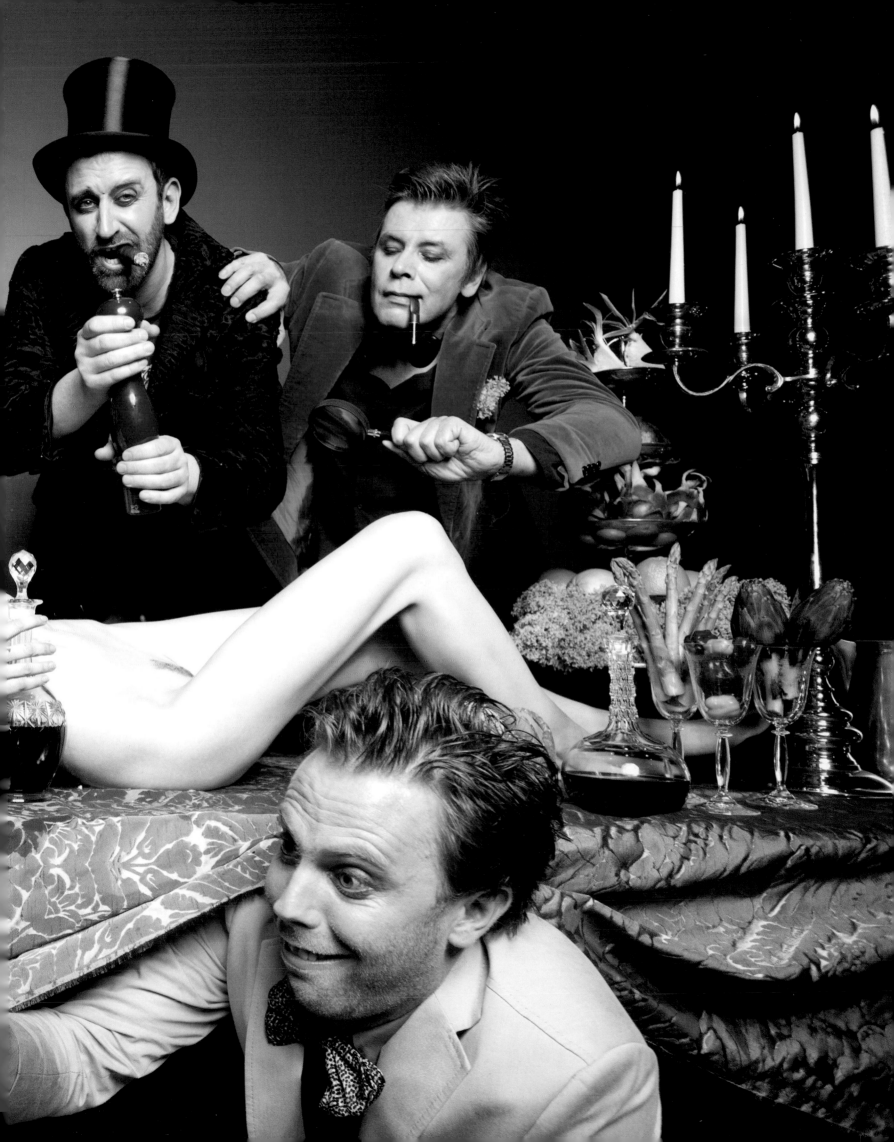

»ICH GLAUBE OLI KOMMT NICHT VON DIESEM PLANETEN, ER IST EINFACH ANDERS. ICH LIEBE SEINE VERRÜCKTE ART, DIE SICH PERFEKT MIT MEINER ERGÄNZT. ICH DENKE, DAS IST DER GRUND, WARUM WIR EINFACH ALLES ZUSAMMEN ROCKEN! ER IST NICHT NUR MEIN FOTOGRAF, SONDERN AUCH EINER MEINER BESTEN FREUNDE. ER HAT SCHON DAMALS DAS BESONDERE IN MIR GESEHEN UND VIEL ZU DEM, WAS ICH JETZT BIN, BEIGETRAGEN. JEMAND, DER VON ANFANG AN AN MICH GEGLAUBT HAT UND MIT SEINEM BLICK GANZ NEUE ASPEKTE DER KUNST ERFASST. EGAL WIE OBERFLÄCHLICH DIESE GANZE SZENE MANCHMAL SCHEINT, ER IST ES NICHT.«

CARO CULT

»OLIVER RATH'S FOTOGRAFIEN SIND WIE EINE EIGENS VON IHM ENTWICKELTE SPRACHE, DIE JEDER VERSTEHT, ABER NUR ER SPRECHEN KANN.«

KOSTJA ULLMANN

»OLIVER IST SO WAS VON EINZIGARTIG, DASS KEIN STATEMENT MEINERSEITS IHM GERECHT WERDEN WÜRDE.«

JOKO WINTERSCHEID

»HE MUST DESIGN A VIDEO GAME WITH THE ACTION SET IN HIS PHOTO STUDIO. PROBABLY JUMP AND RUN OR A SHOOTER GAME; HE WOULD BE THE HERO, A SORT OF LARA CROFT OF THE 21ST CENTURY.«

WESTBAM

»OLI IS NOT A PERSON WHO RESTS ON HIS LAURELS. HE ALWAYS PUSHES HIMSELF TO EVOLVE. BOUNDARIES ARE NONEXISTENT TO HIM. AND I REALLY APPRECIATE THAT.«

ESTHER PERBANDT

»OLIVER RATH IMMEDIATELY CAUGHT MY EYE BY HIS INCREDIBLE OUTPUT. EVERY DAY IN HIS BLOG THERE ARE NEW SCENES RANGING FROM BIZARRE TO AESTHETIC, BUT NEVER BORING!«

H.P. BAXXTER

»I LOVE THE DARING, YET ELEGANT SEXUALITY IN OLI'S WORK ... DOPENESS.«

MOUSSE T.

»OLI RATH IS A HUNGRY HEART HUNTING FOR THE PERFECT MOMENT, WHEN PEOPLE DON'T JUST TAKE OFF THEIR CLOTHES, NO, THEY TAKE OFF THEIR MASKS. PEOPLE DO THAT BECAUSE THIS GUY IS TRULY STUFFED WITH LOVE FOR LIFE AND NATURE'S BEAUTY. OLI IS A LIGHTSABER OF INSPIRATION TO ME.«

TIMO JACOBS

»OLIVER RATH FEUERT GERADE IN SCHALLGESCHWINDIGKEIT EIN GUTES BILD NACH DEM ANDEREN RAUS. DAS MACHT SEHR VIEL SPASS DABEI ZUZUSCHAUEN, WIE DER KERL BRENNT.« OLLI SCHULZ

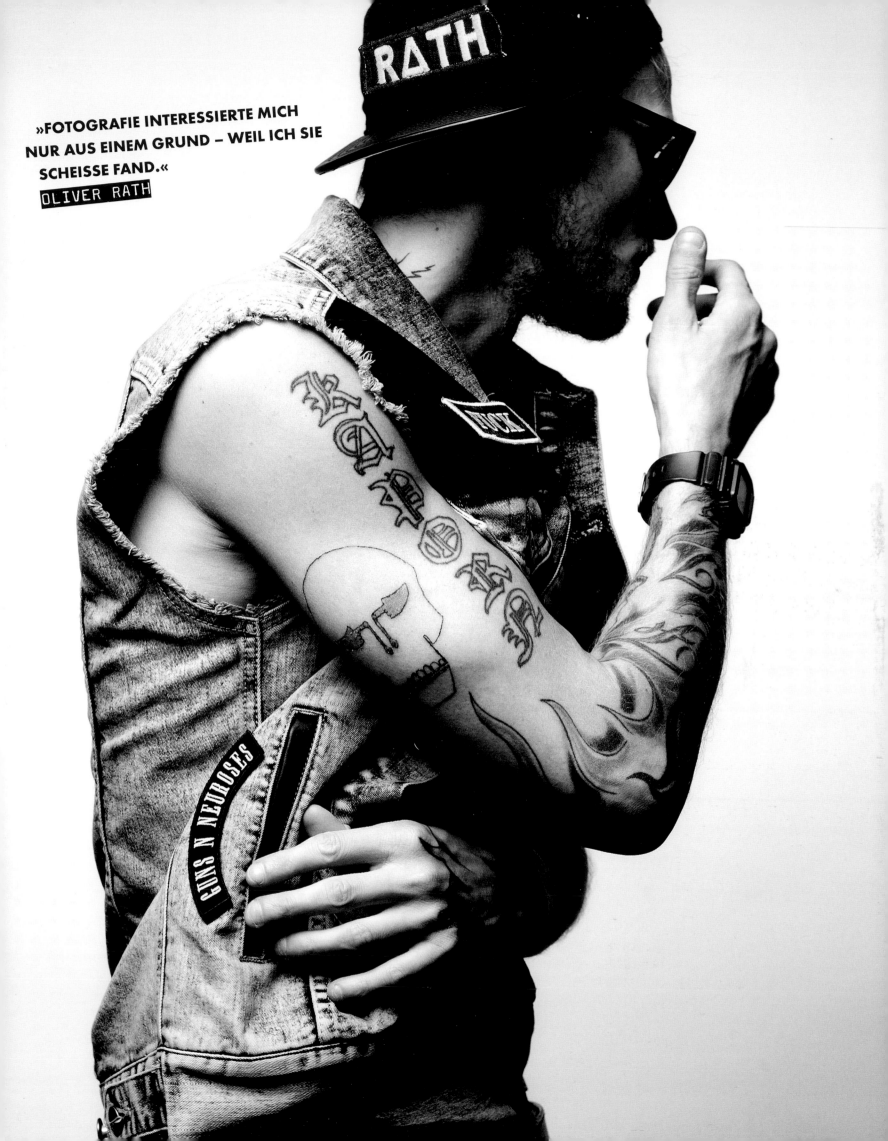

»FOTOGRAFIE INTERESSIERTE MICH NUR AUS EINEM GRUND – WEIL ICH SIE SCHEISSE FAND.«
OLIVER RATH

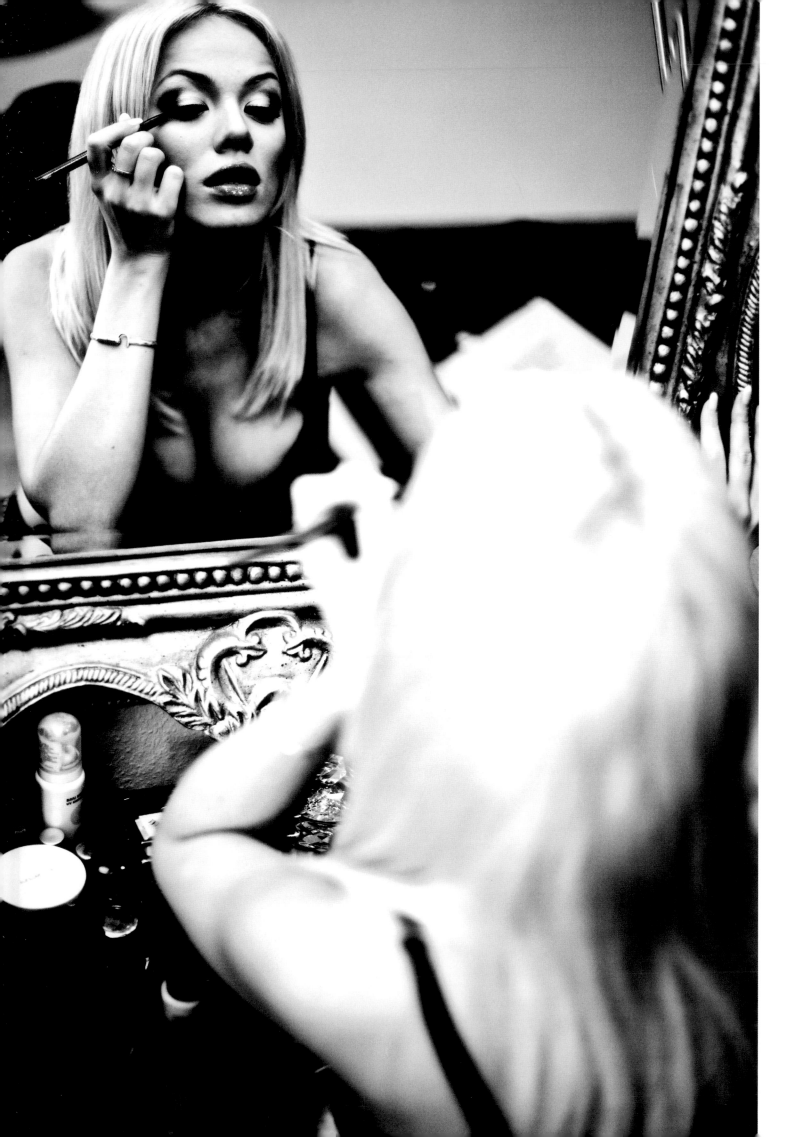

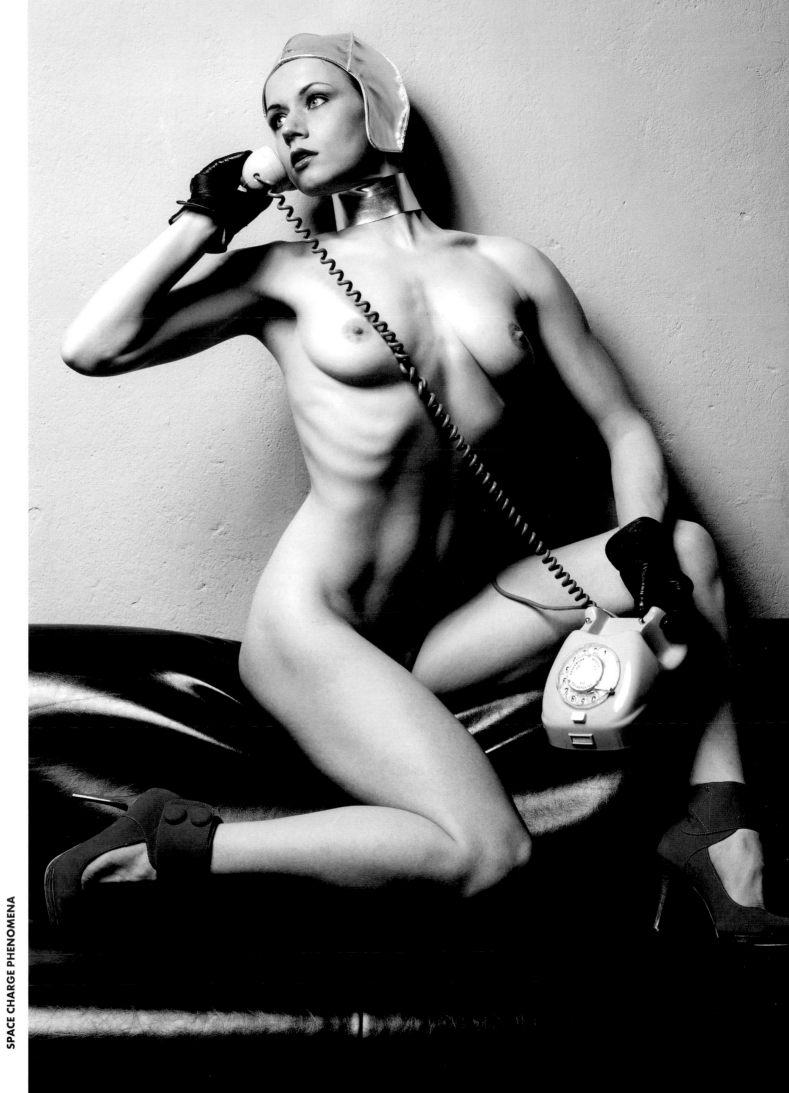

11

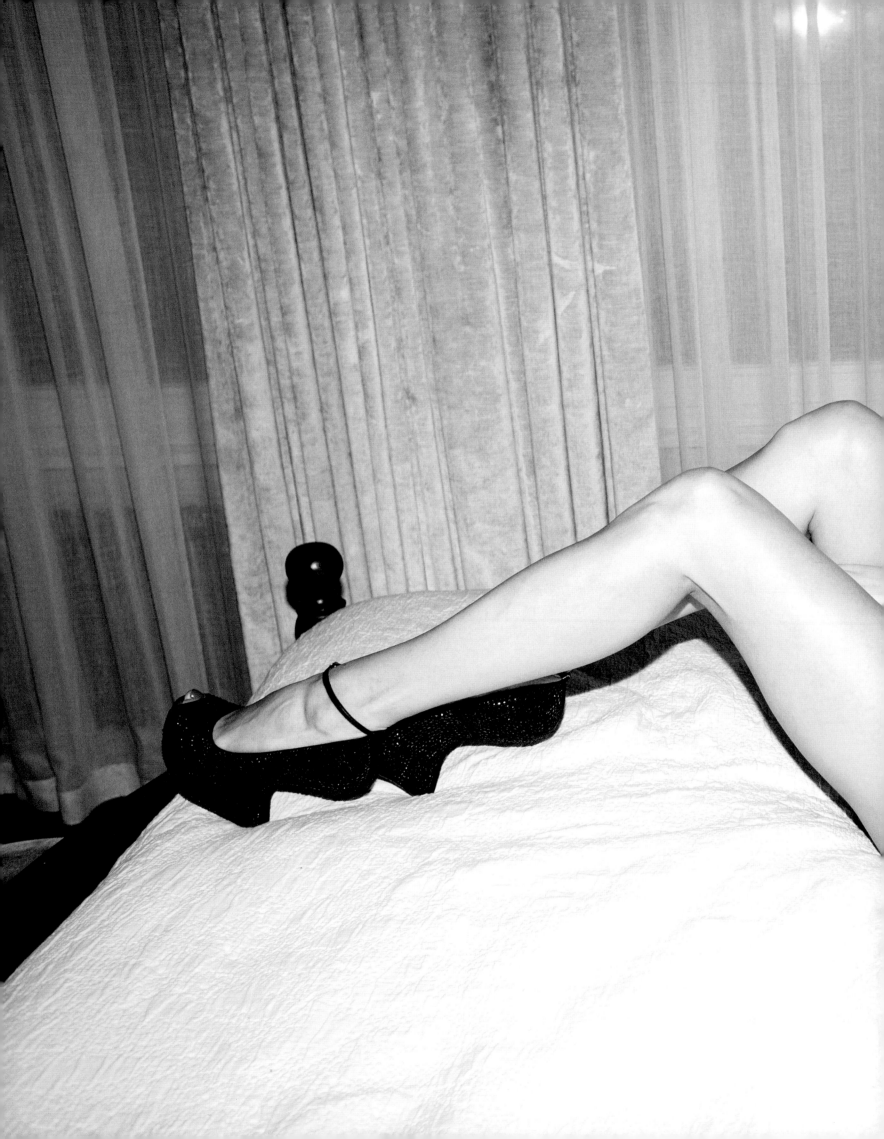

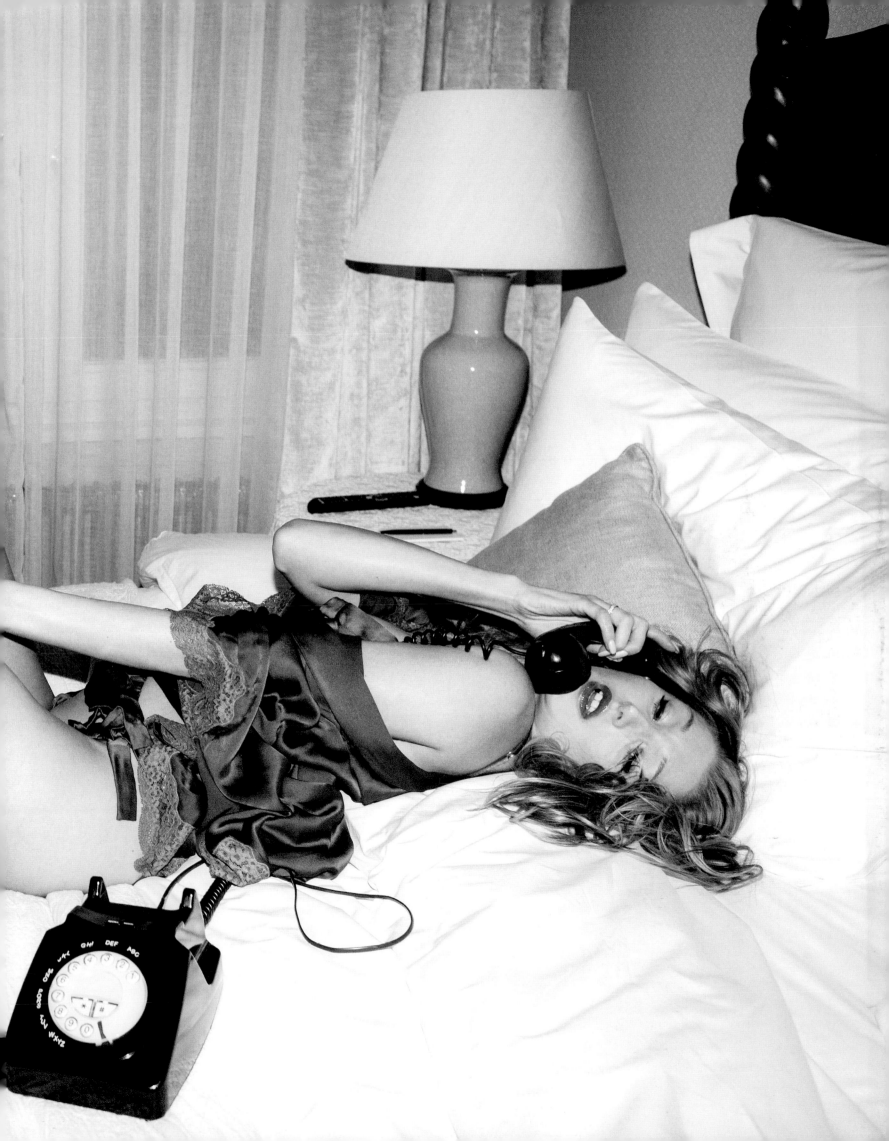

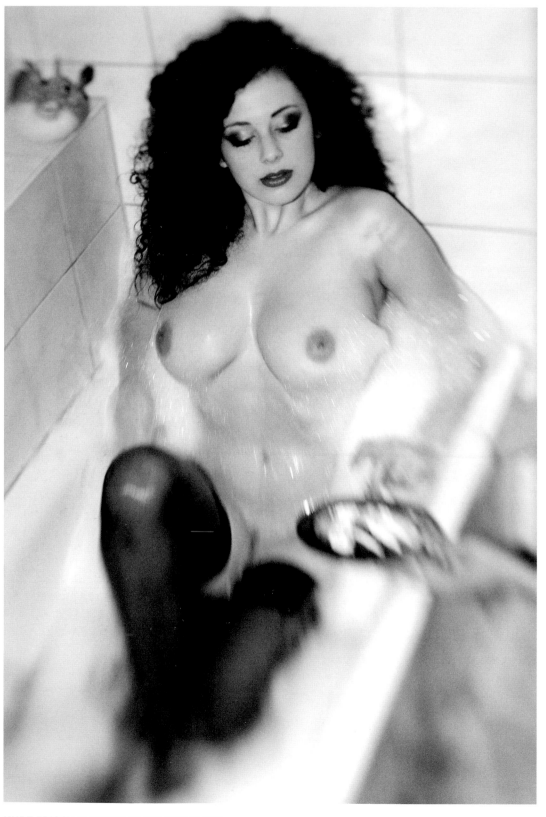

KURZ FRISCH MACHEN QUICK FRESHEN UP

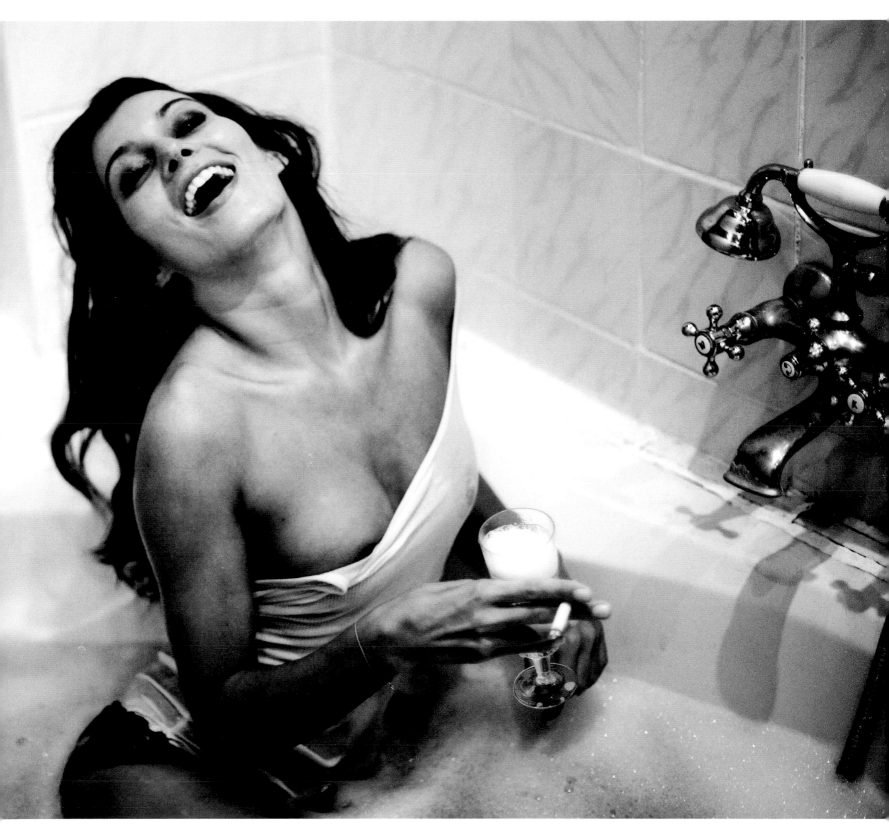

UNSATISFIED

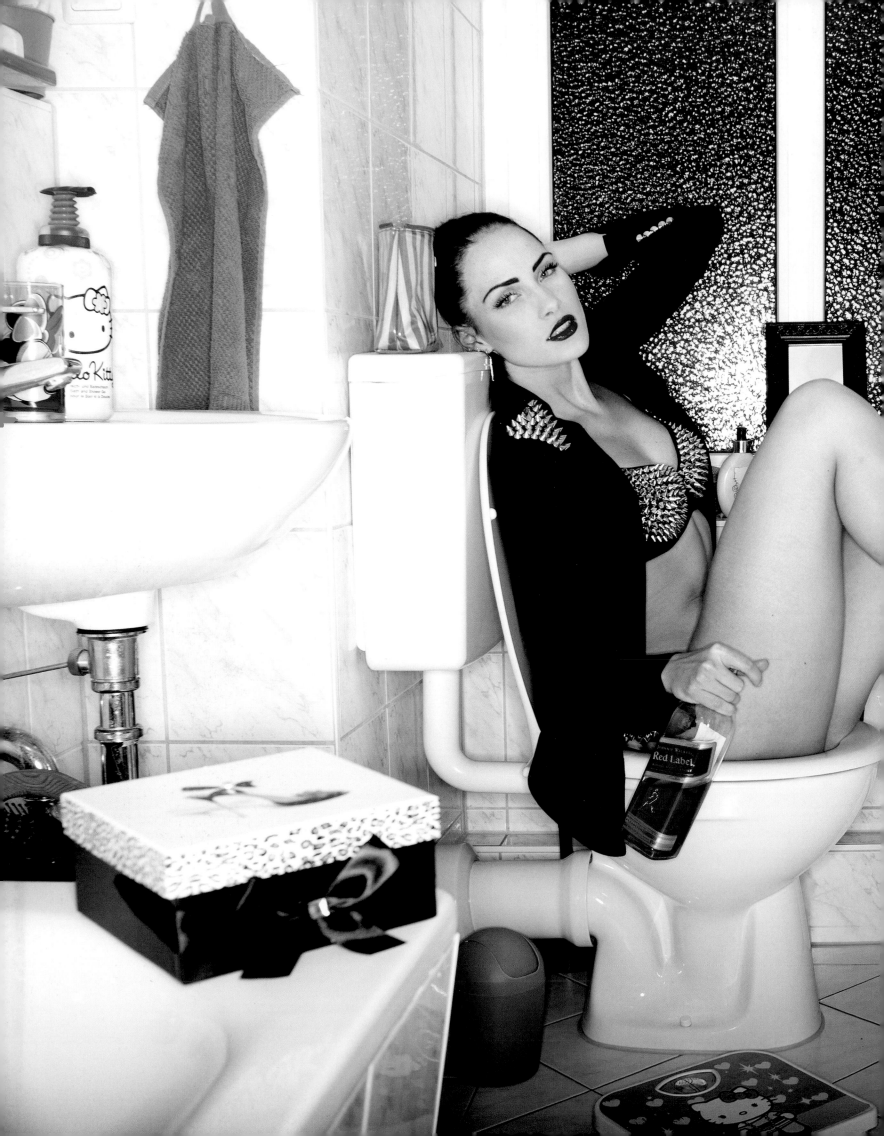

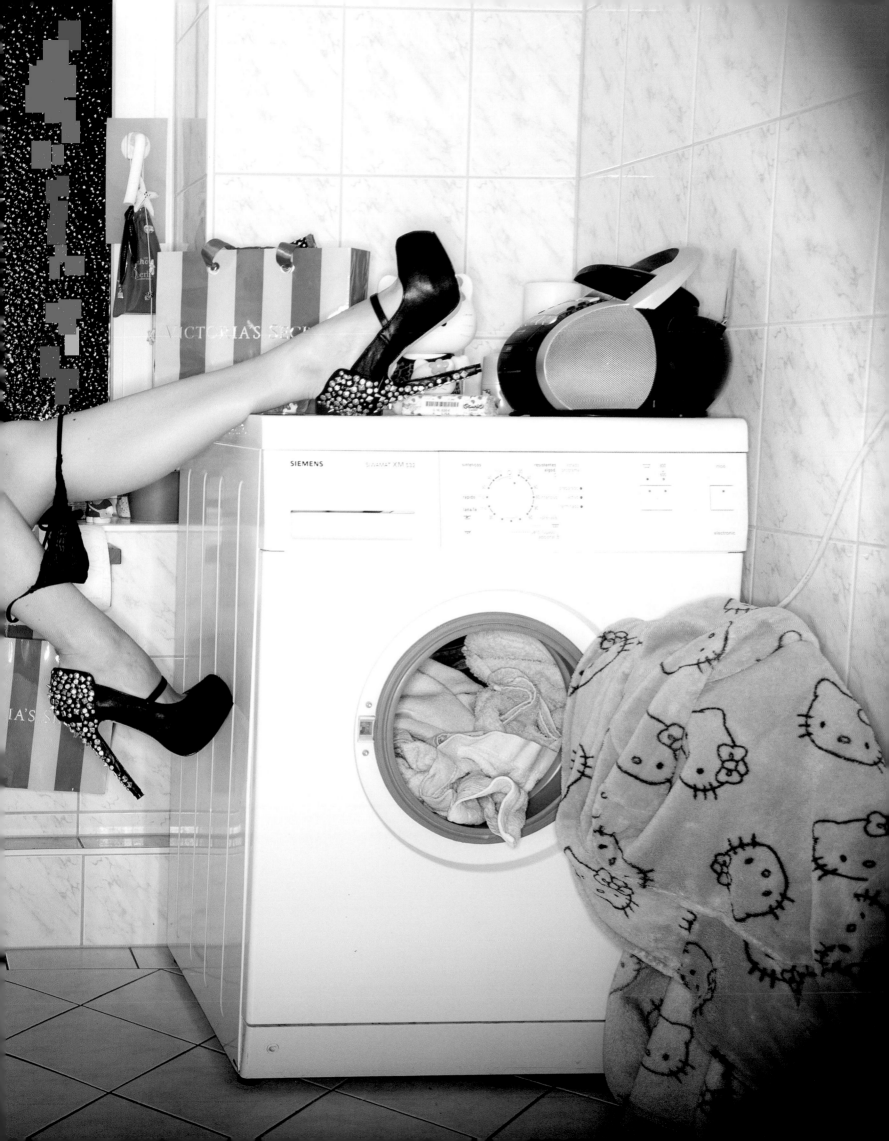

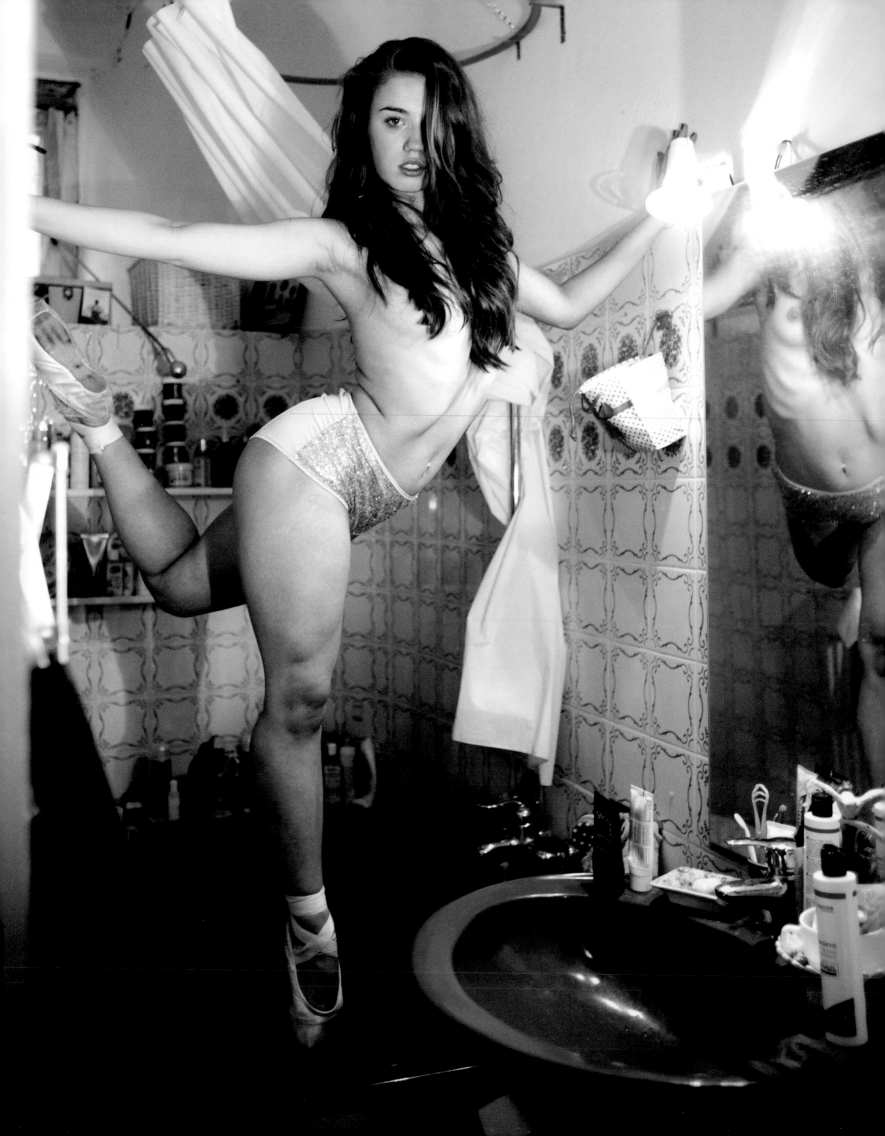

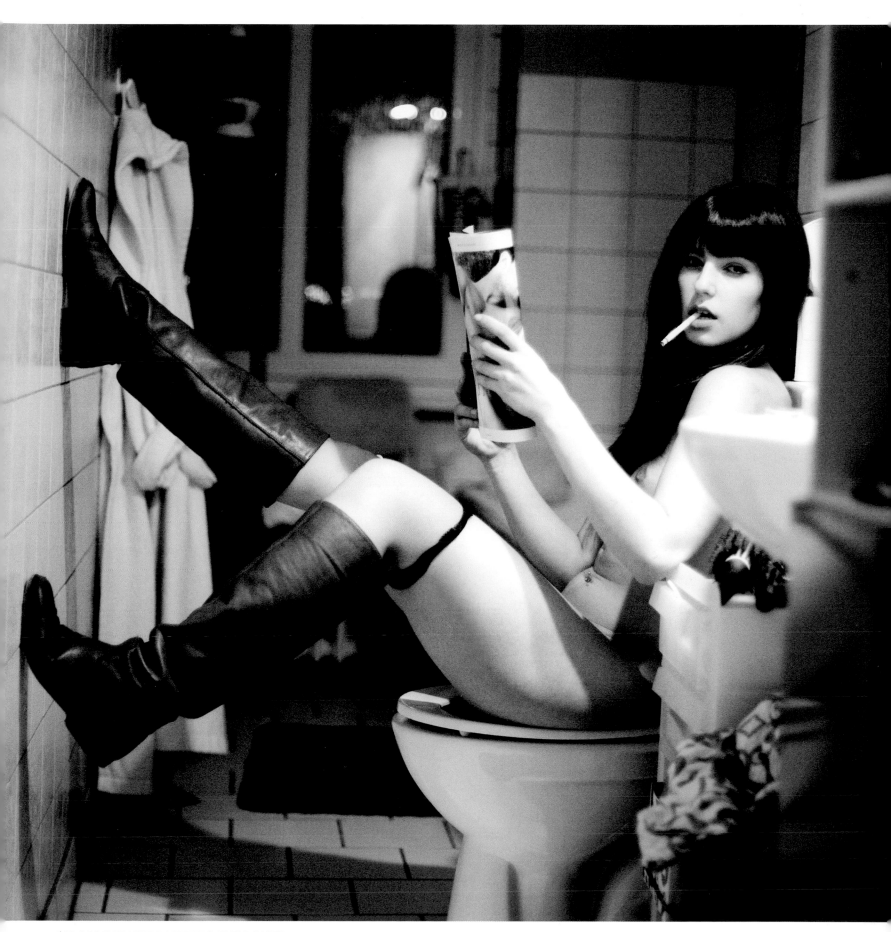

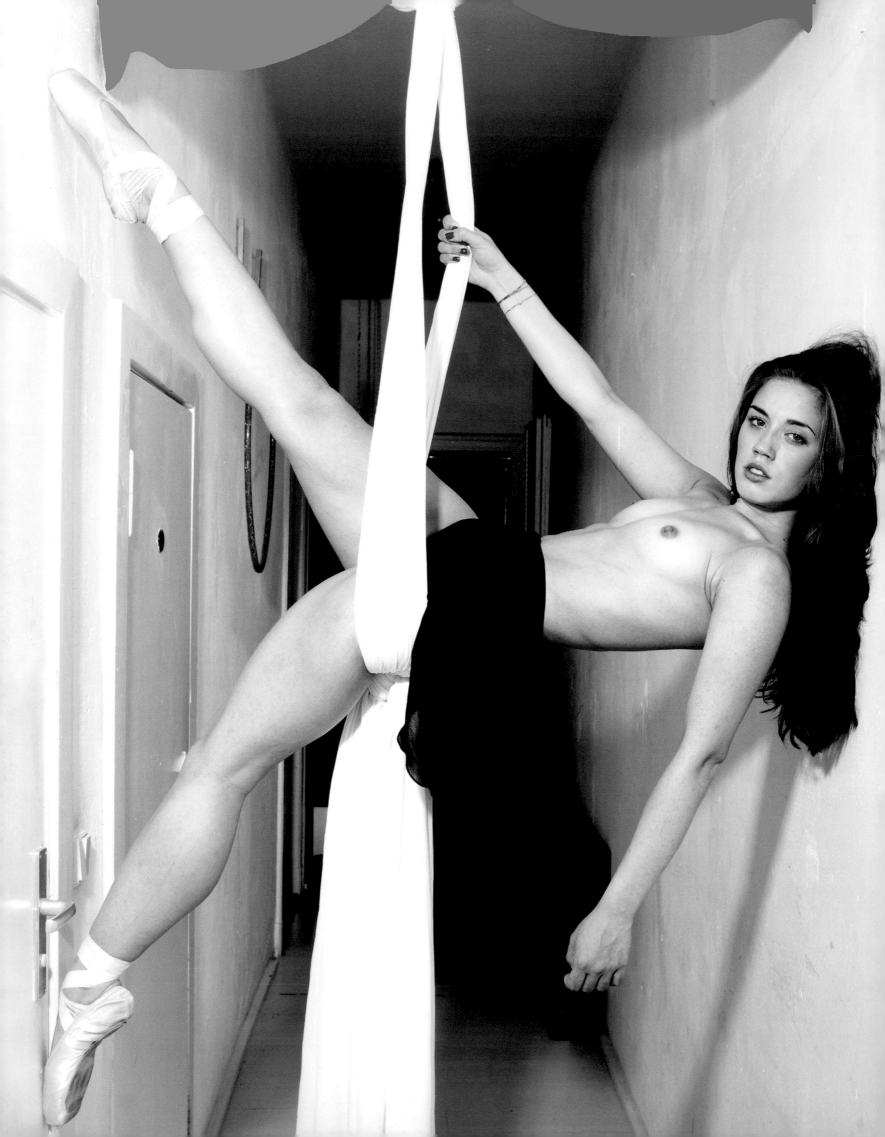

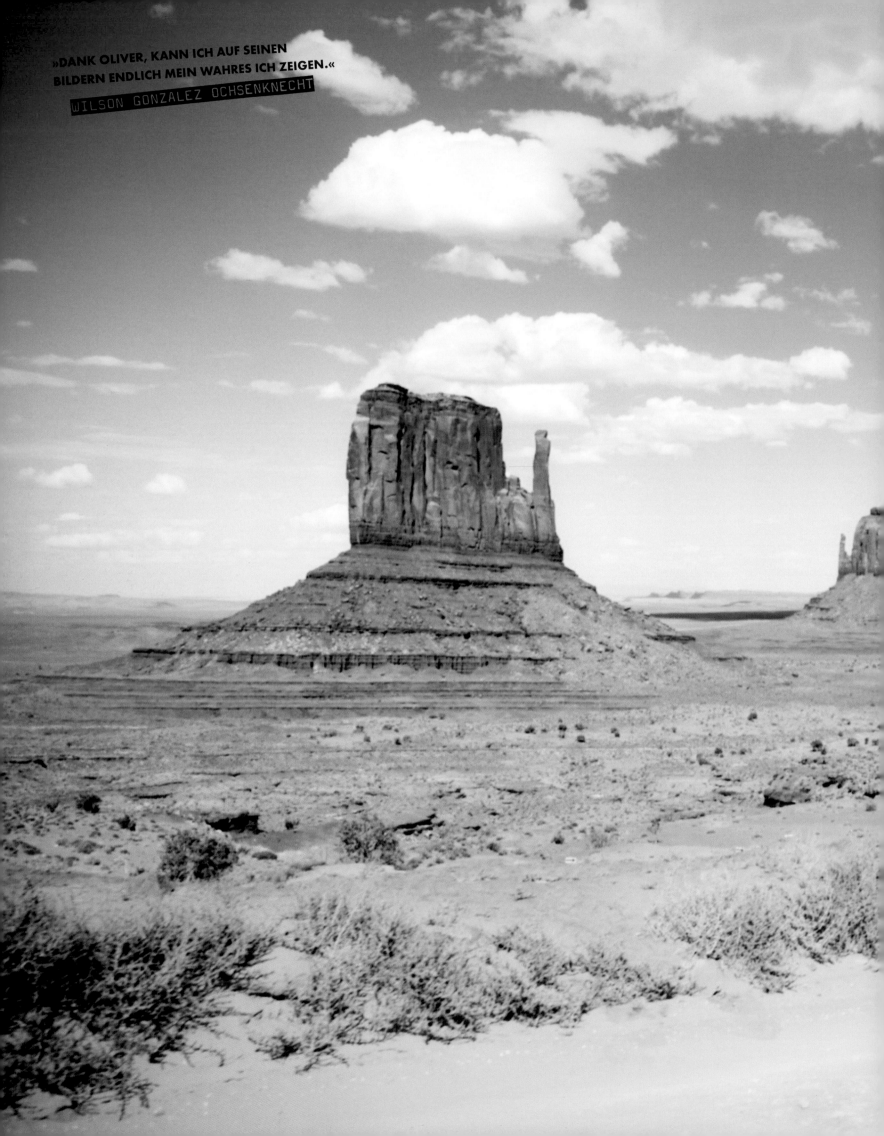

»DANK OLIVER, KANN ICH AUF SEINEN
BILDERN ENDLICH MEIN WAHRES ICH ZEIGEN.«
WILSON GONZALEZ OCHSENKNECHT

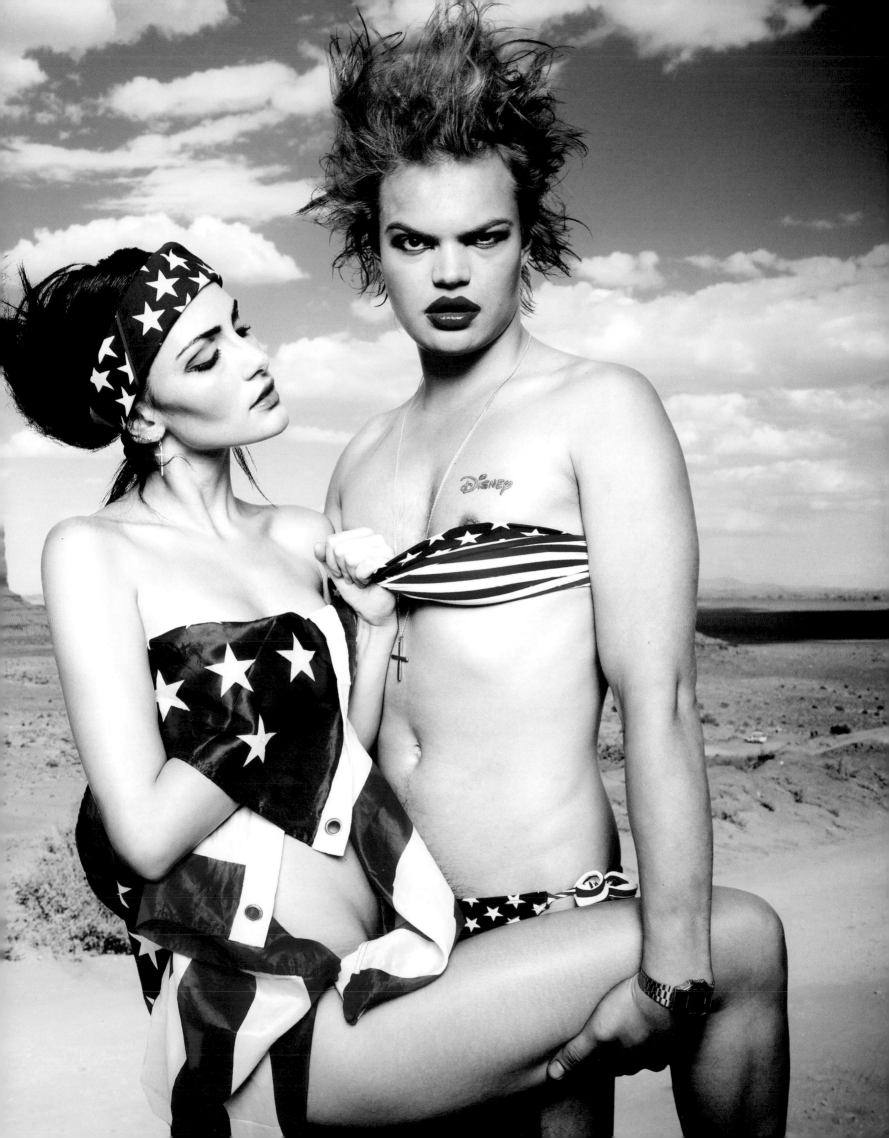

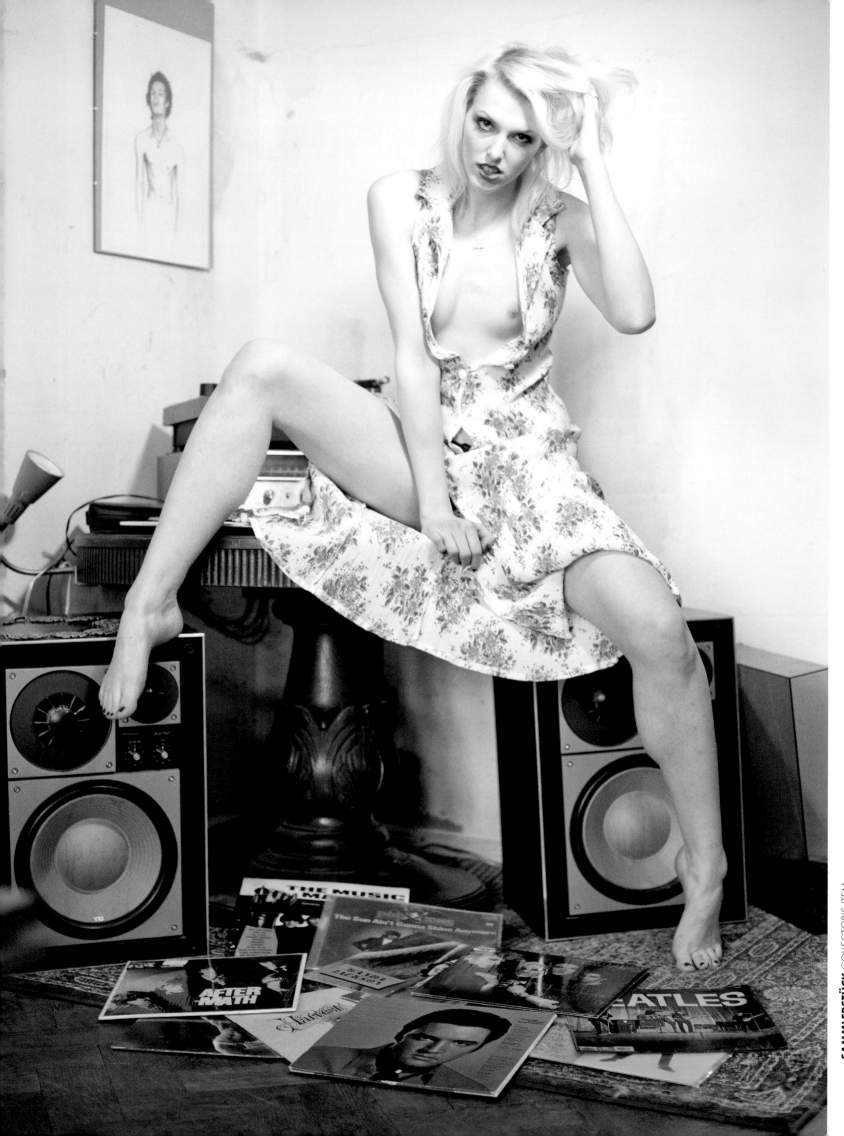

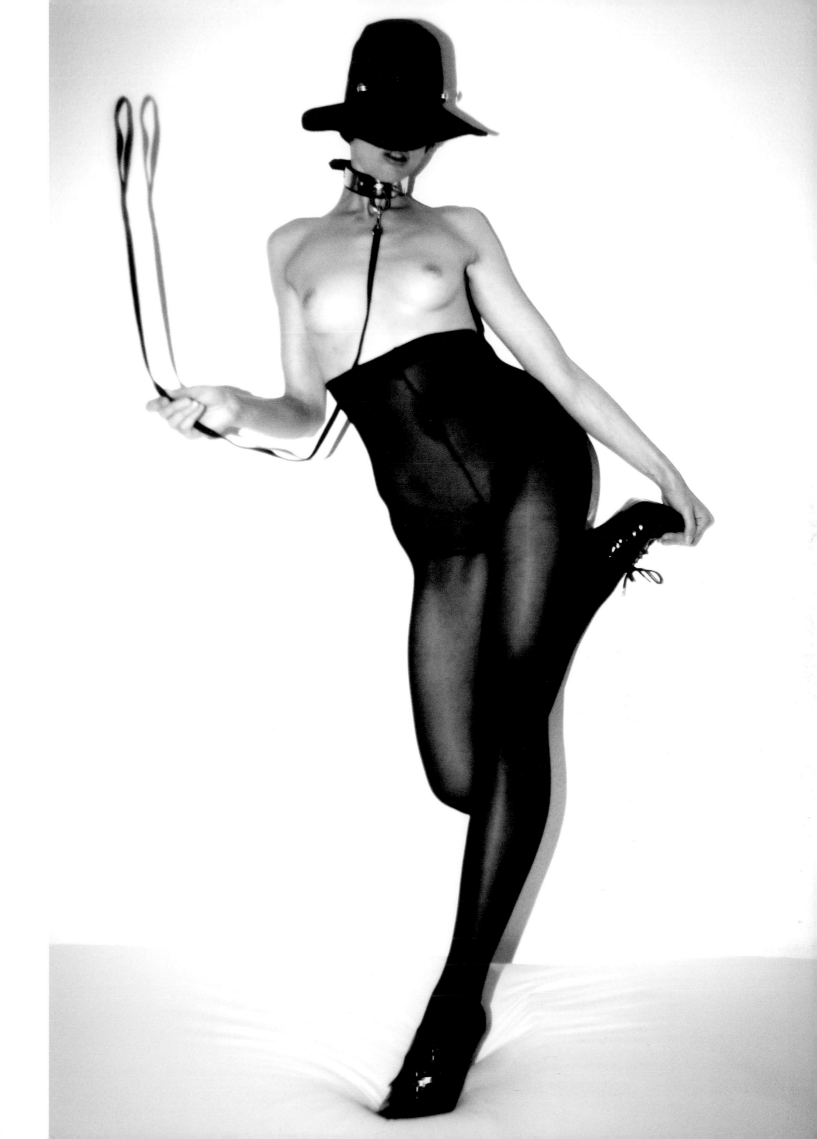

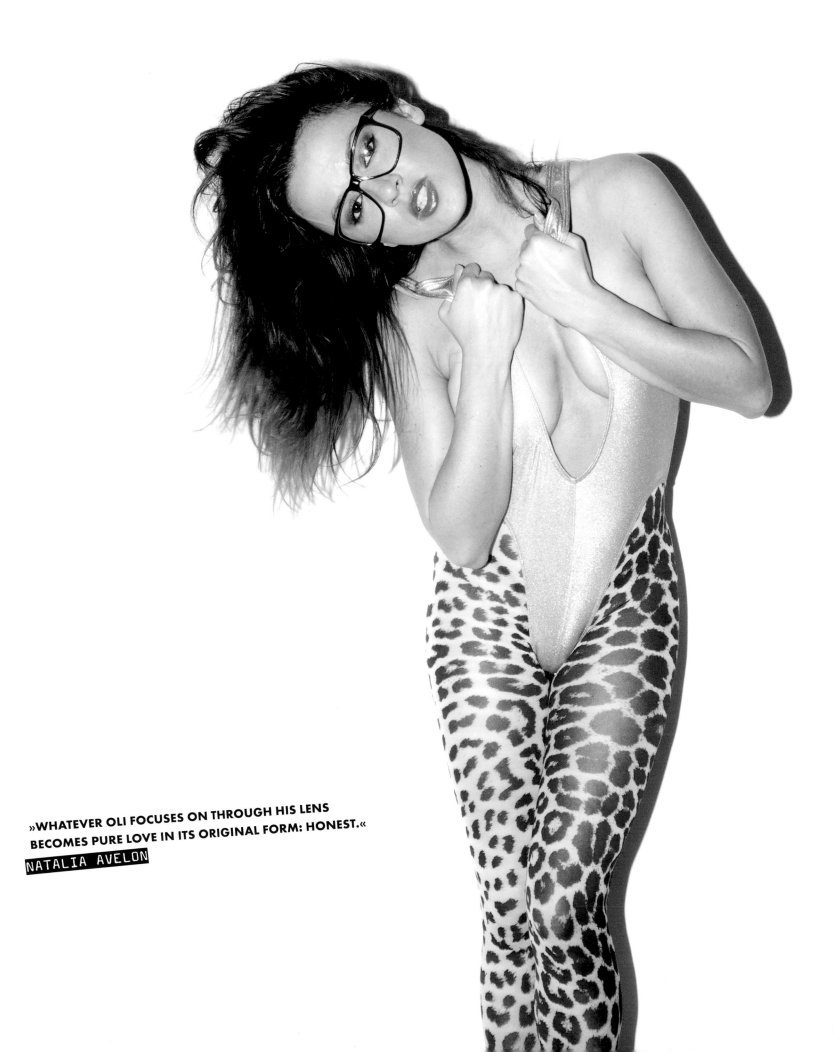

»WHATEVER OLI FOCUSES ON THROUGH HIS LENS
BECOMES PURE LOVE IN ITS ORIGINAL FORM: HONEST.«
NATALIA AVELON

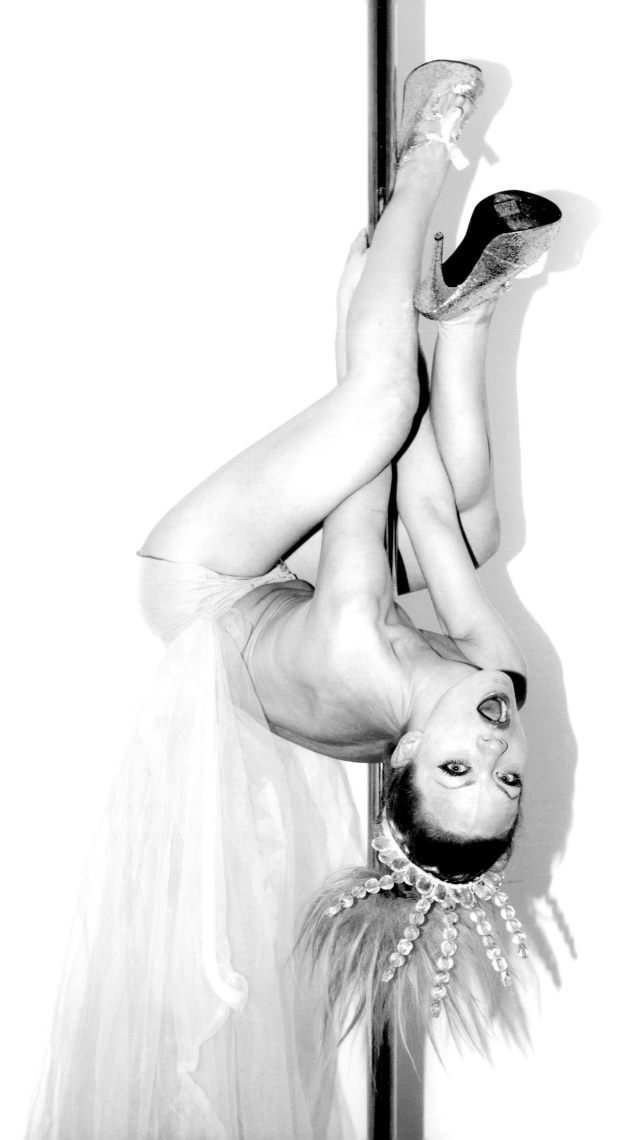

MEIN ROHR GLÄNZT MY GLISTENING POLE

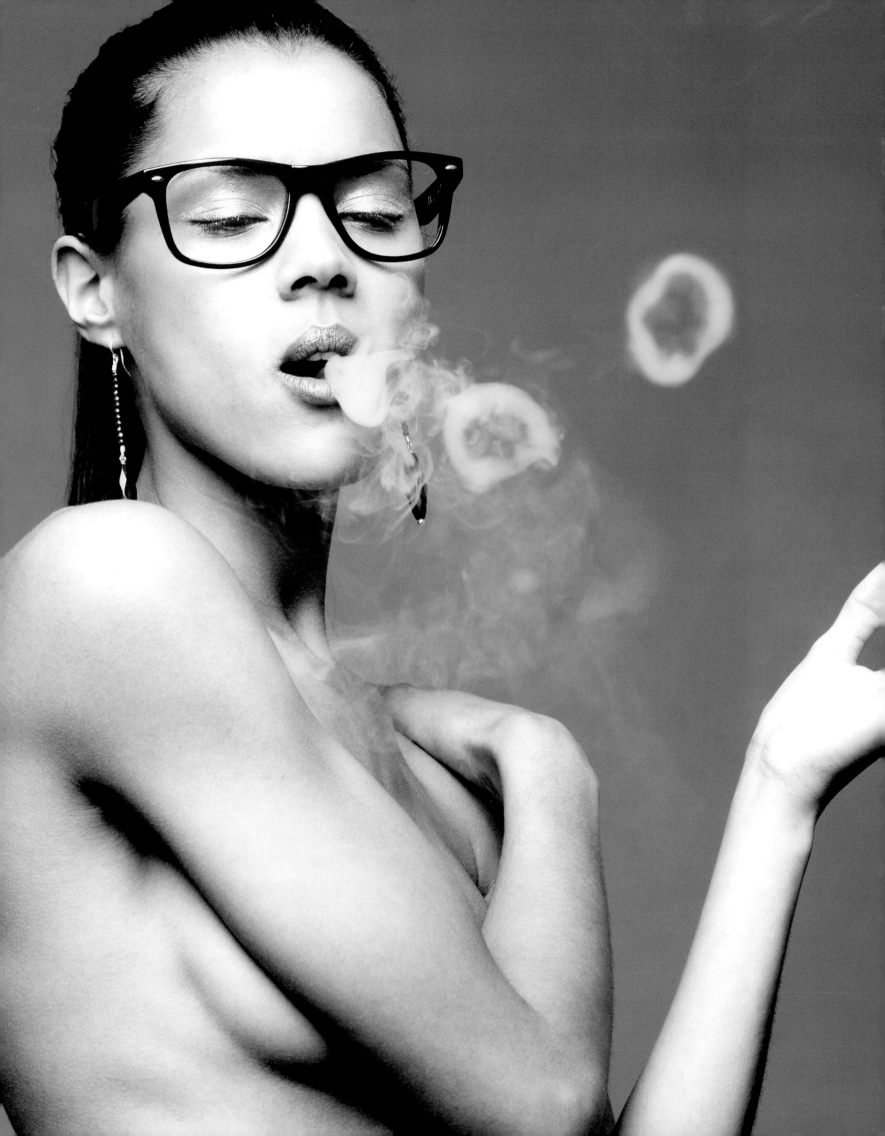

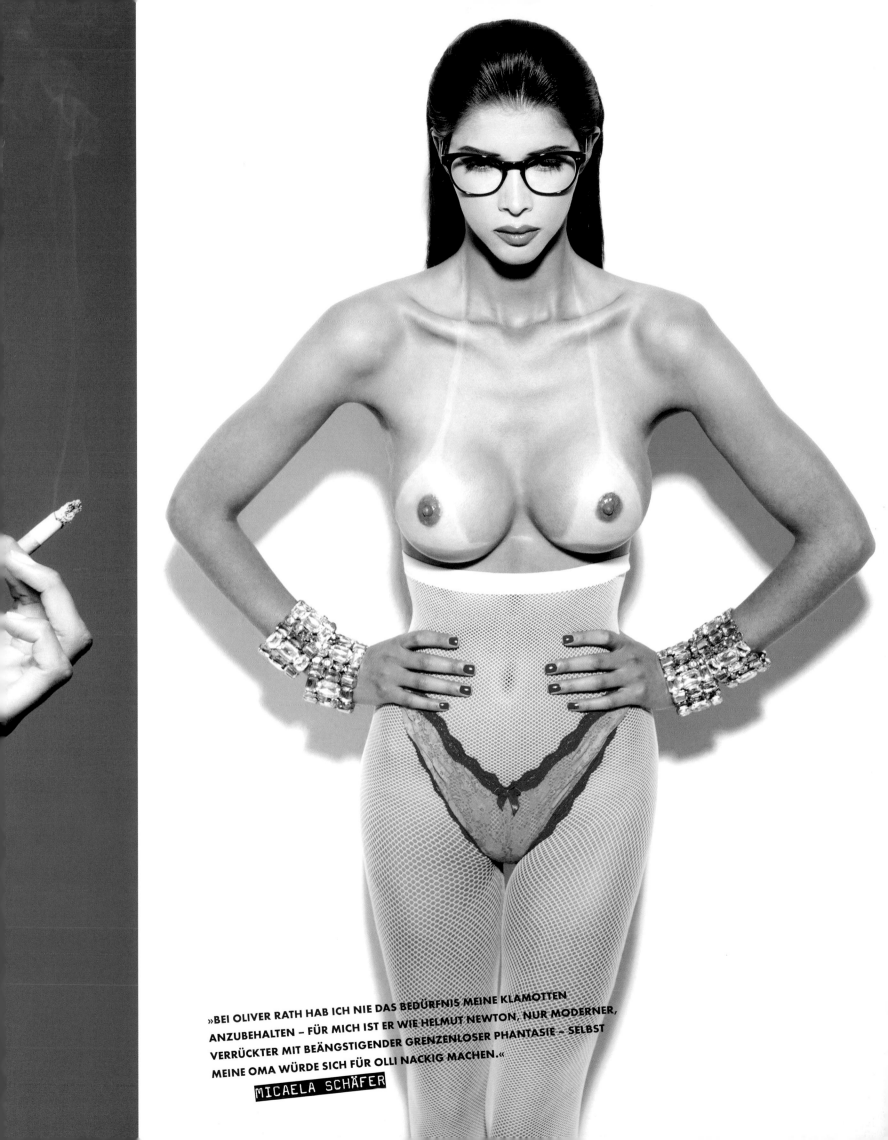

»BEI OLIVER RATH HAB ICH NIE DAS BEDÜRFNIS MEINE KLAMOTTEN
ANZUBEHALTEN – FÜR MICH IST ER WIE HELMUT NEWTON, NUR MODERNER,
VERRÜCKTER MIT BEÄNGSTIGENDER GRENZENLOSER PHANTASIE – SELBST
MEINE OMA WÜRDE SICH FÜR OLLI NACKIG MACHEN.«
MICAELA SCHÄFER

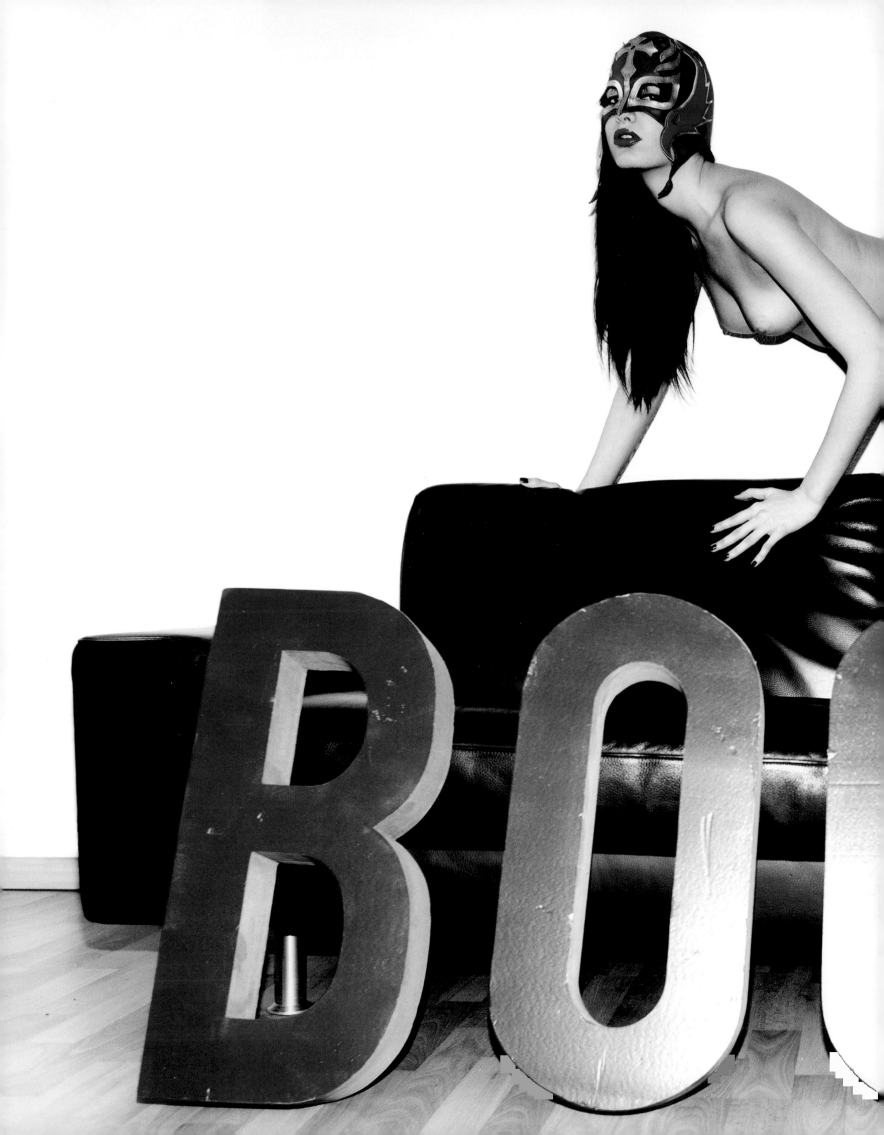

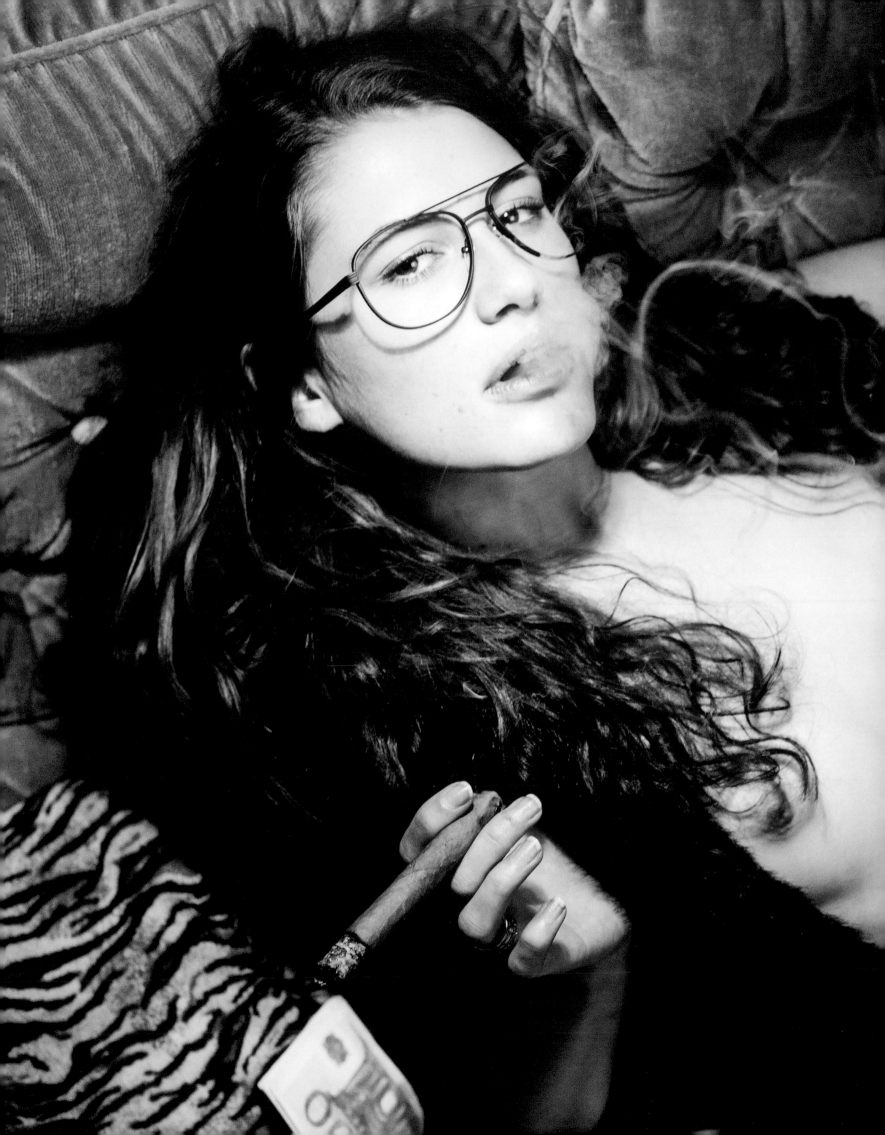

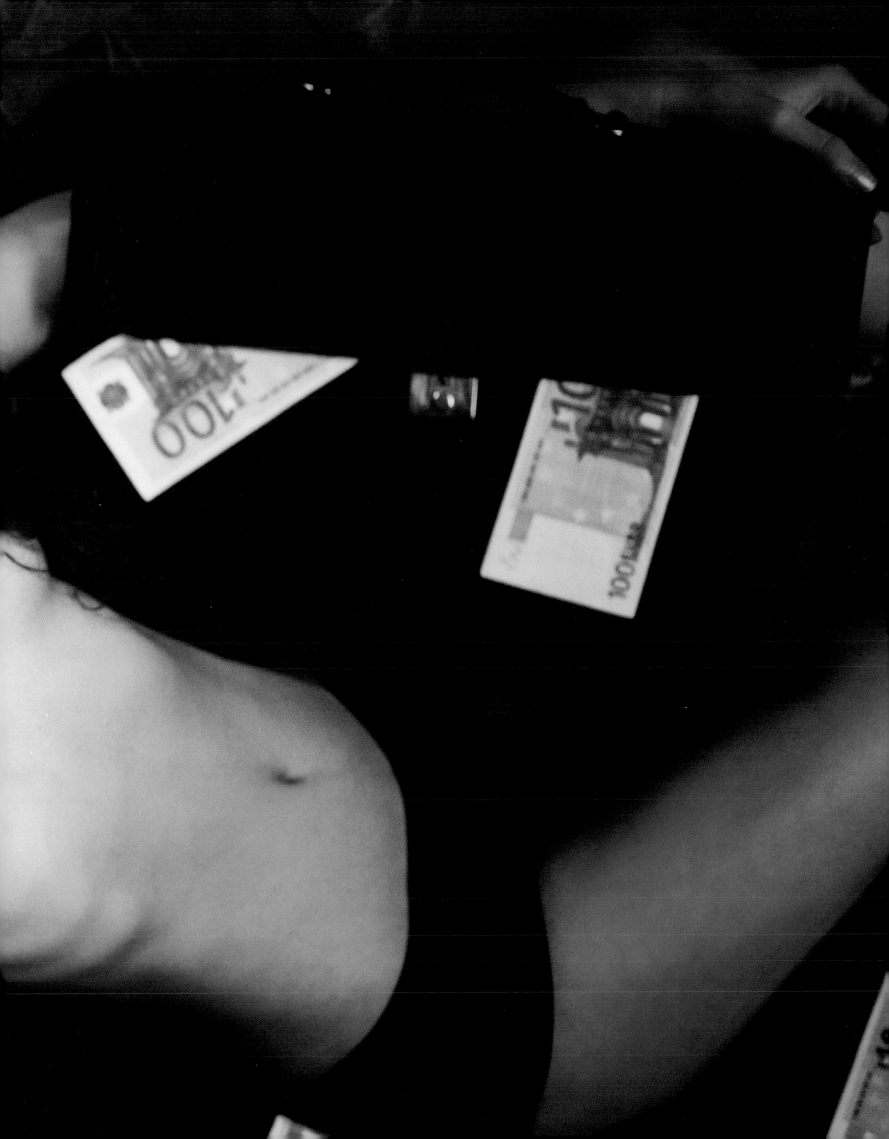

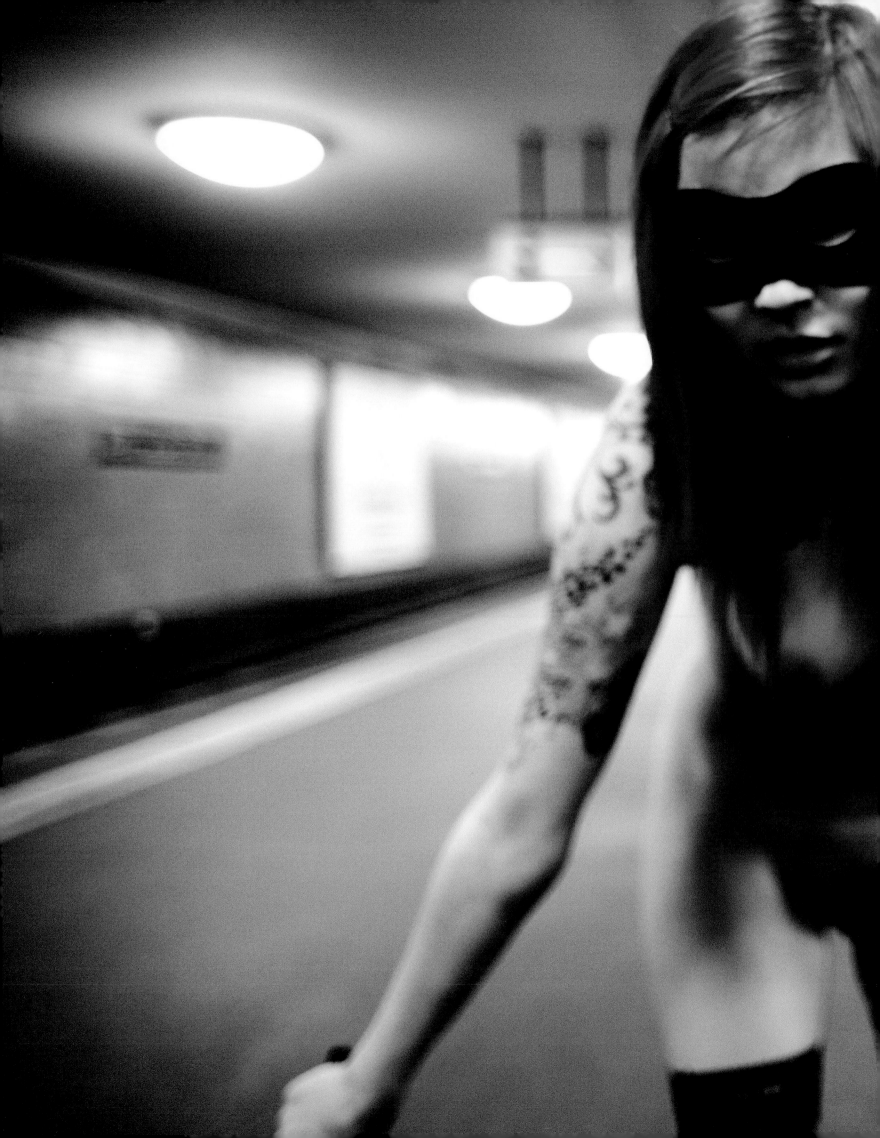

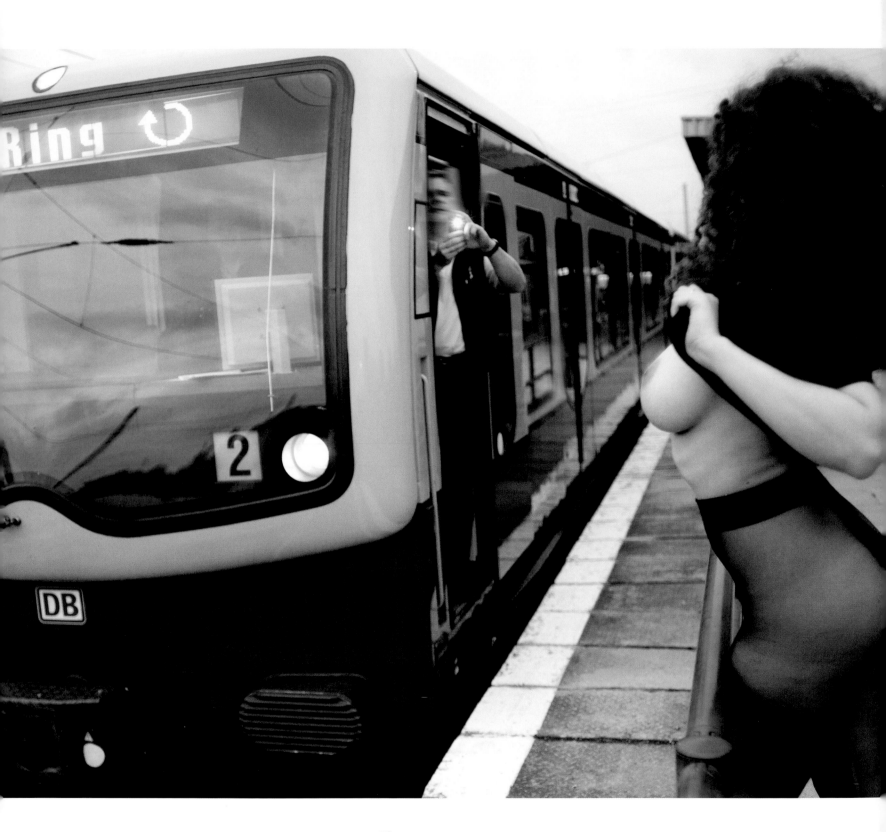

»RATH'S ARBEITEN SIND ROMANTISIERTE WAHRHEITEN,
VERPACKT IN ÄSTHETIK UM ANZUECKEN, OHNE ZU VERSCHEUCHEN.«
LEILA LOWFIRE

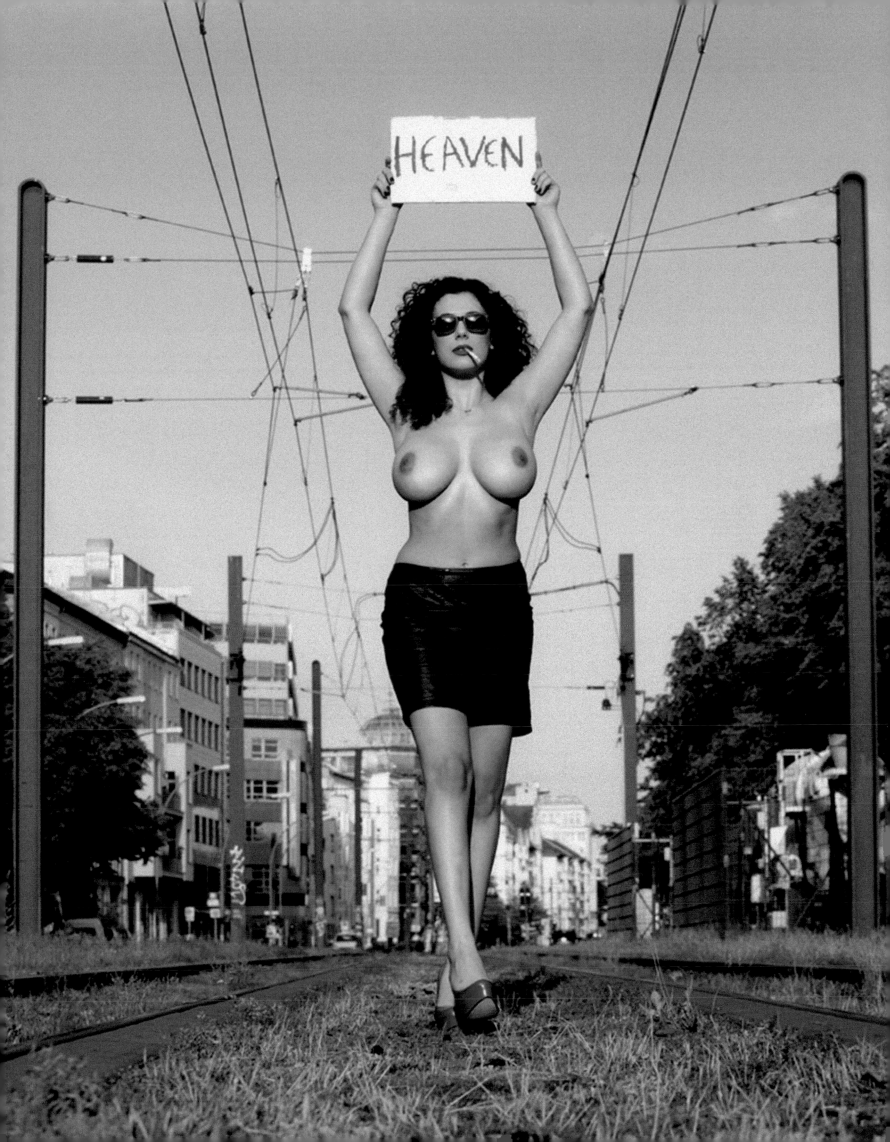

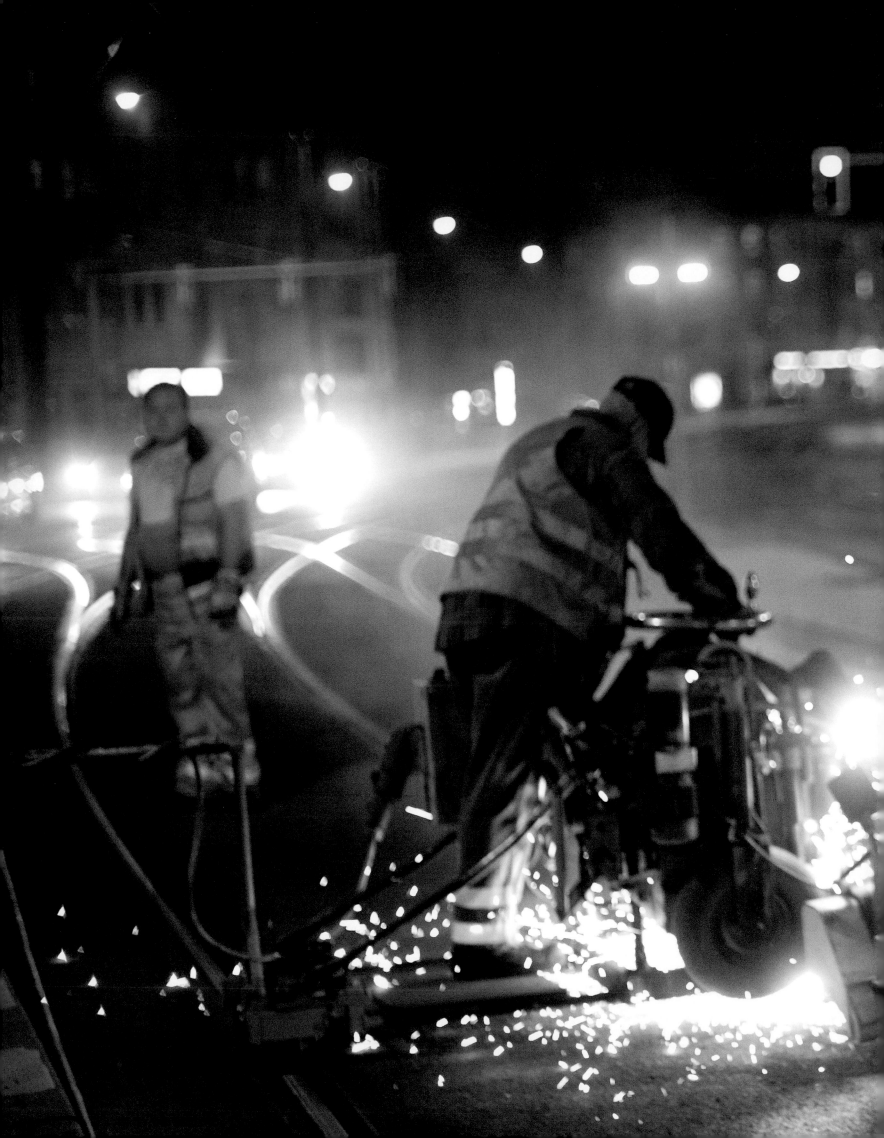

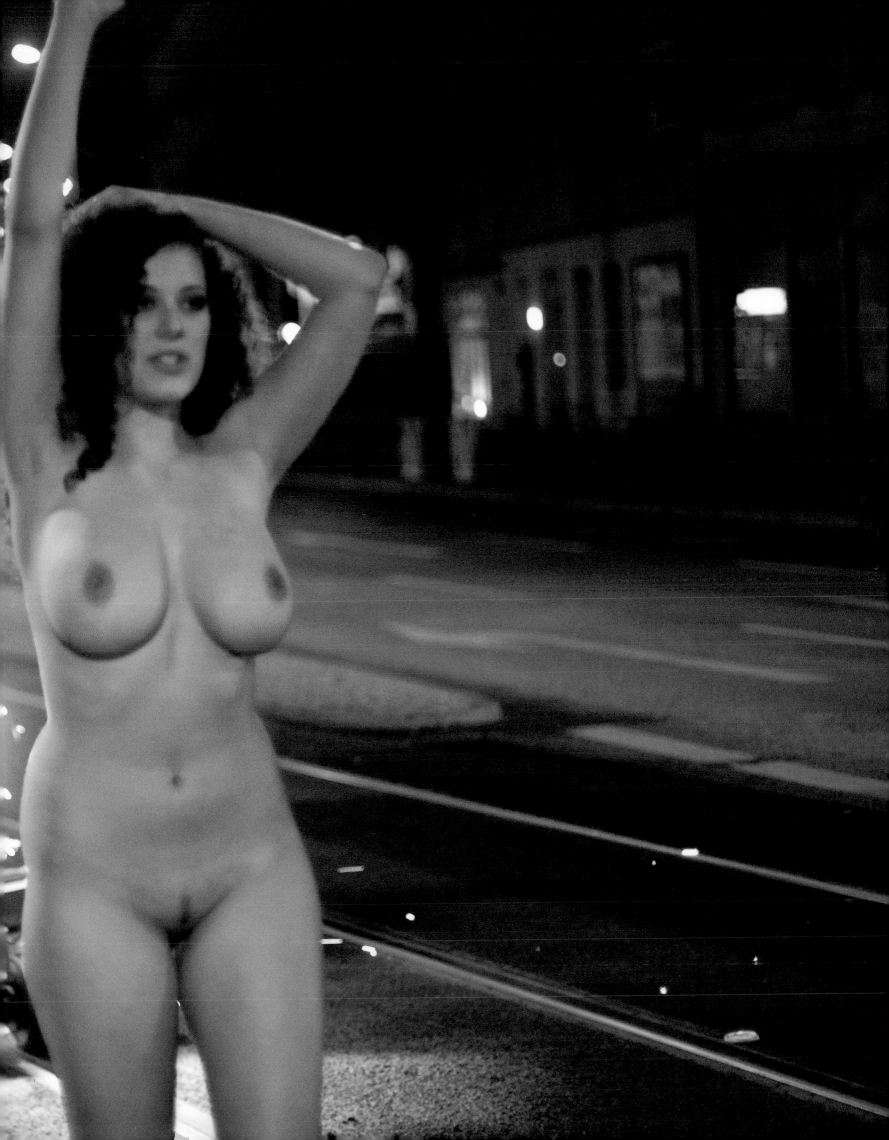

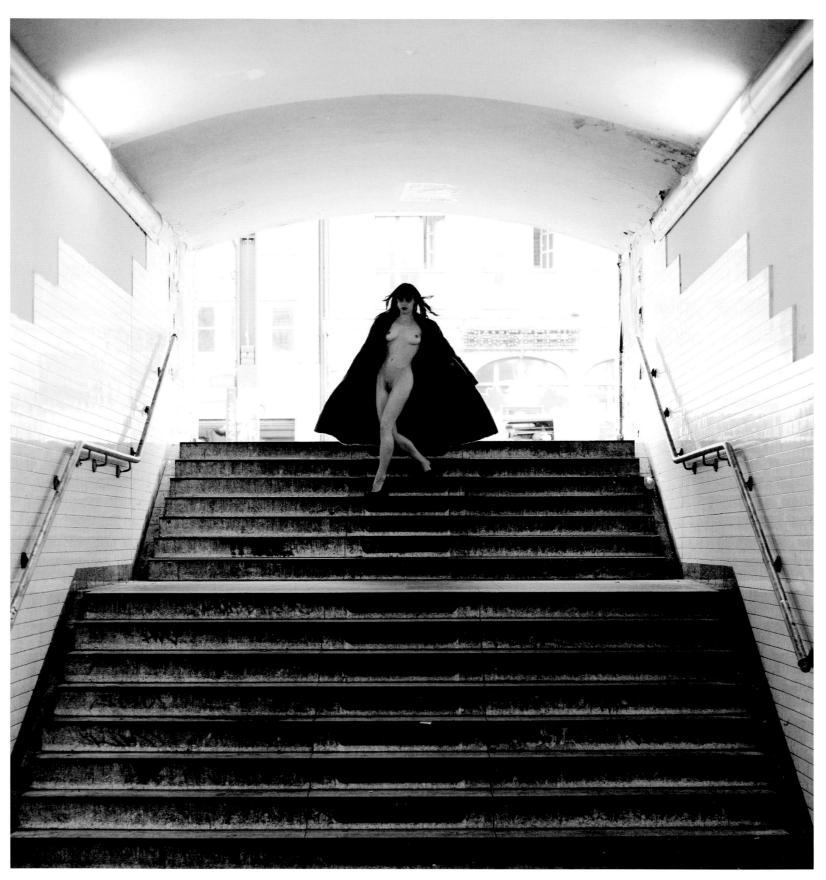

ESCALIER DROIT Á UNE VOLEÉ

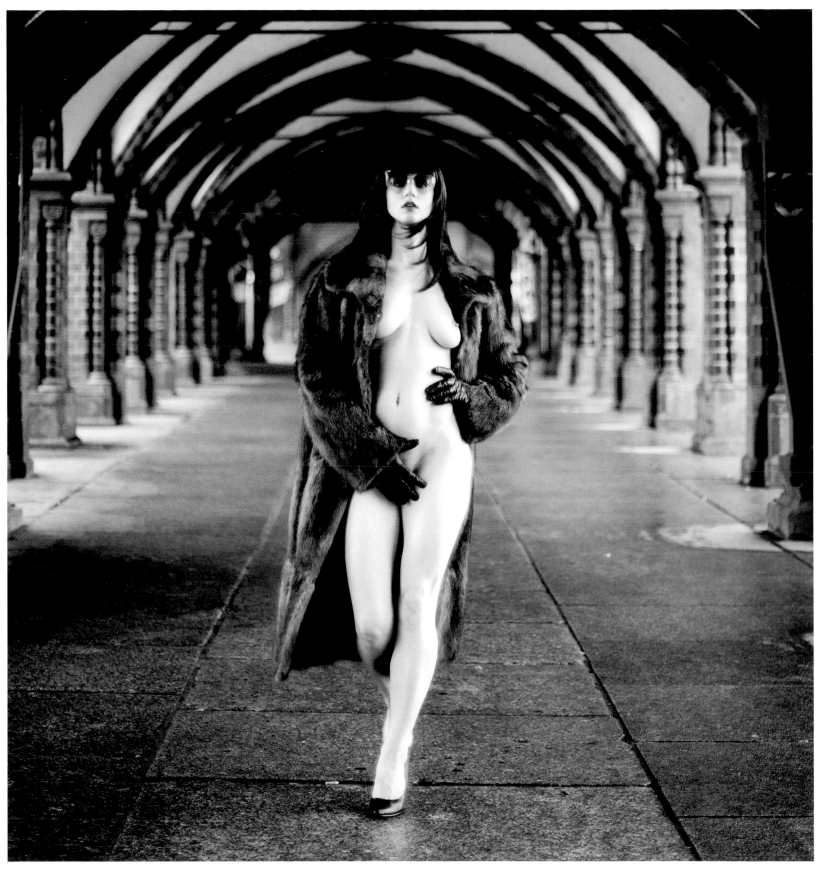

OBERBAUMBRÜCKE

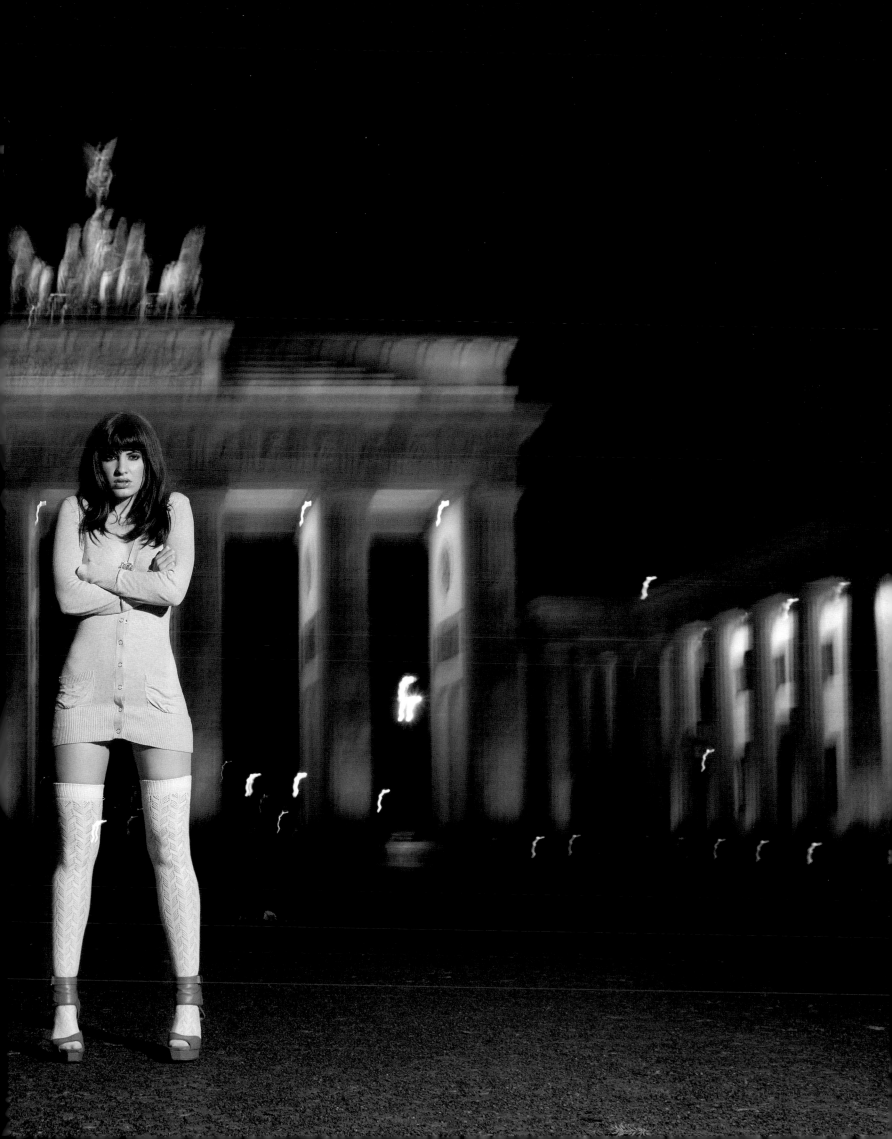

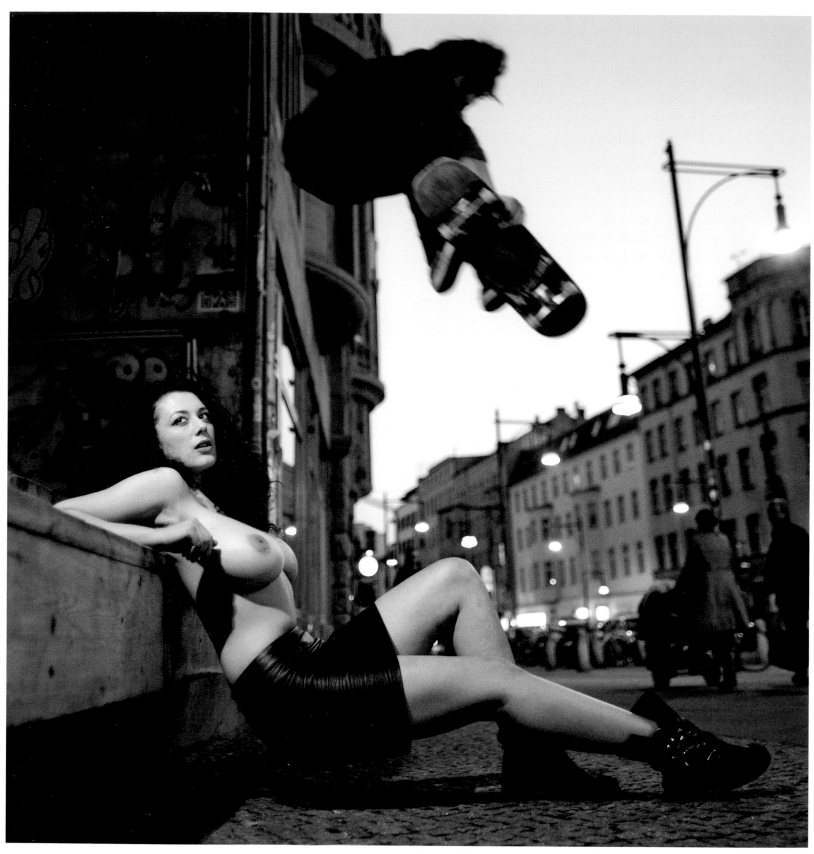

WARUM HABE ICH KEIN KIND MIT IHR WHY DO I NOT HAVE A CHILD WITH HER

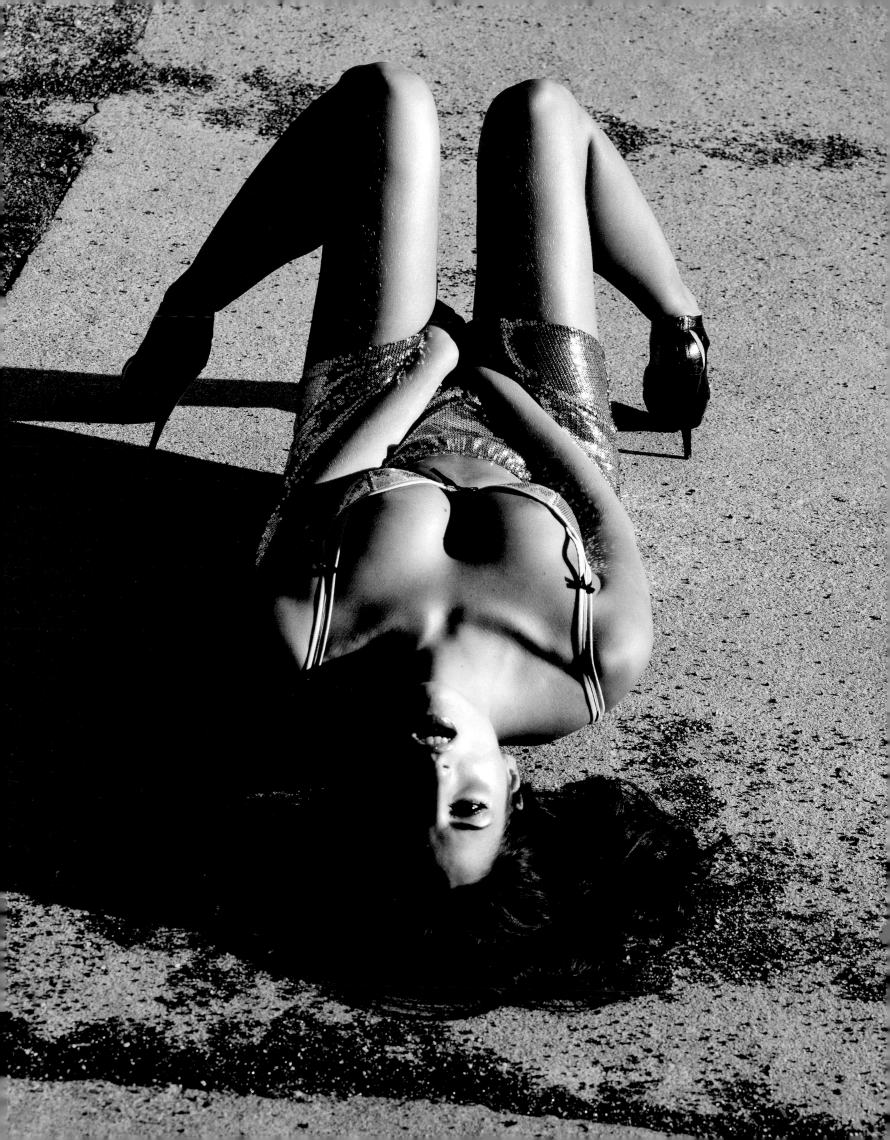

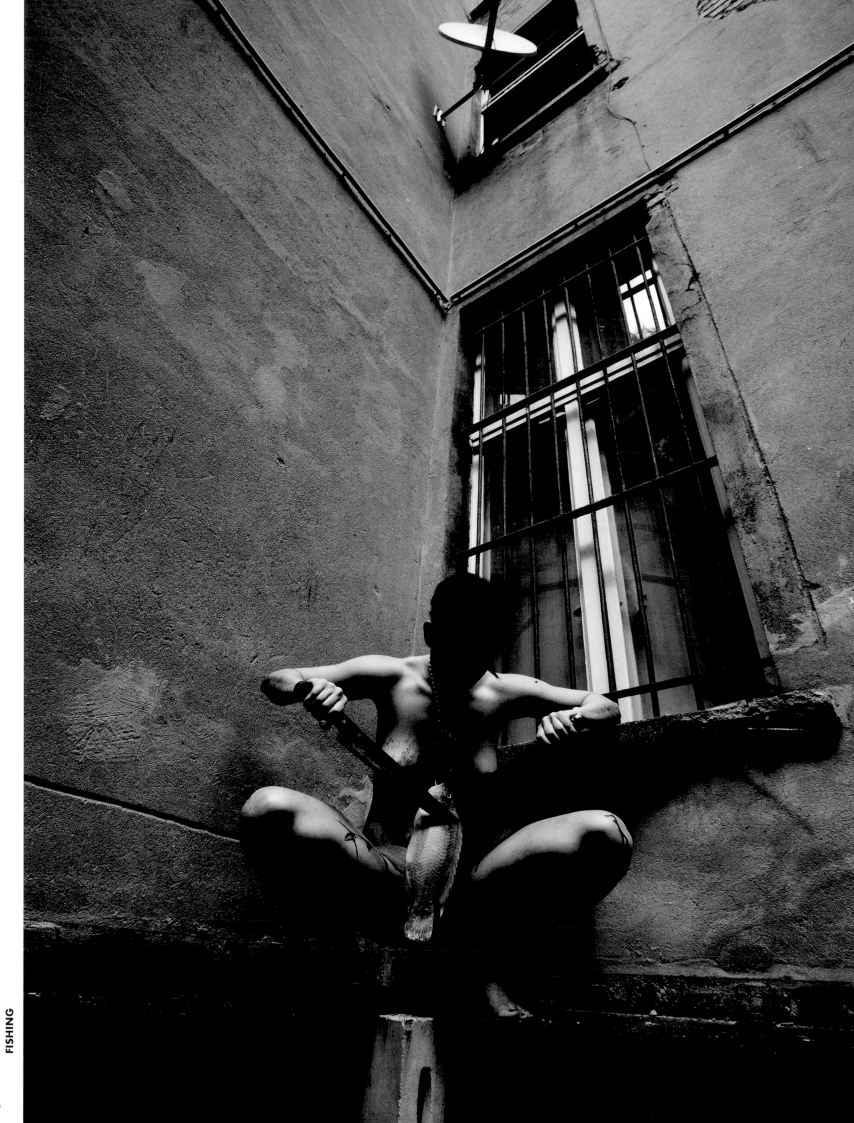

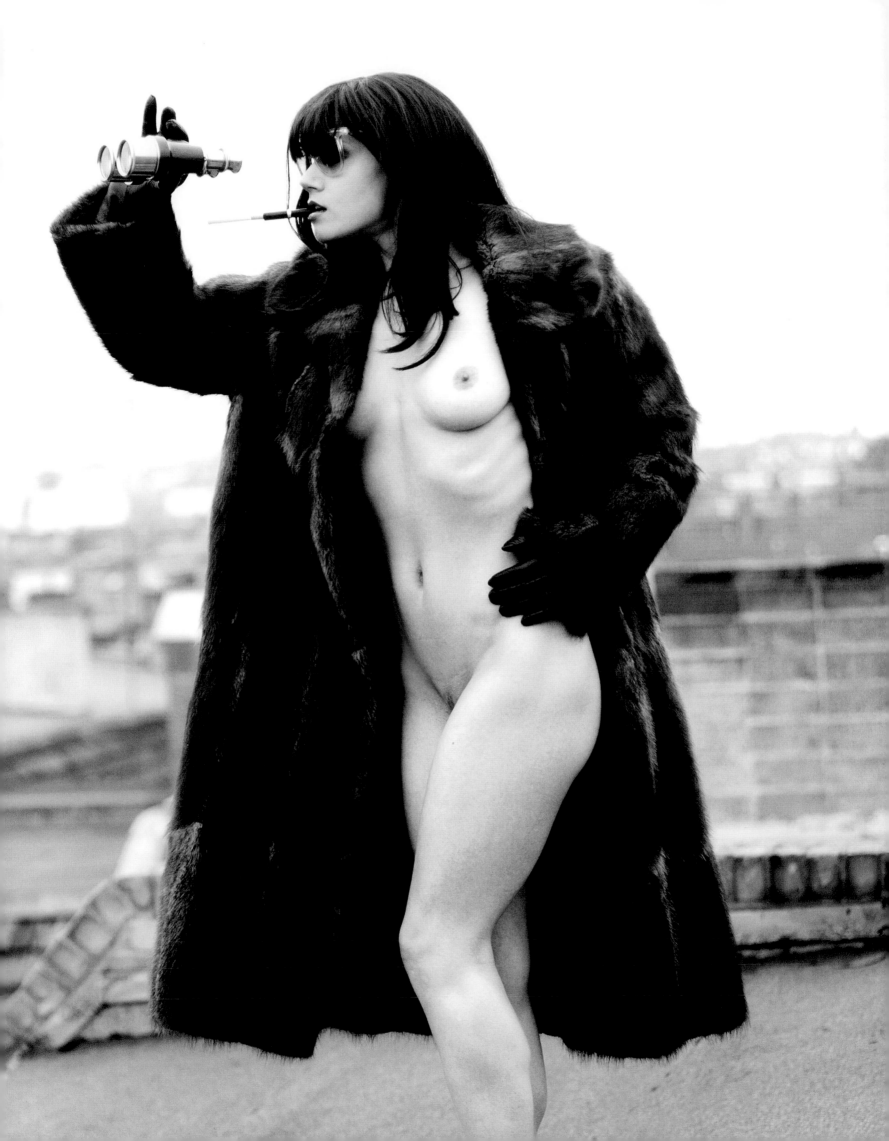

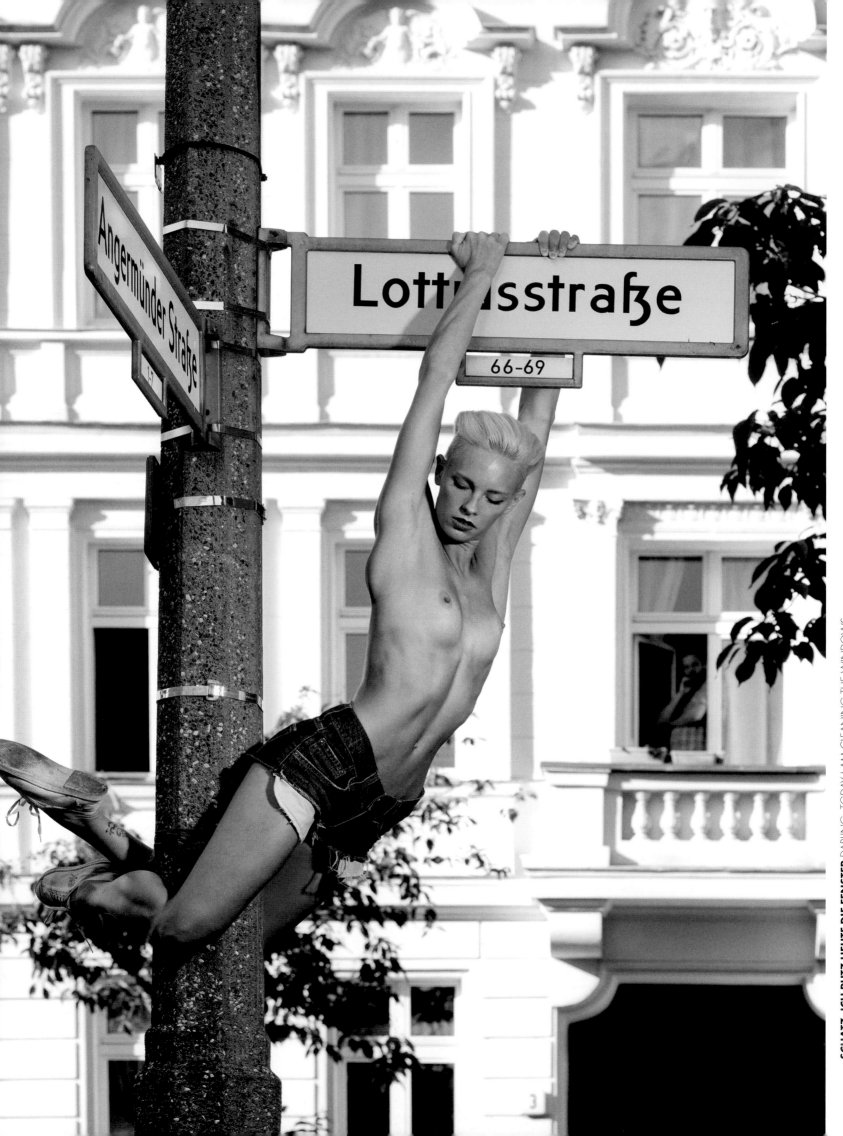

SCHATZ, ICH PUTZ HEUTE DIE FENSTER DARLING, TODAY I AM CLEANING THE WINDOWS

CELA M'A FAIT RIRE

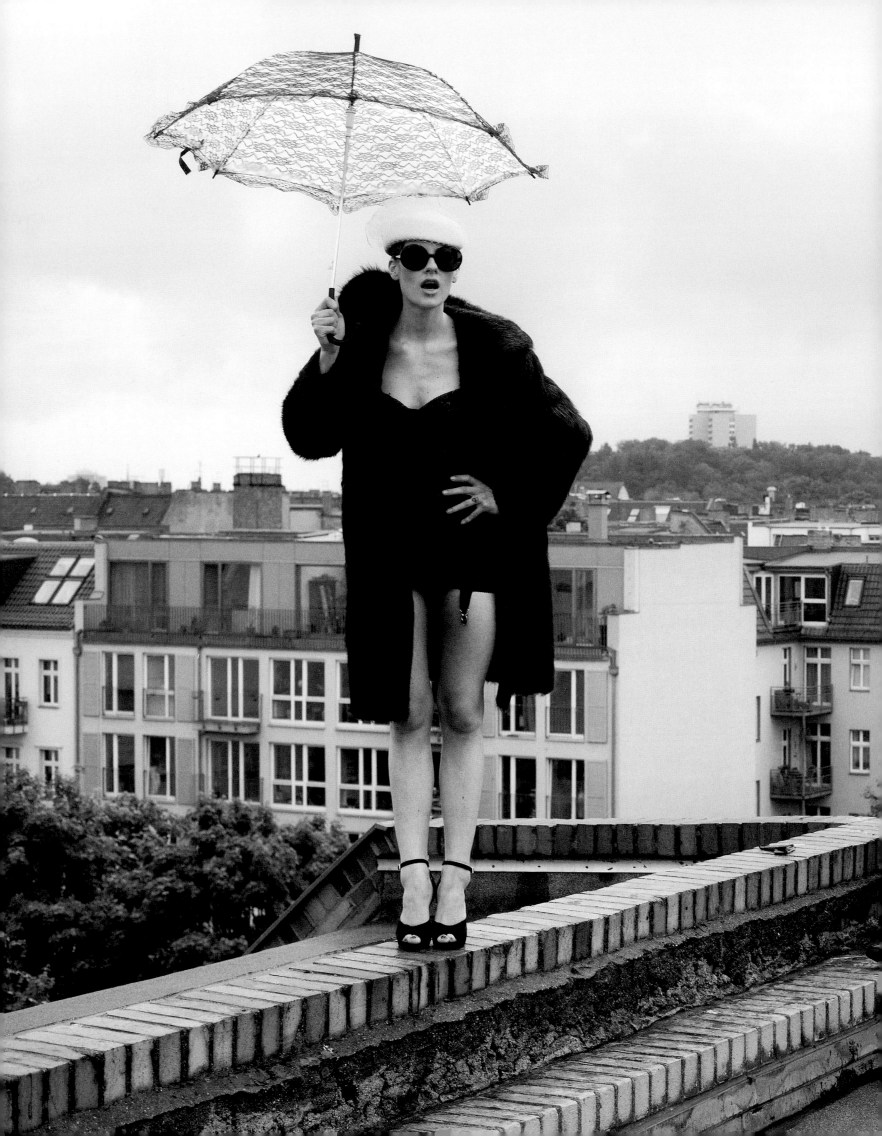

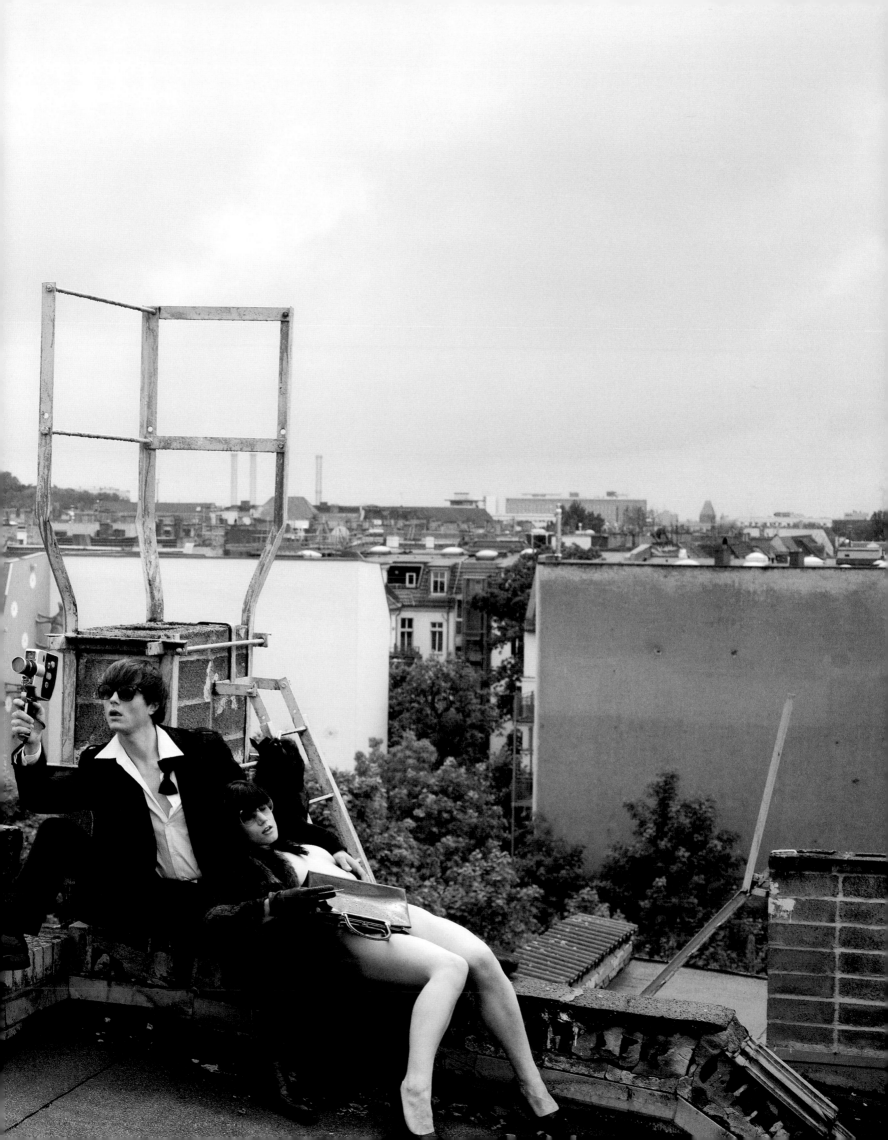

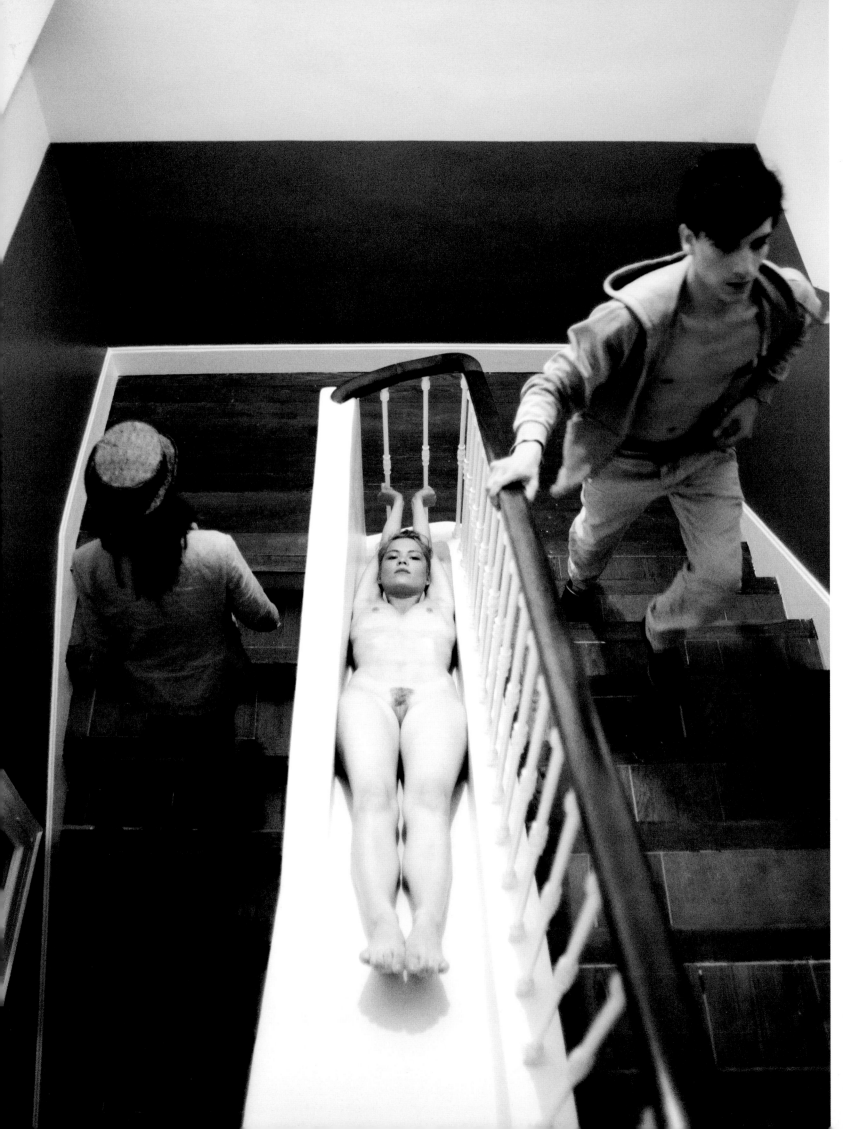

RUN BOY RUN

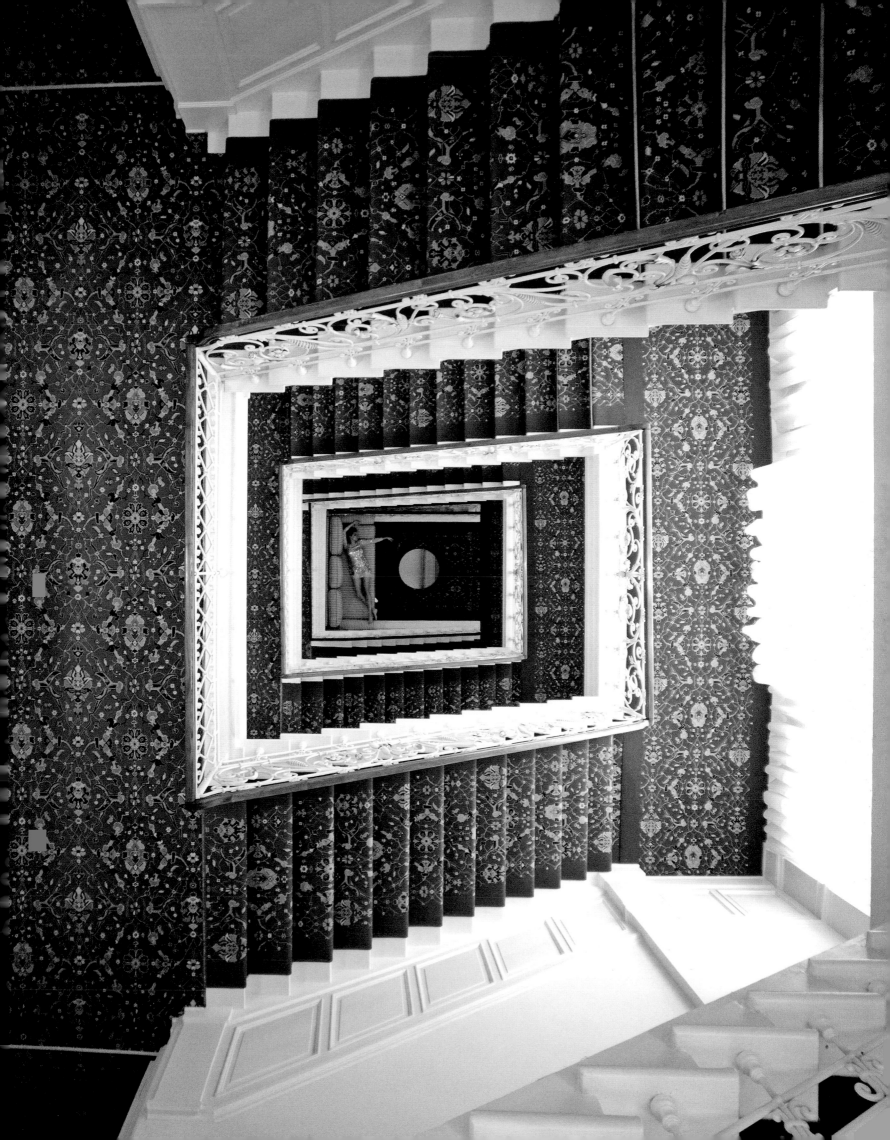

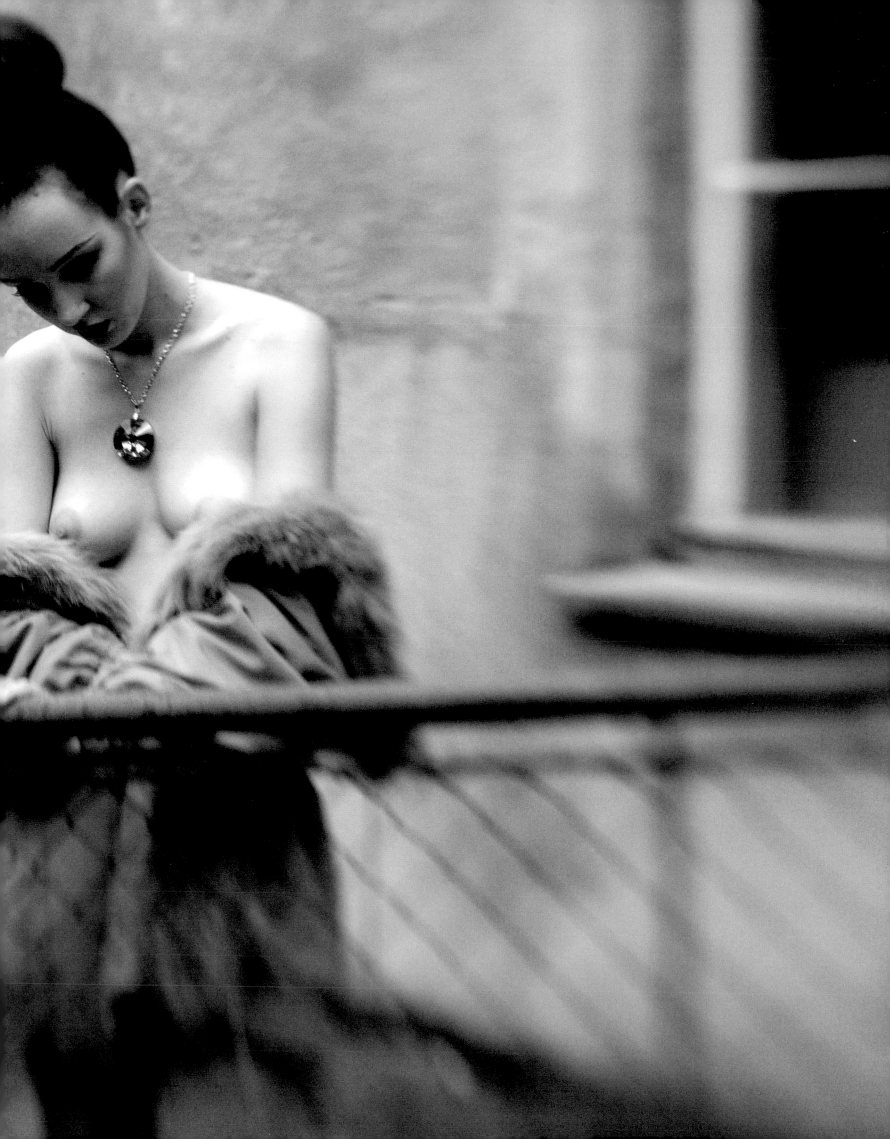

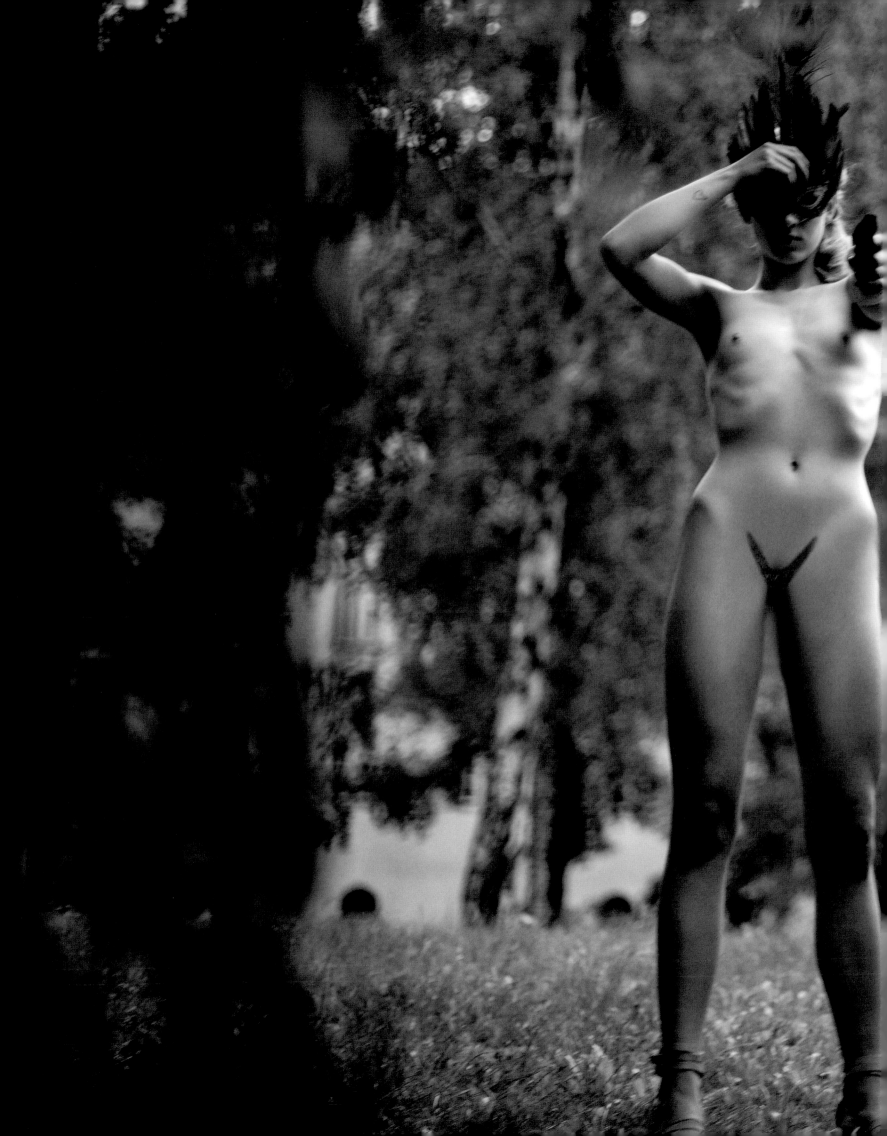

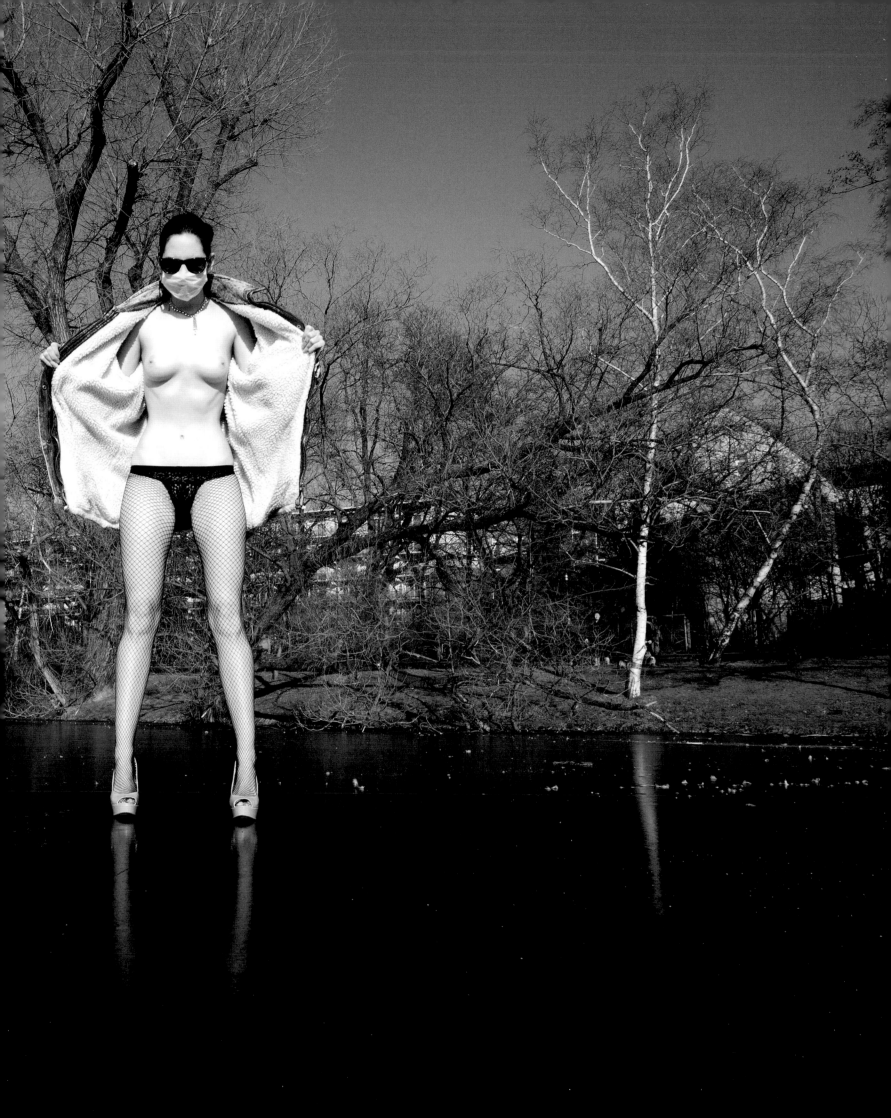

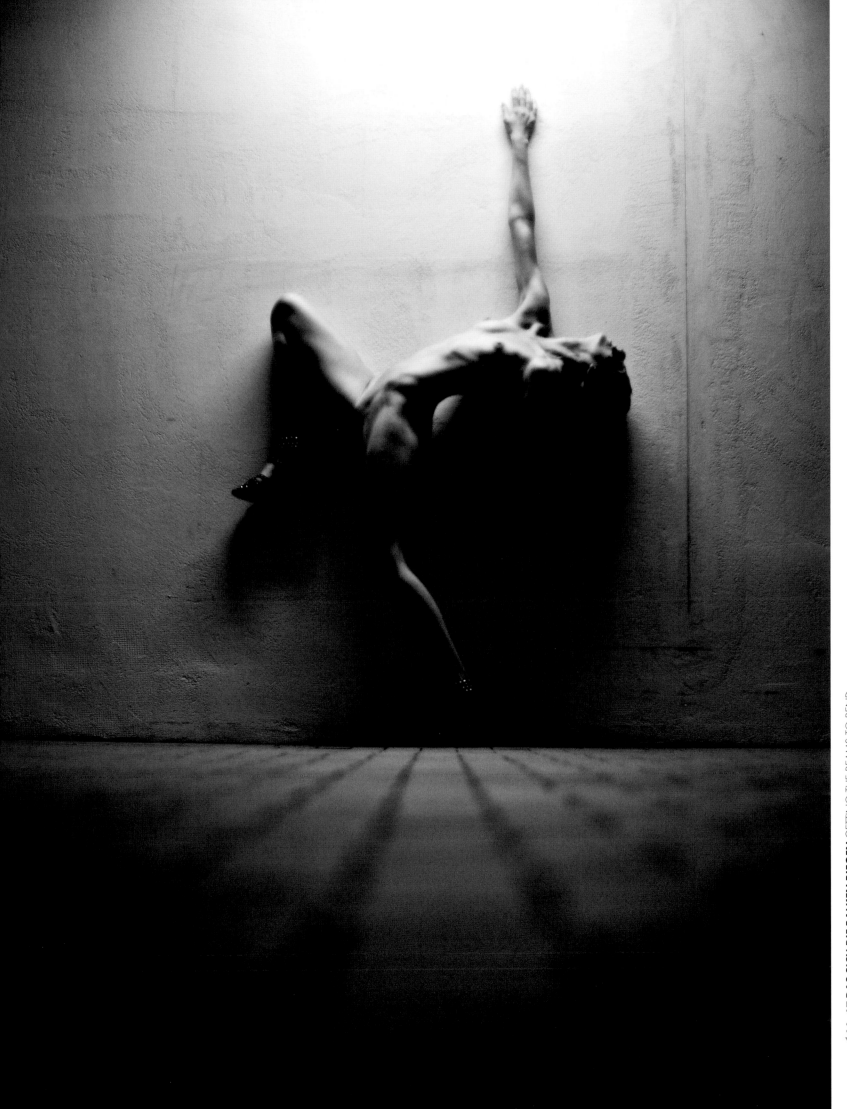

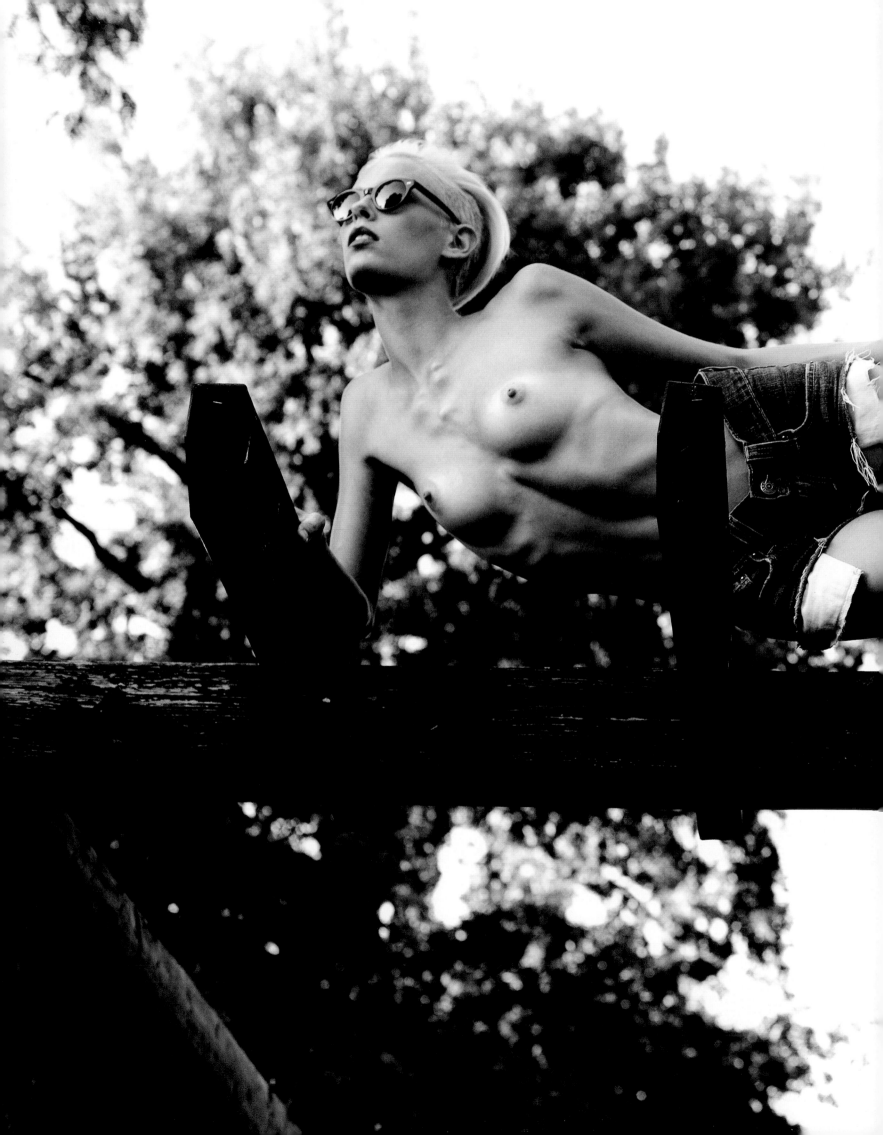

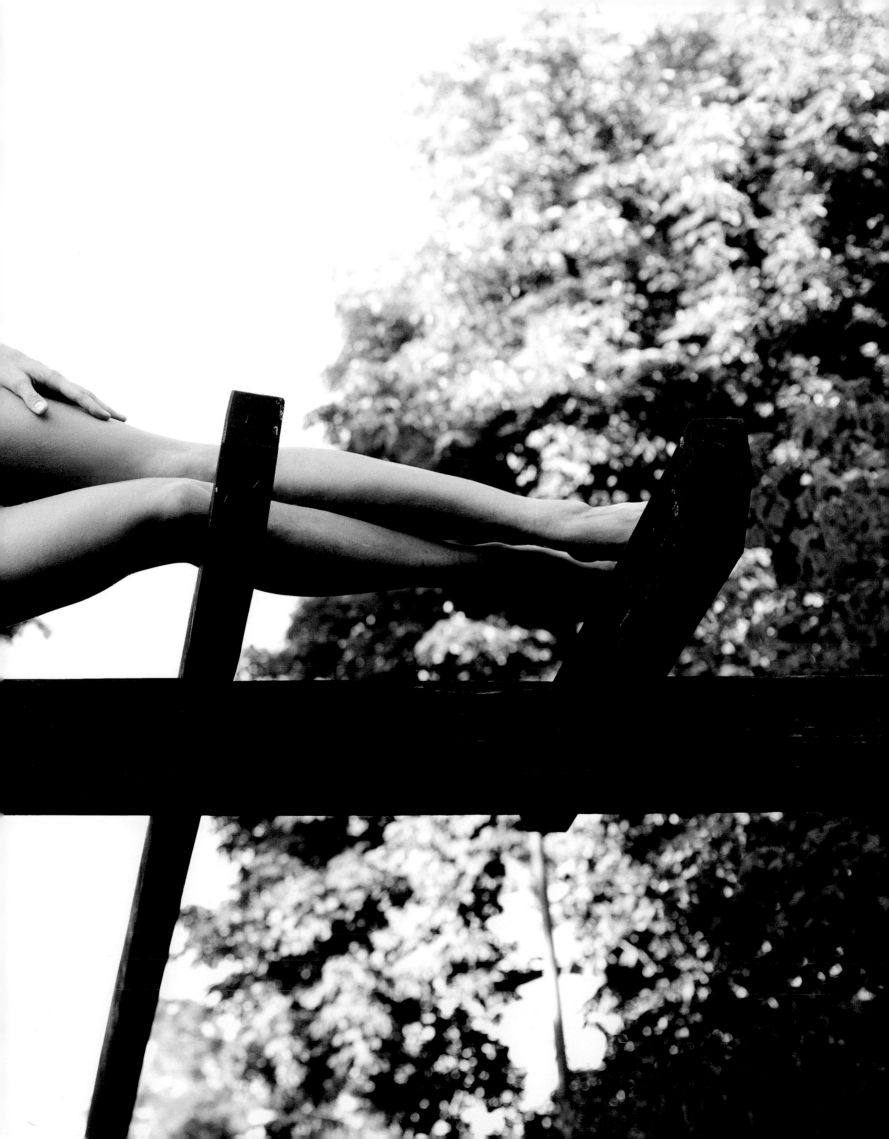

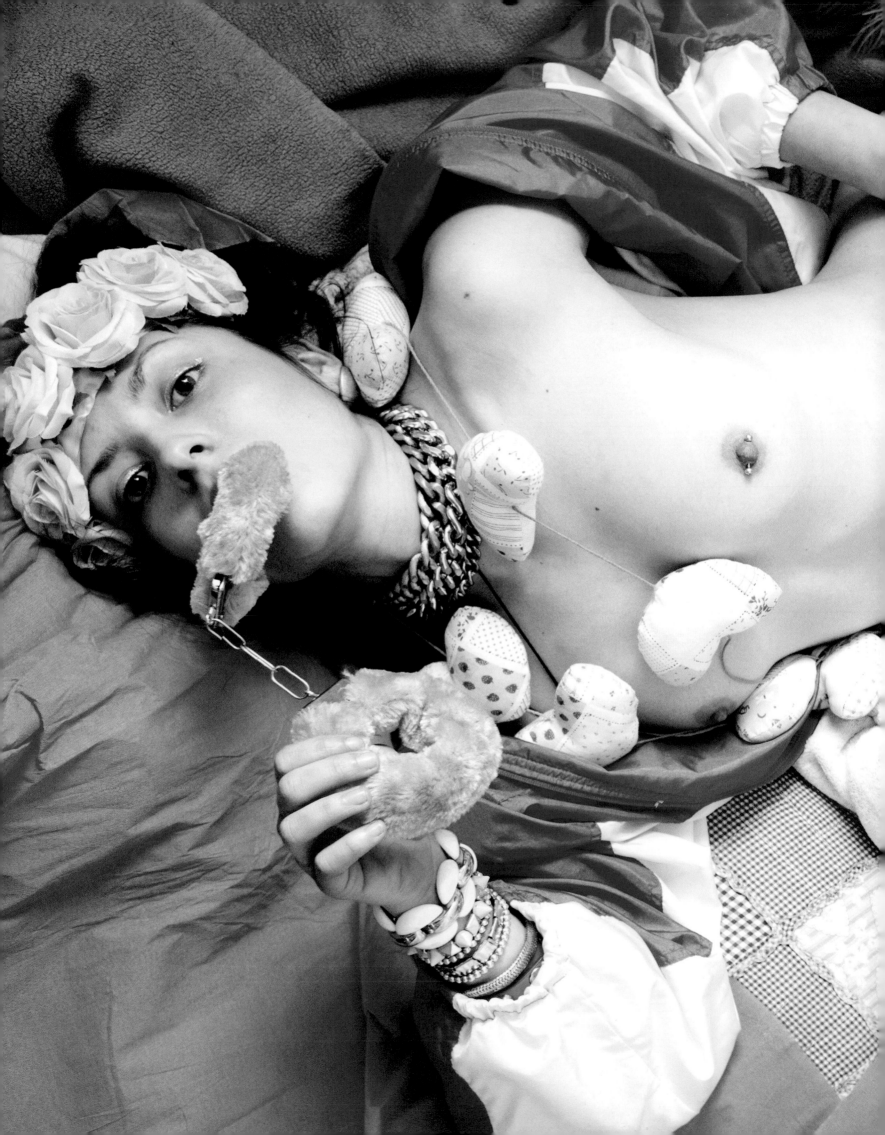

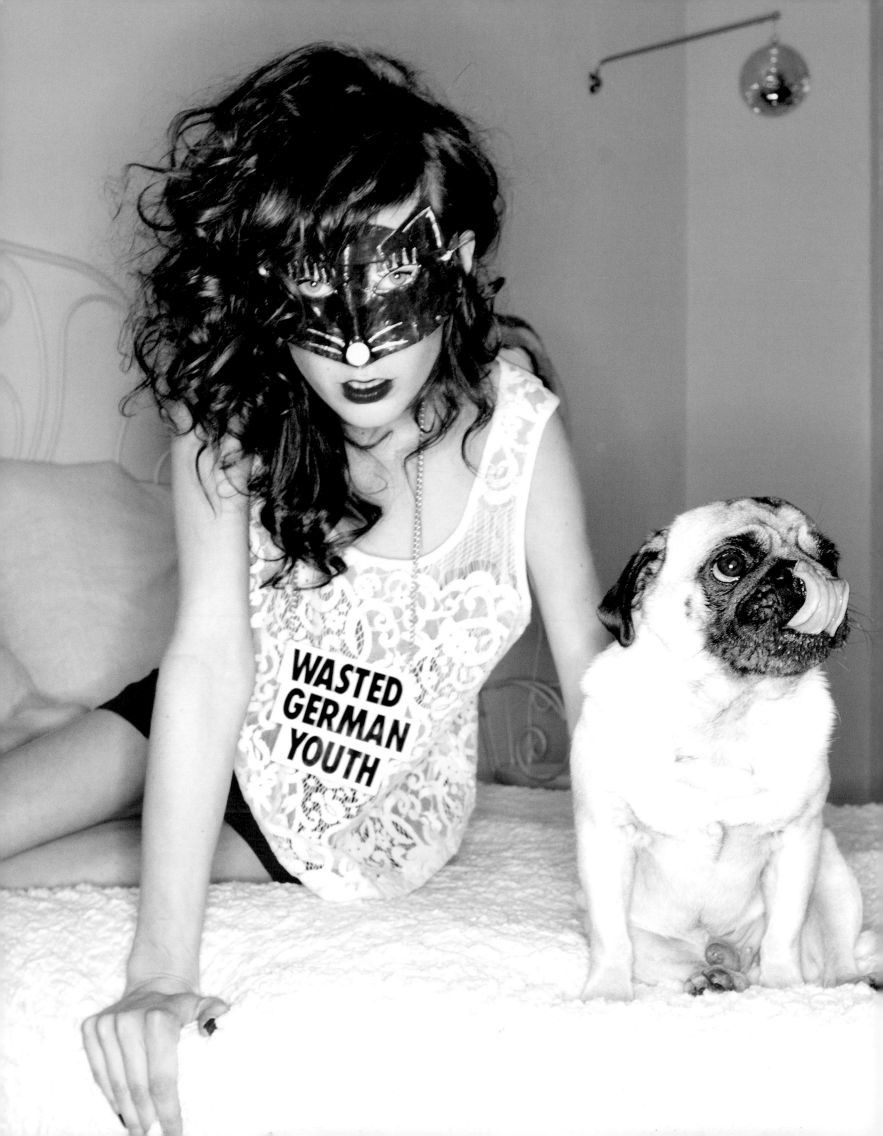

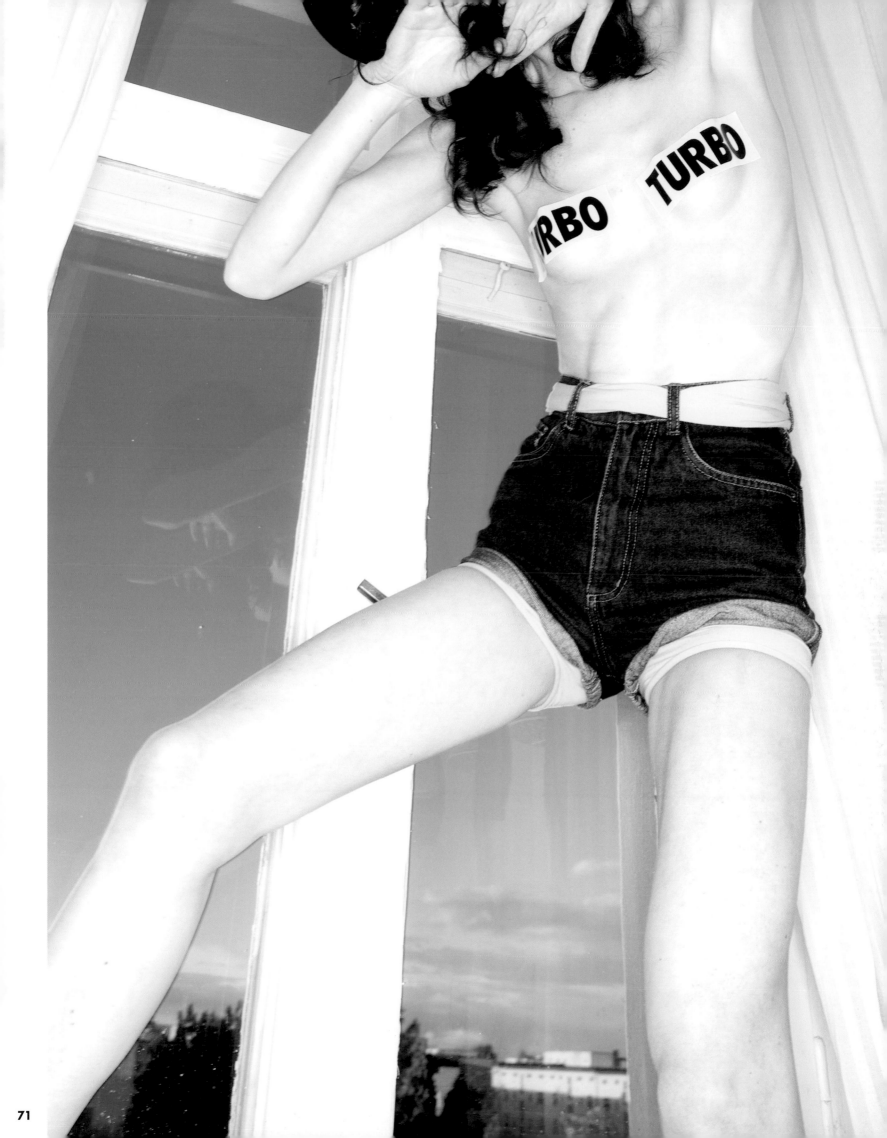

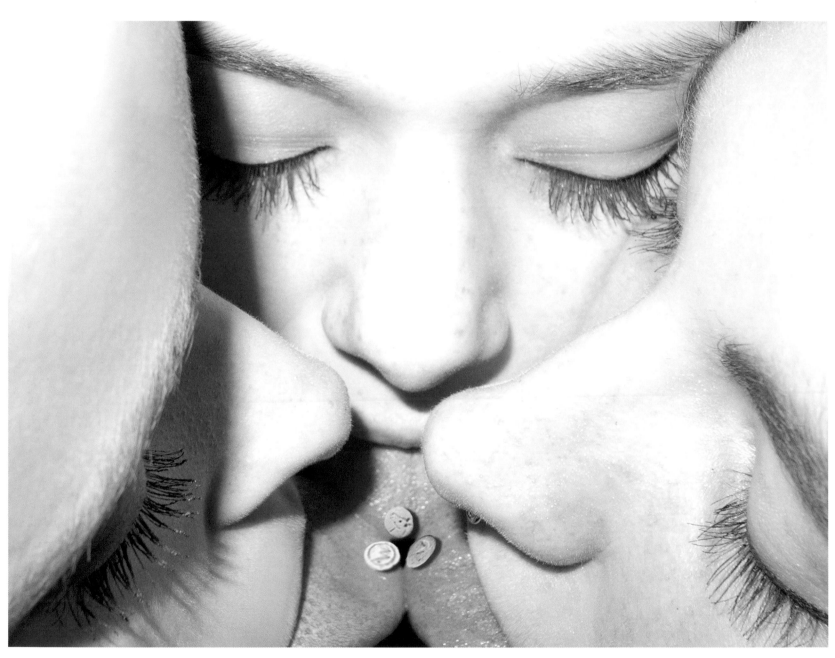

»DREI ZUNGEN TANKEN SUPER « THREE TONGUES TANK UP

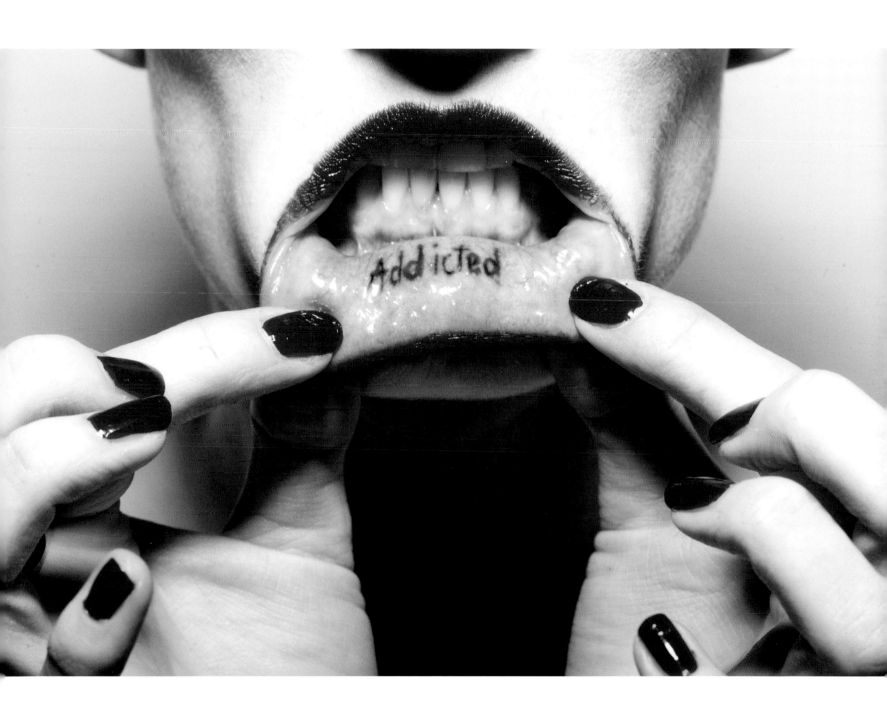

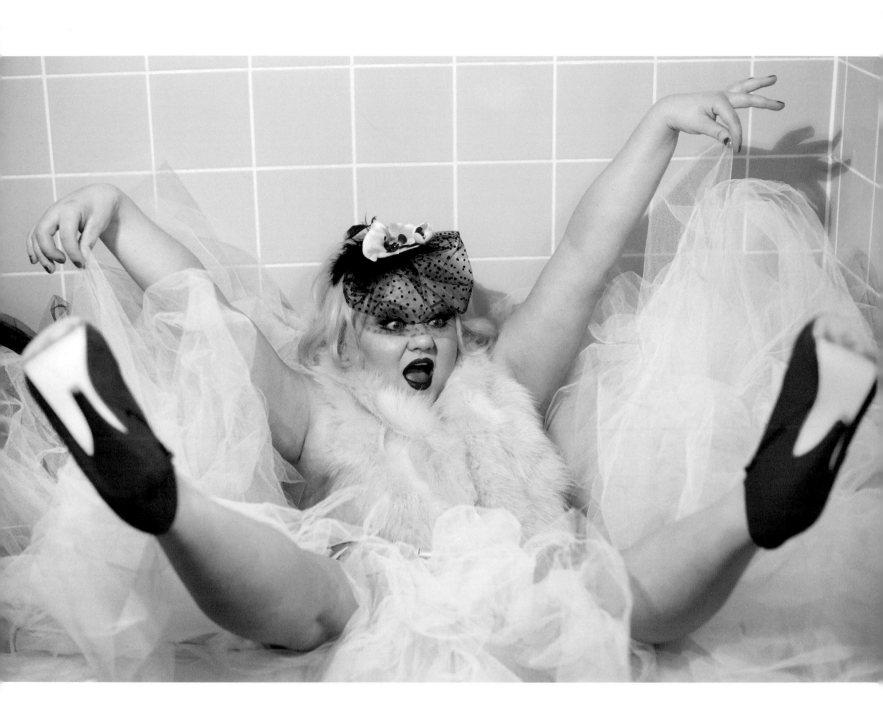

»OLIVER RATH IS AN ARTIST WITH THE CAMERA. HIS OPEN-
MINDEDNESS, CREATIVITY AND SURREAL VISION TELL US HOW HE SEES
THE WORLD, AND HOW IT COULD BE EVEN BETTER FOR MANY PEOPLE!
I LOVE YOU OLI.«
BETTY AMRHEIN

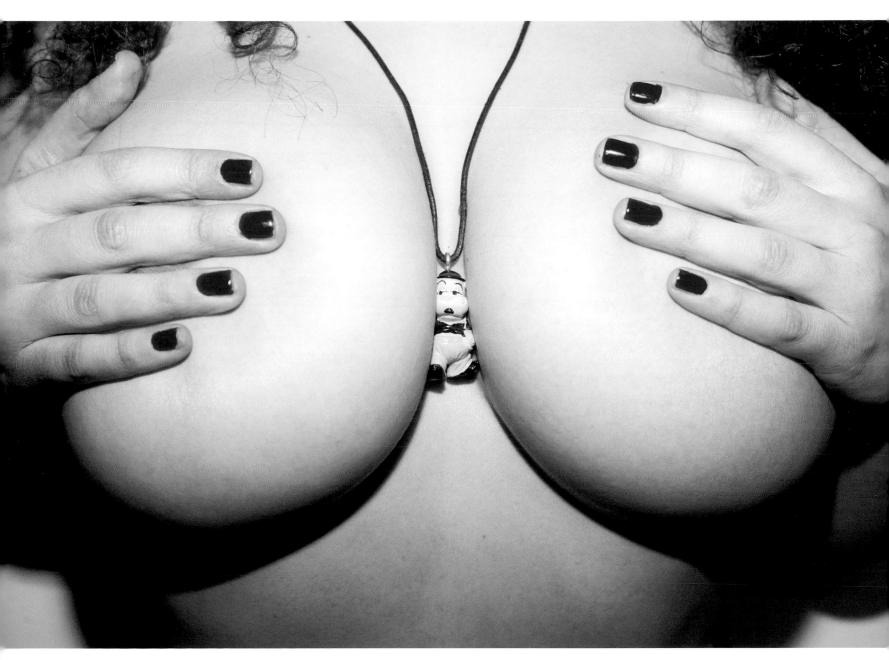

IN JEDER SIEBTEN BRUST IN EVERY SEVENTH BREAST

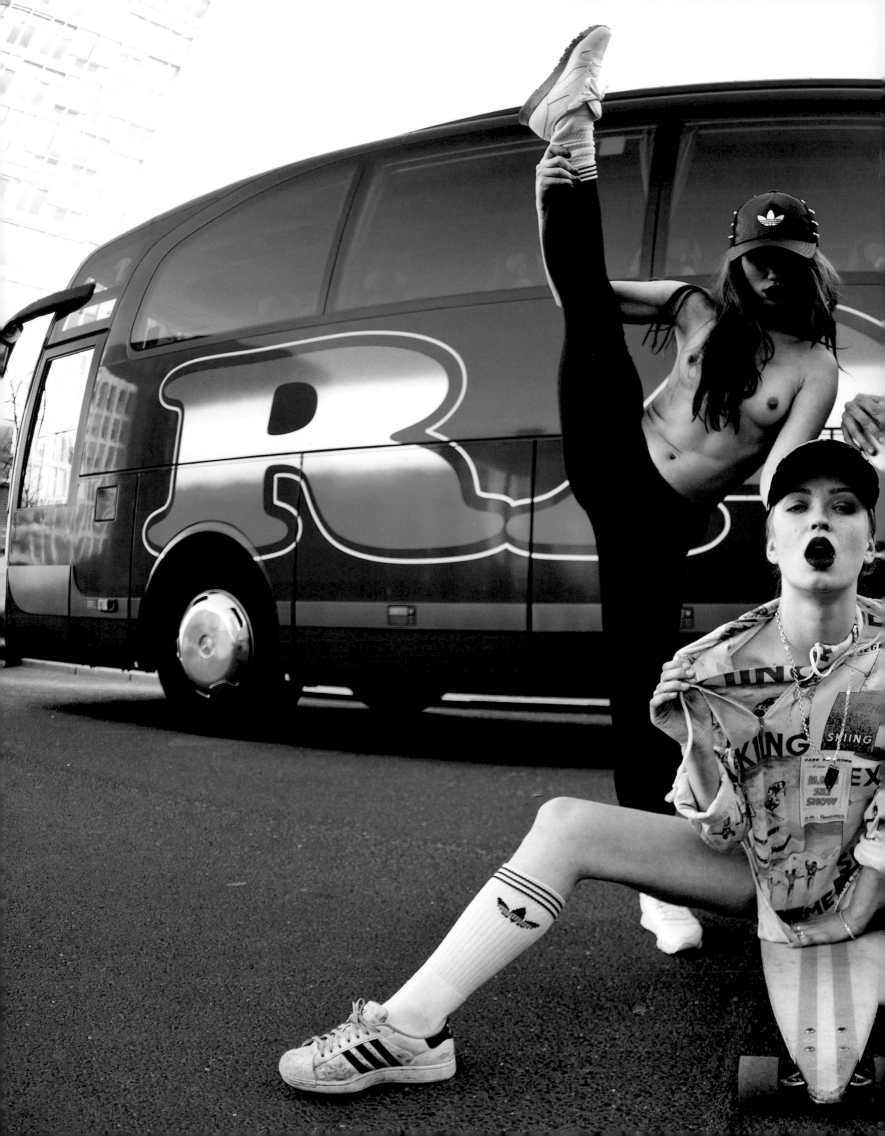

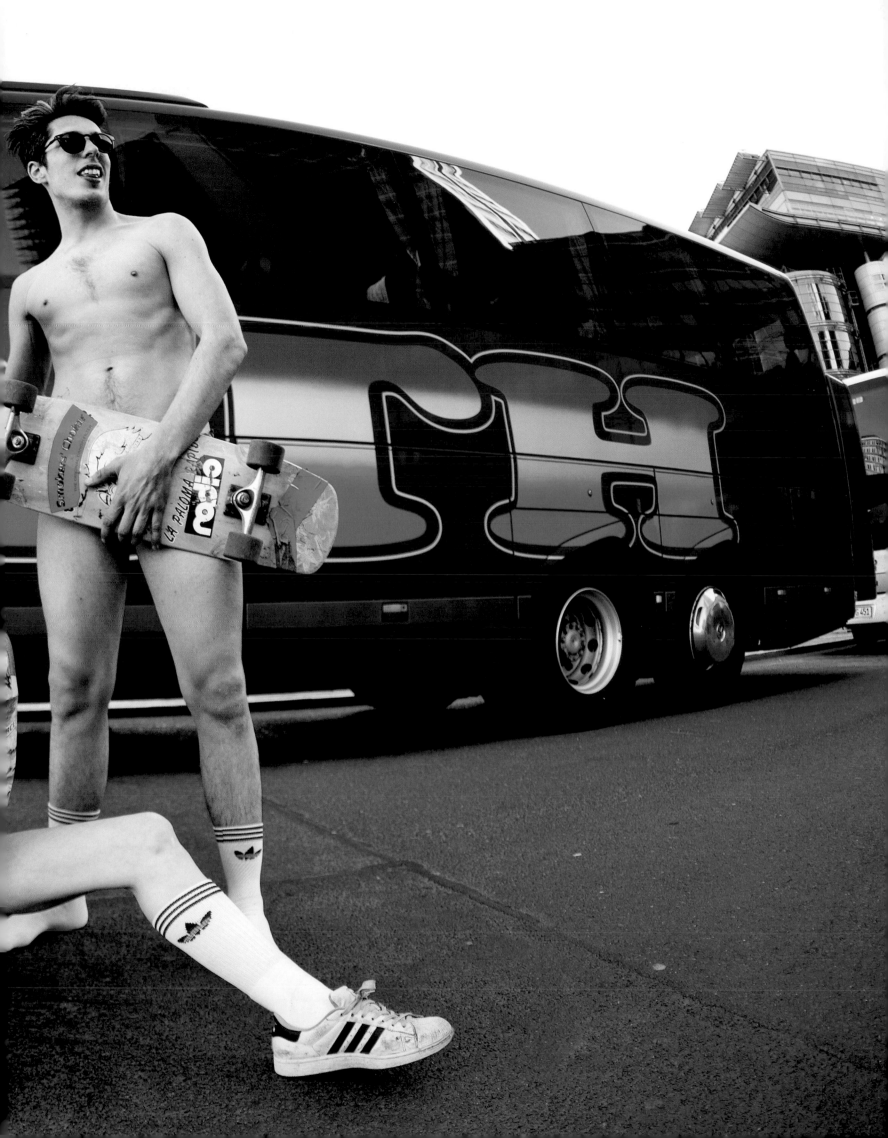

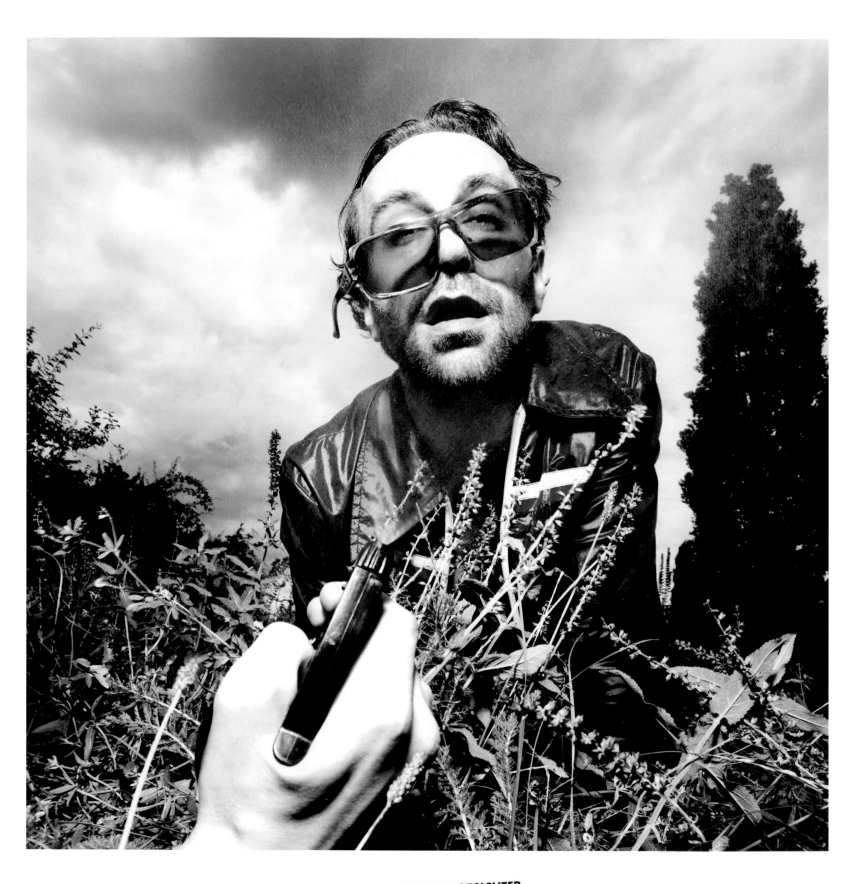

»DER SELTSAME FALL DES DR. JEKYLL UND MR. HYDE ODER DIE ZWEI GESICHTER DES OLIVER RATH … ICH KENNE KEINEN MENSCHEN, DER LAUSBUB, LIEBEVOLLER VATER, BESTER FREUND SEIN KANN UND GLEICHZEITIG SO EINE PORNÖSE AUSSENDARSTELLUNG SCHAFFT.« JAN EHRET

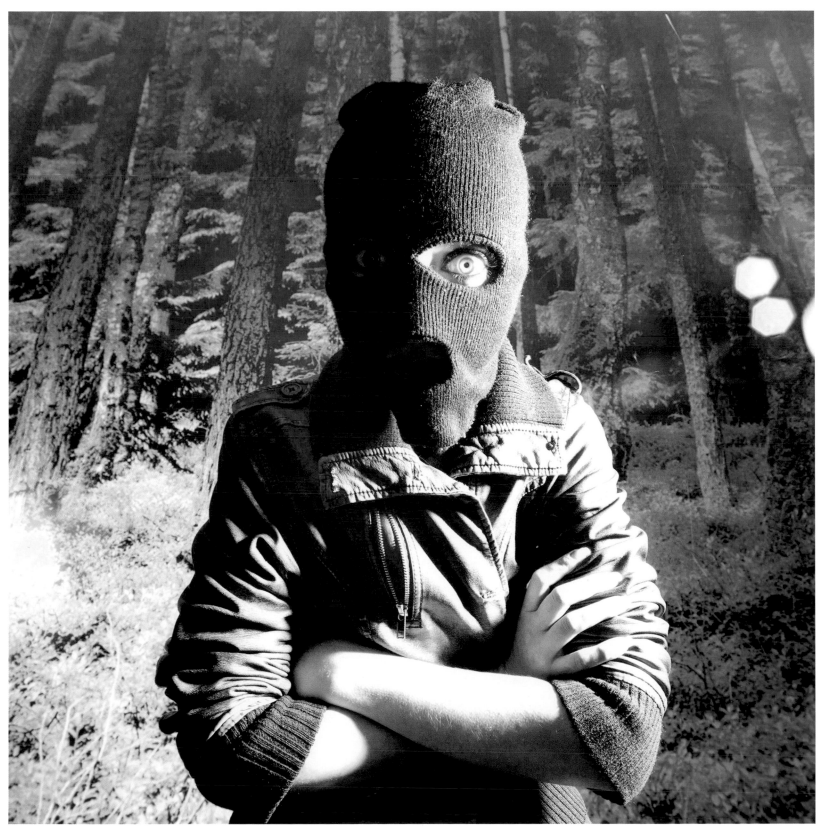

MONUCULAR

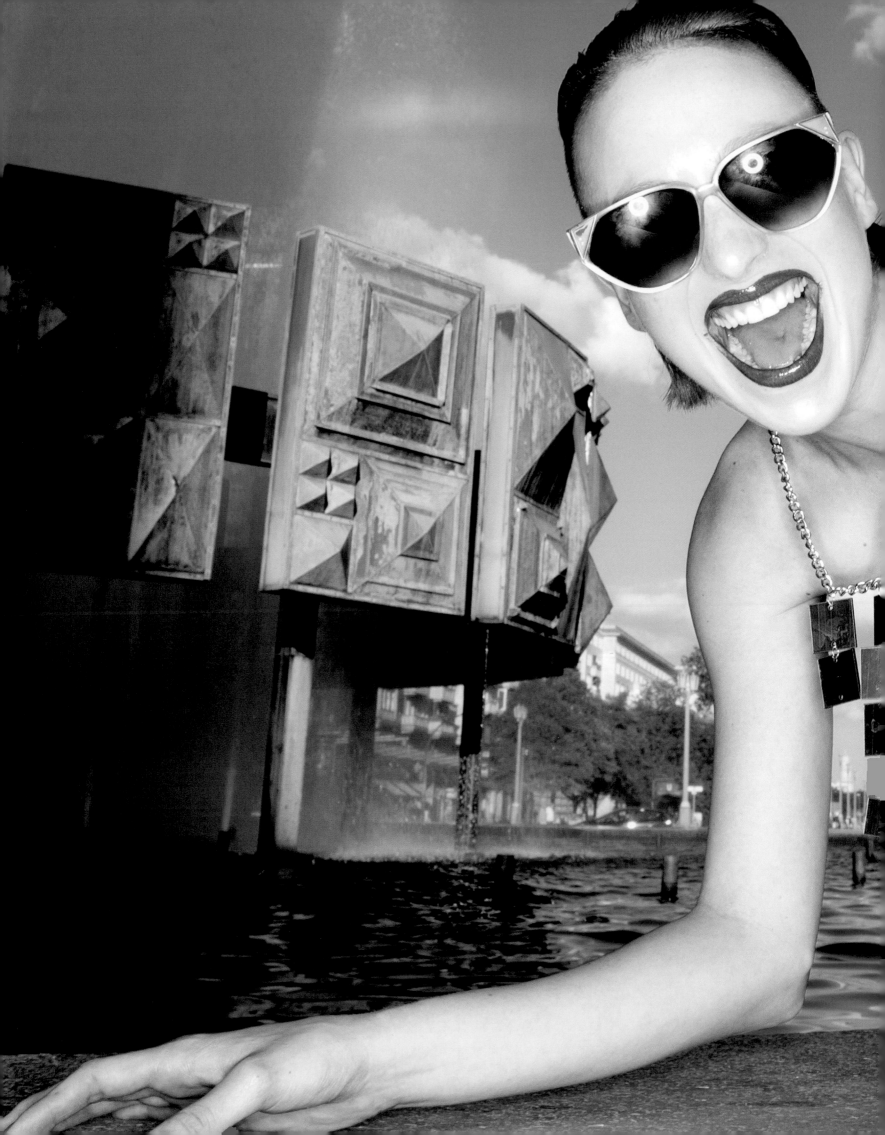

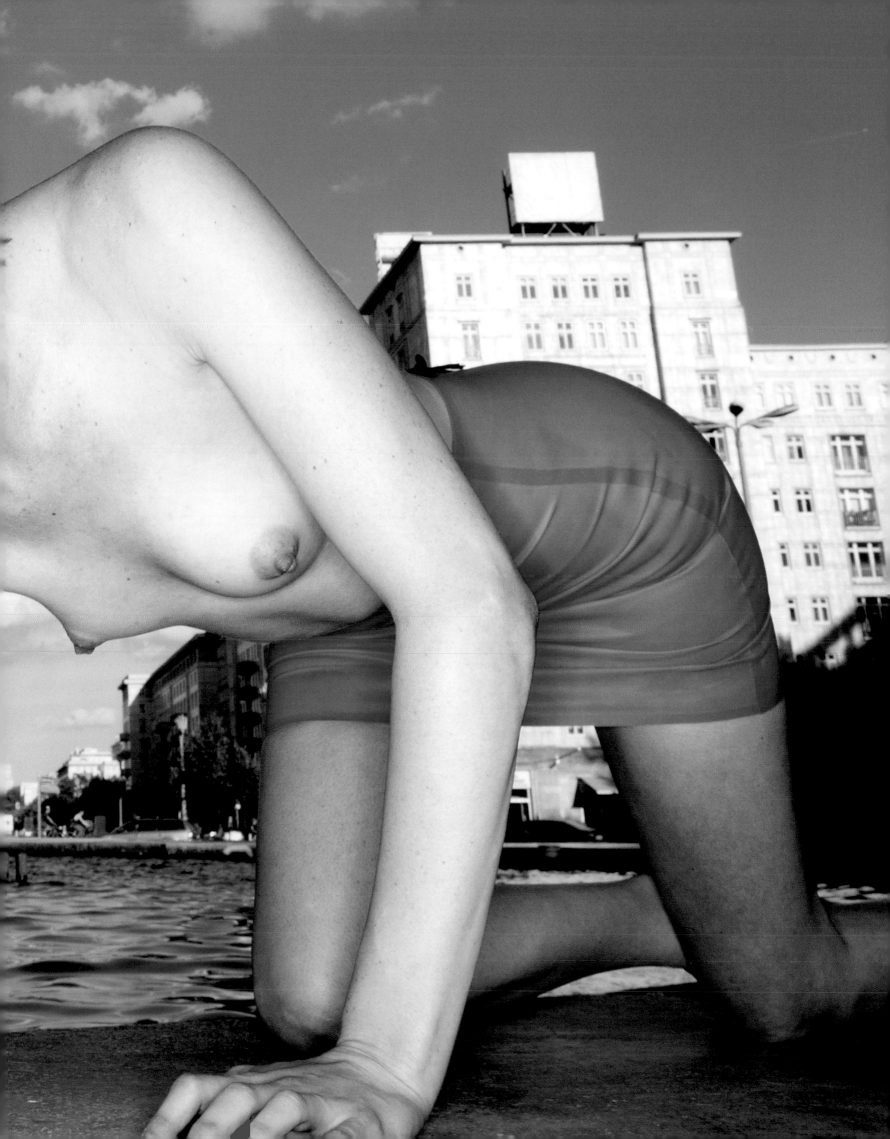

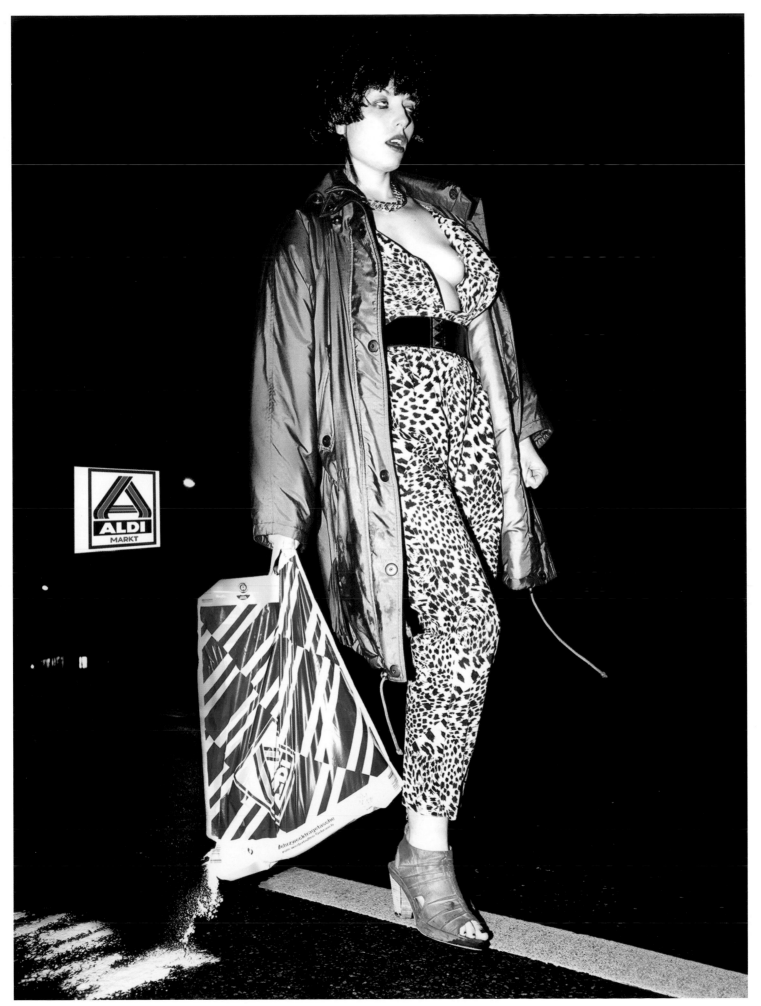

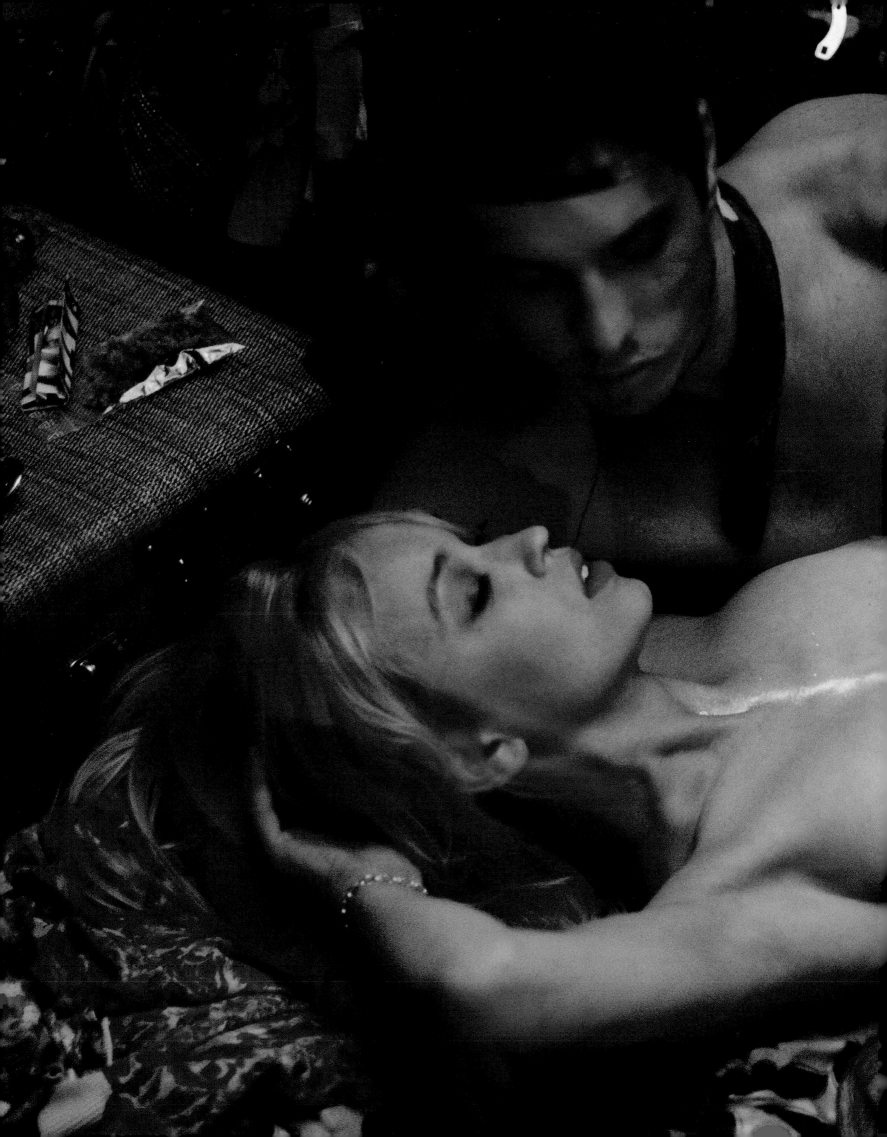

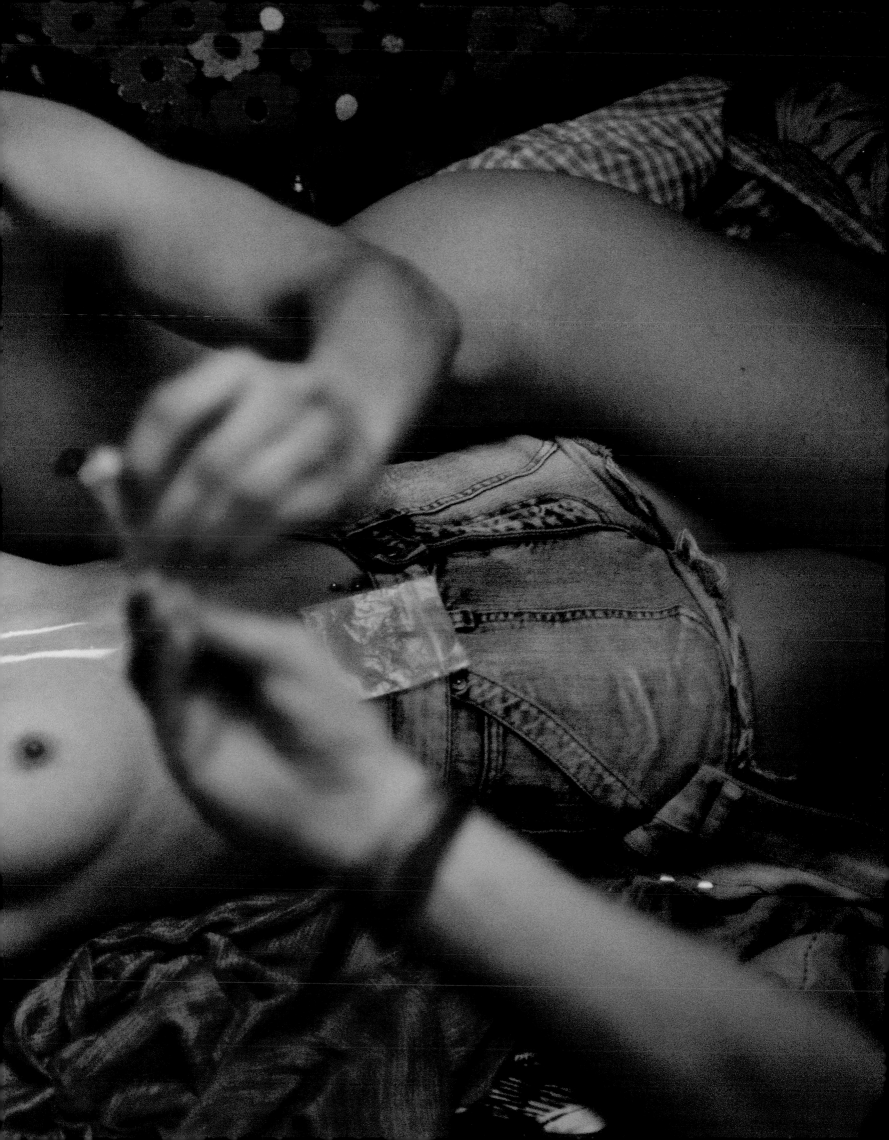

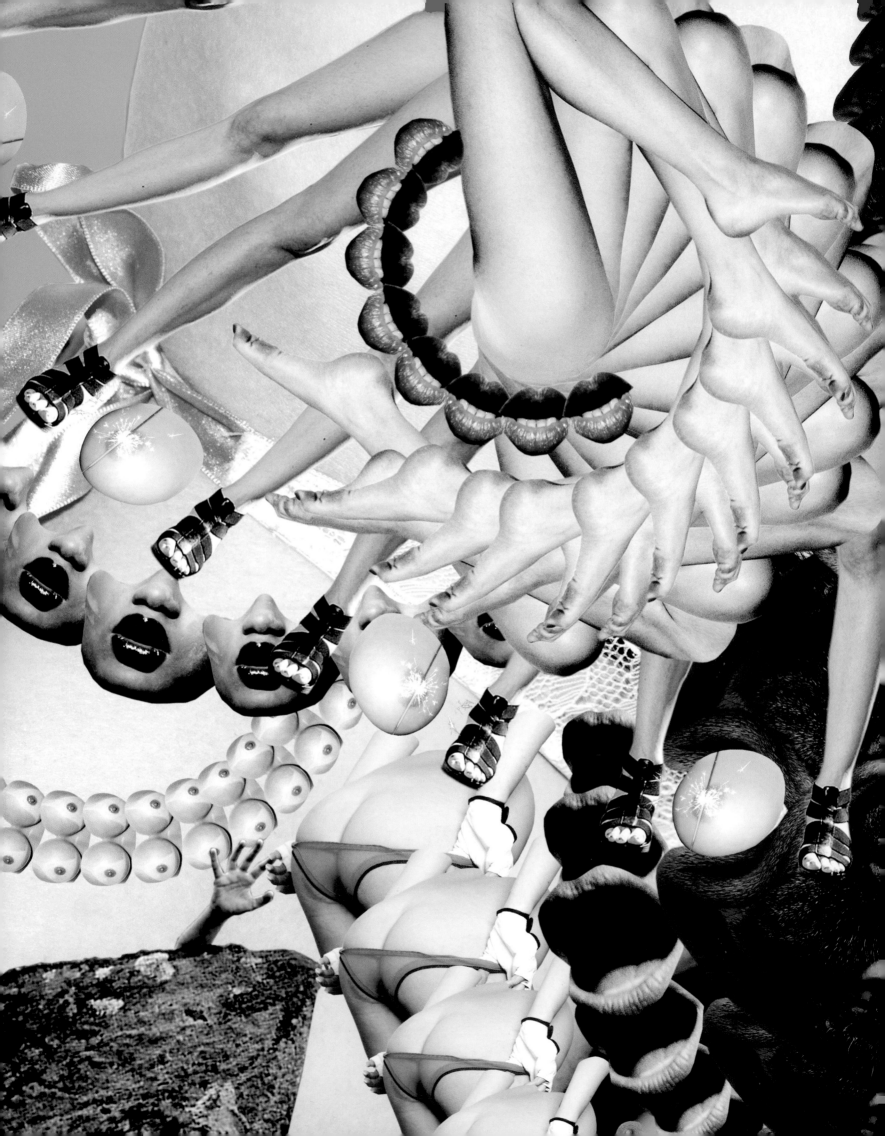

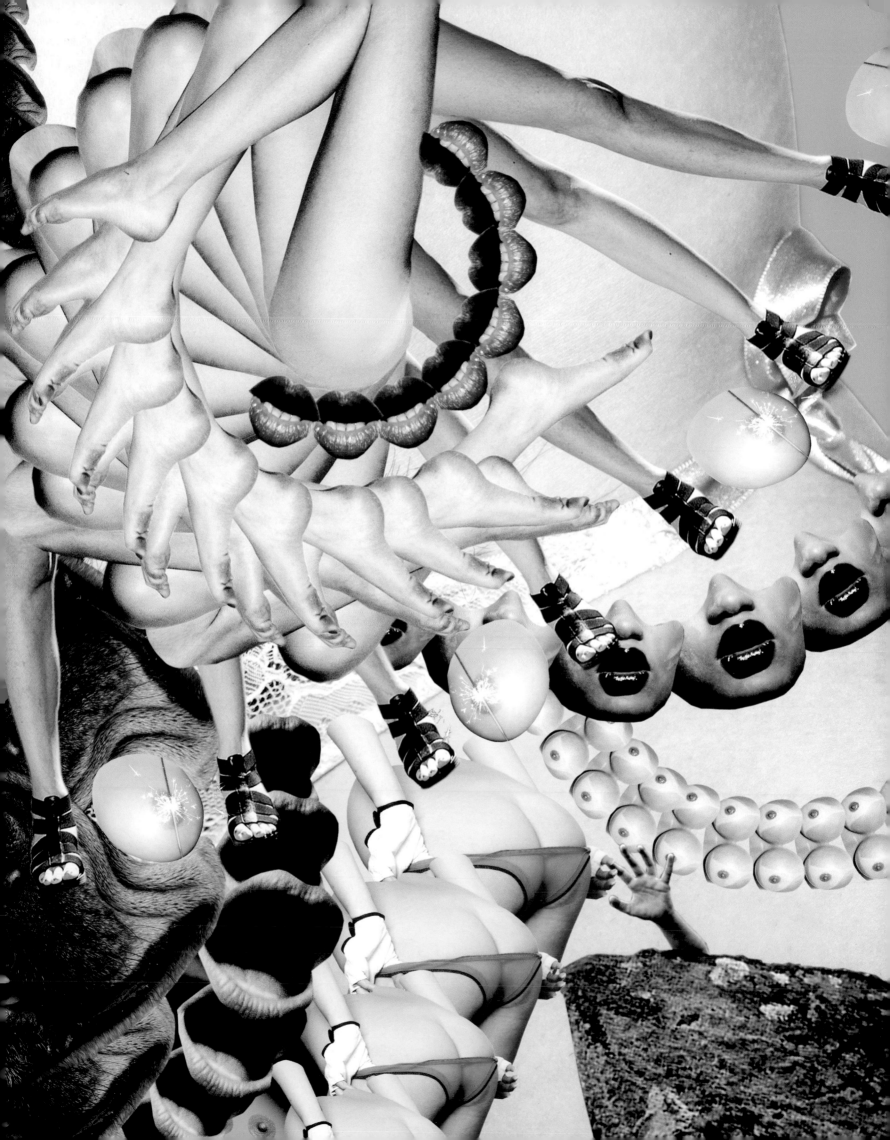

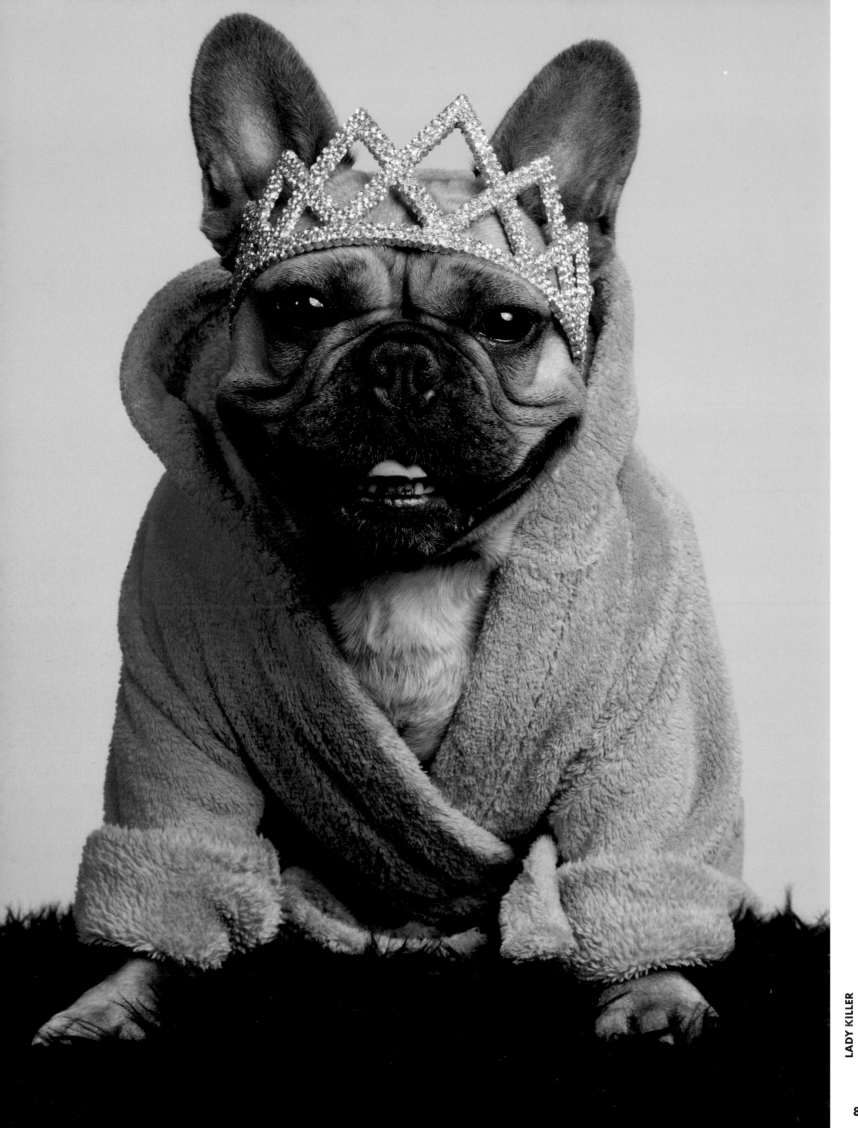

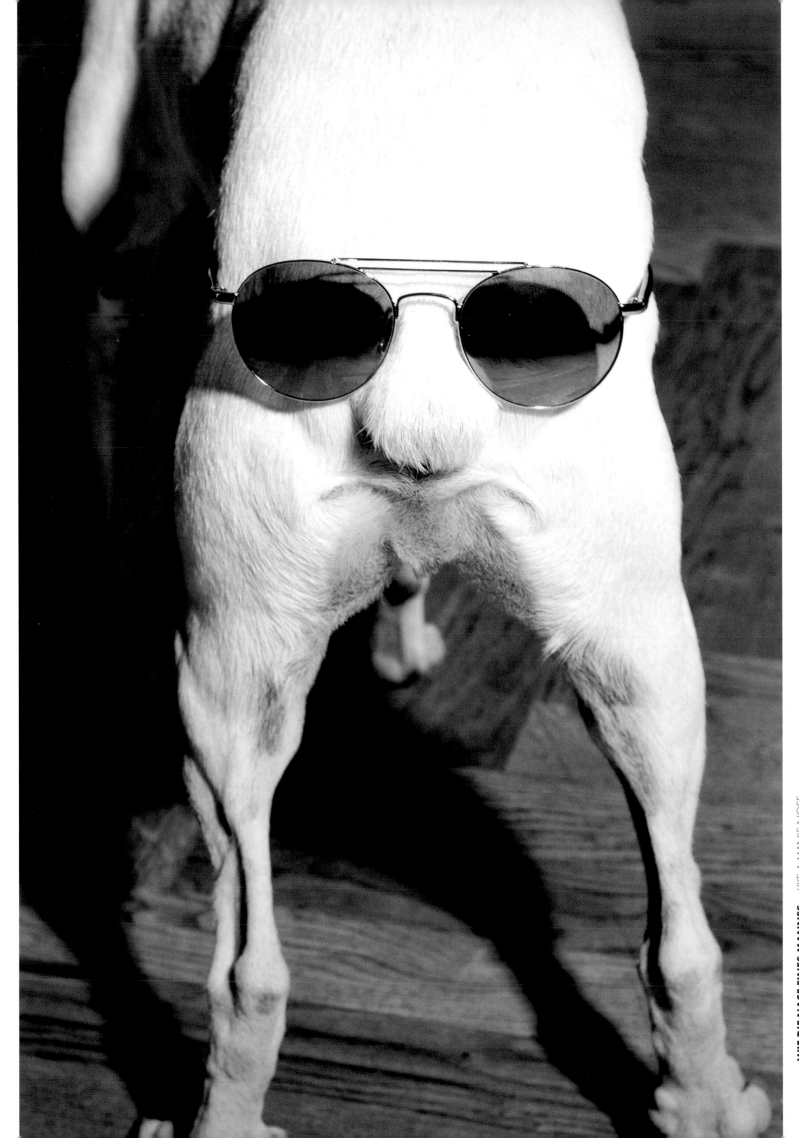

WIE DIE NASE EINES MANNES... ...LIKE A MAN'S NOSE...

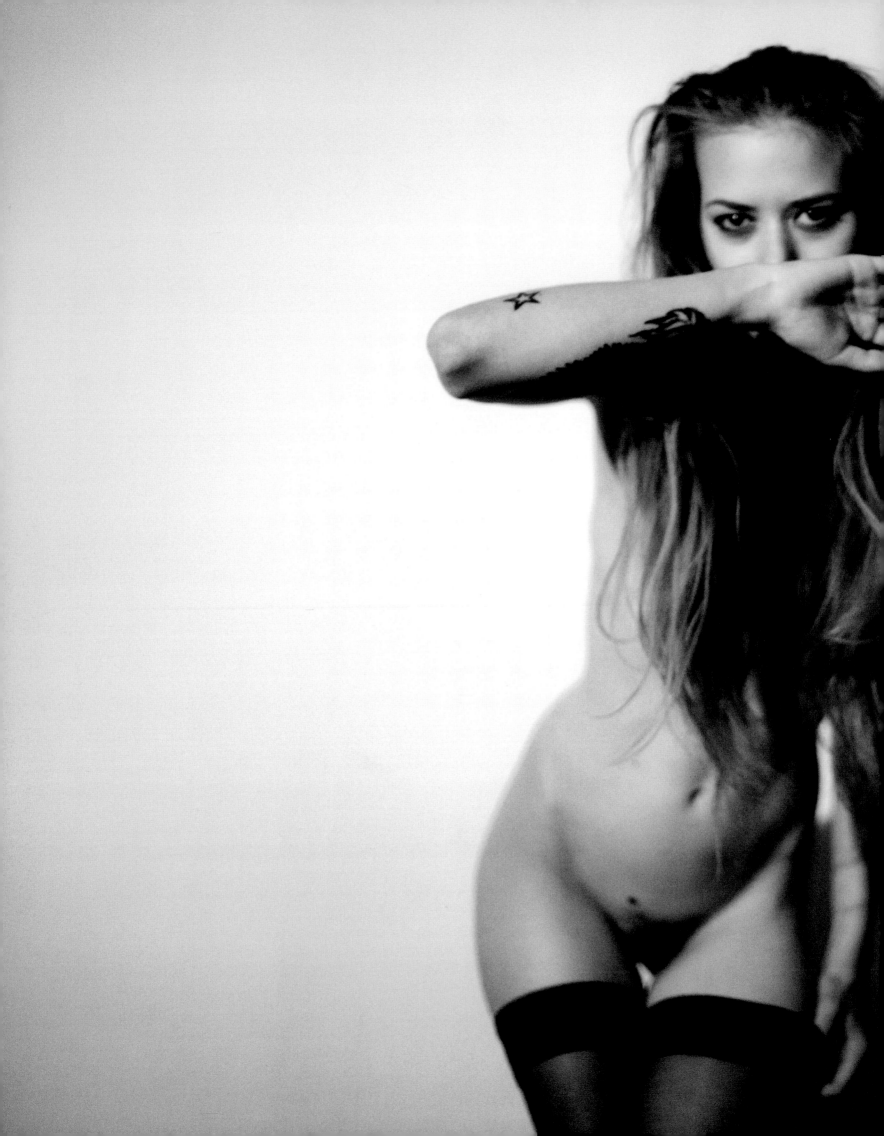

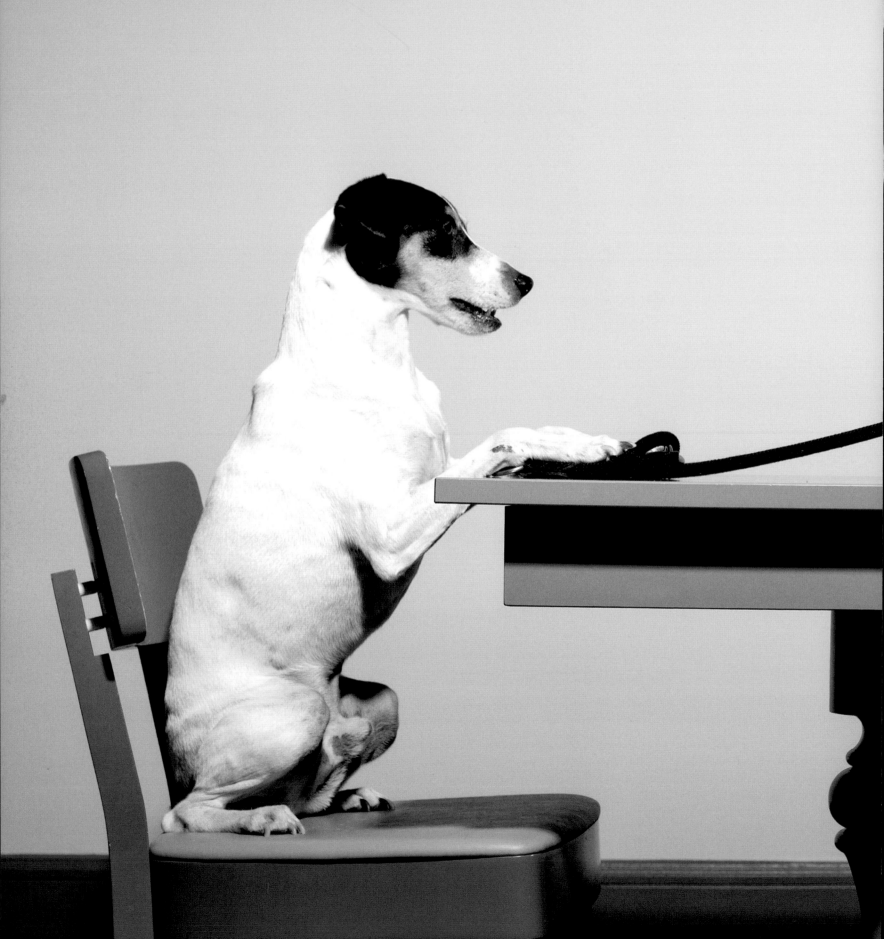

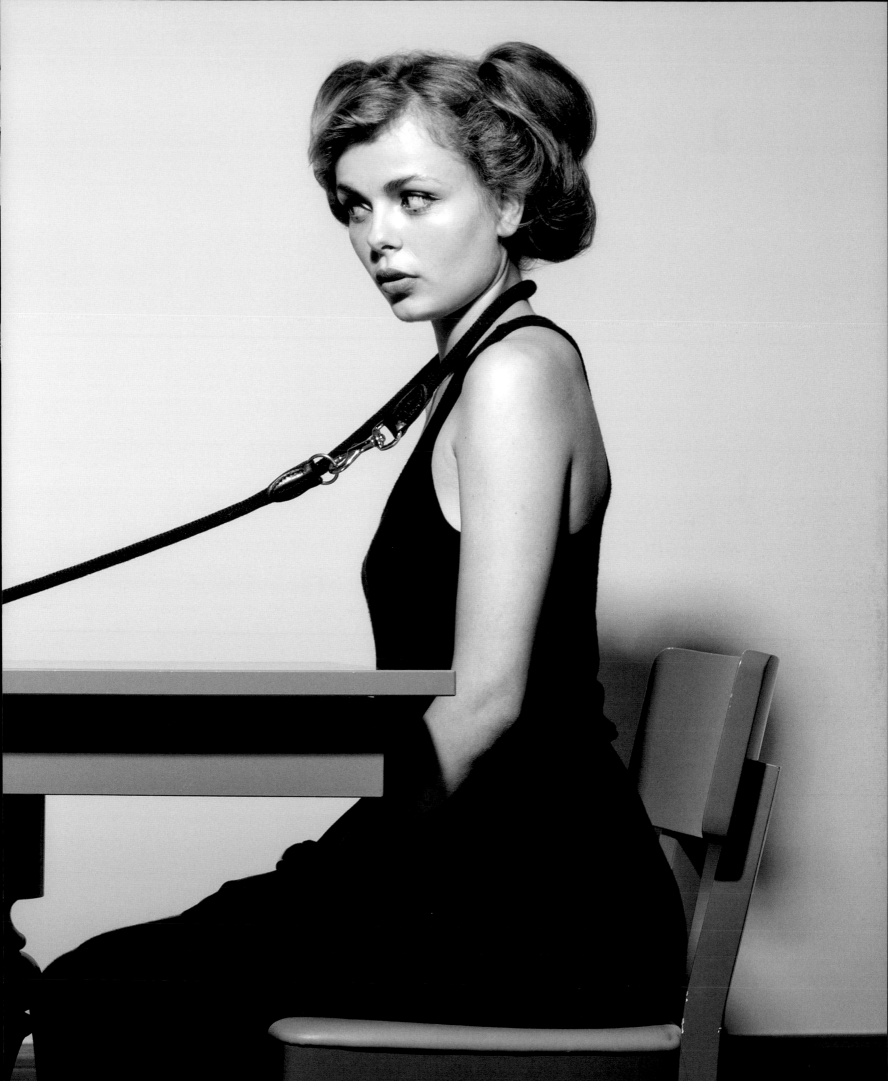

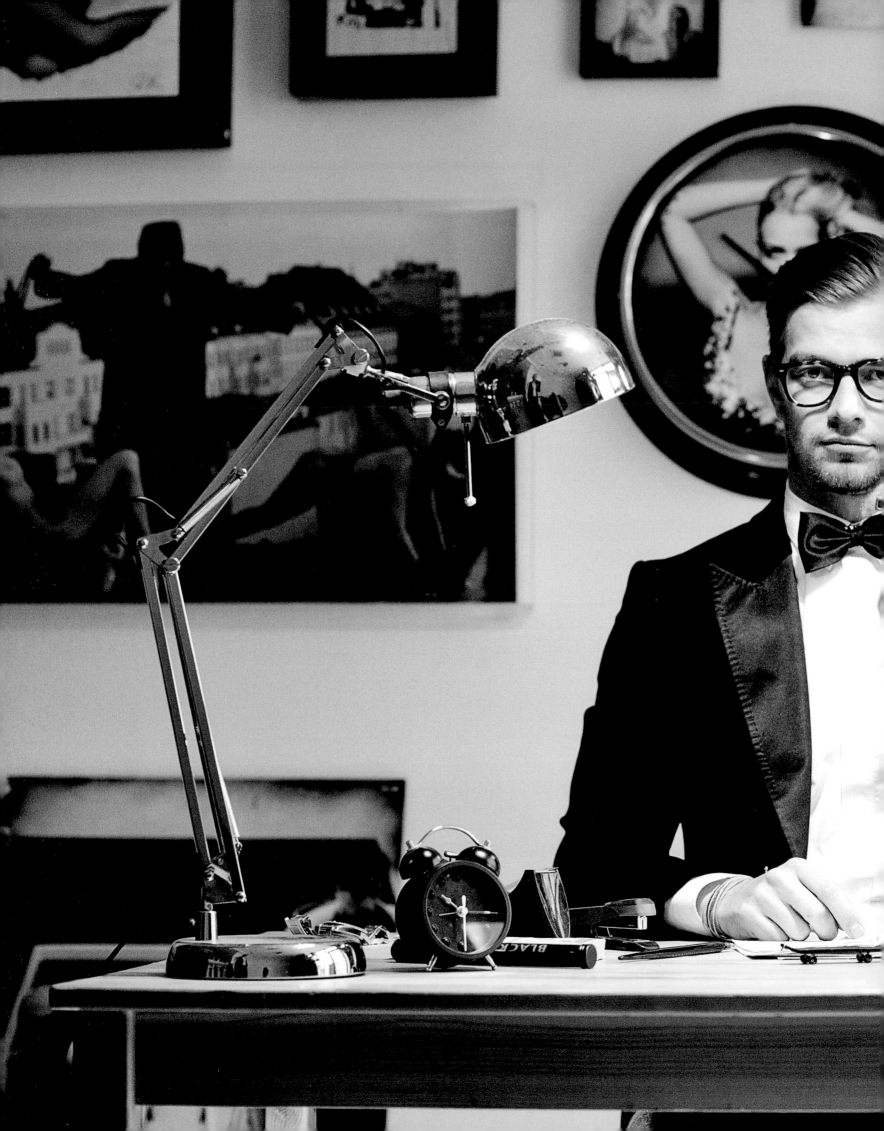

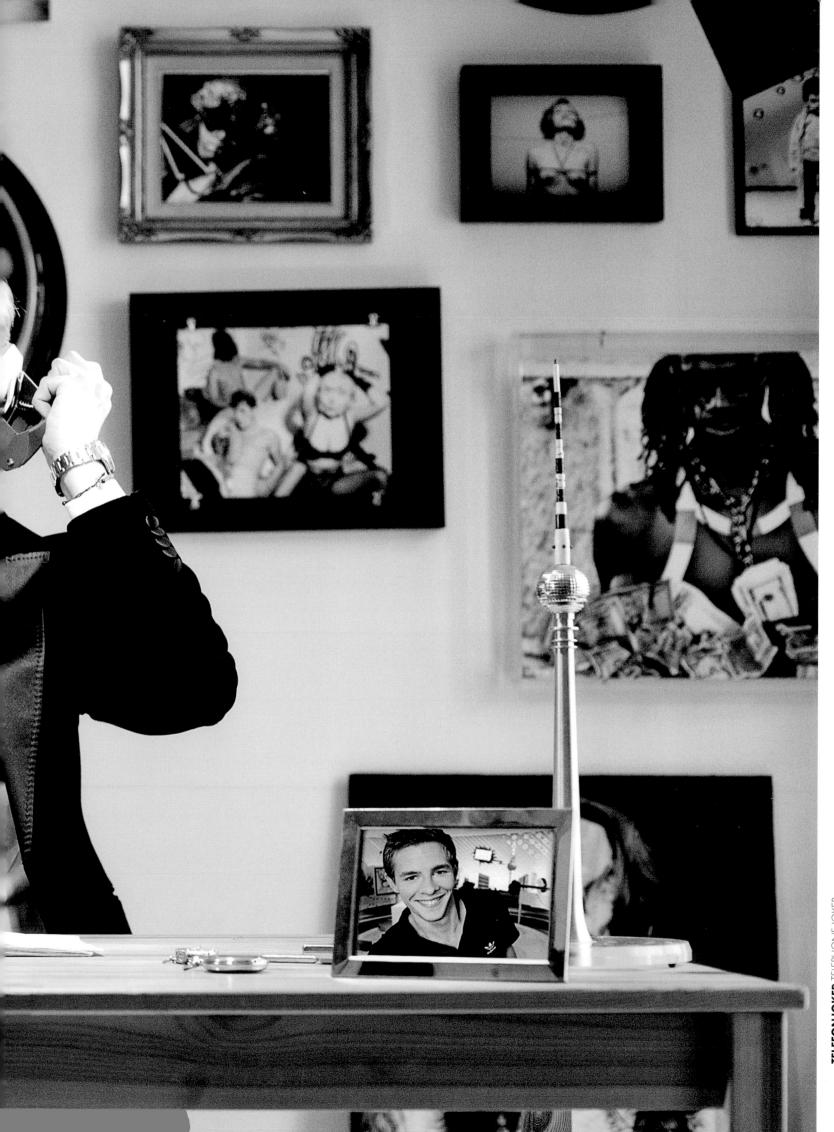

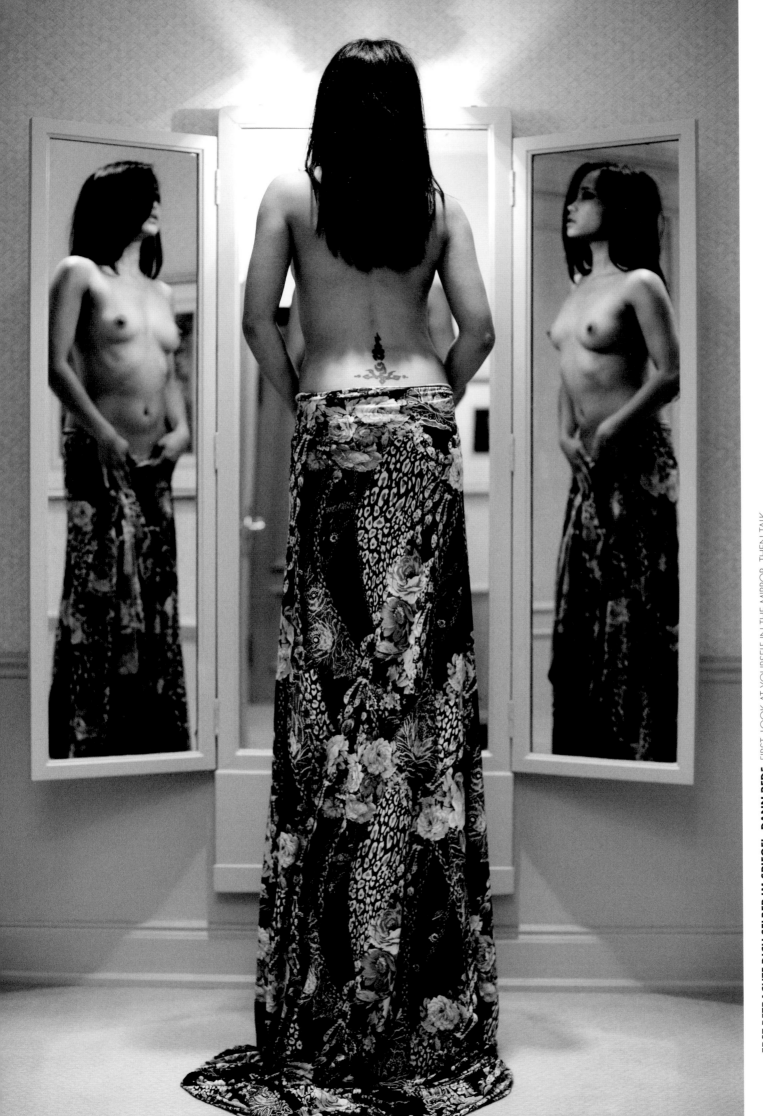

ERST BETRACHTE DICH SELBER IM SPIEGEL, DANN REDE. FIRST, LOOK AT YOURSELF IN THE MIRROR, THEN TALK.

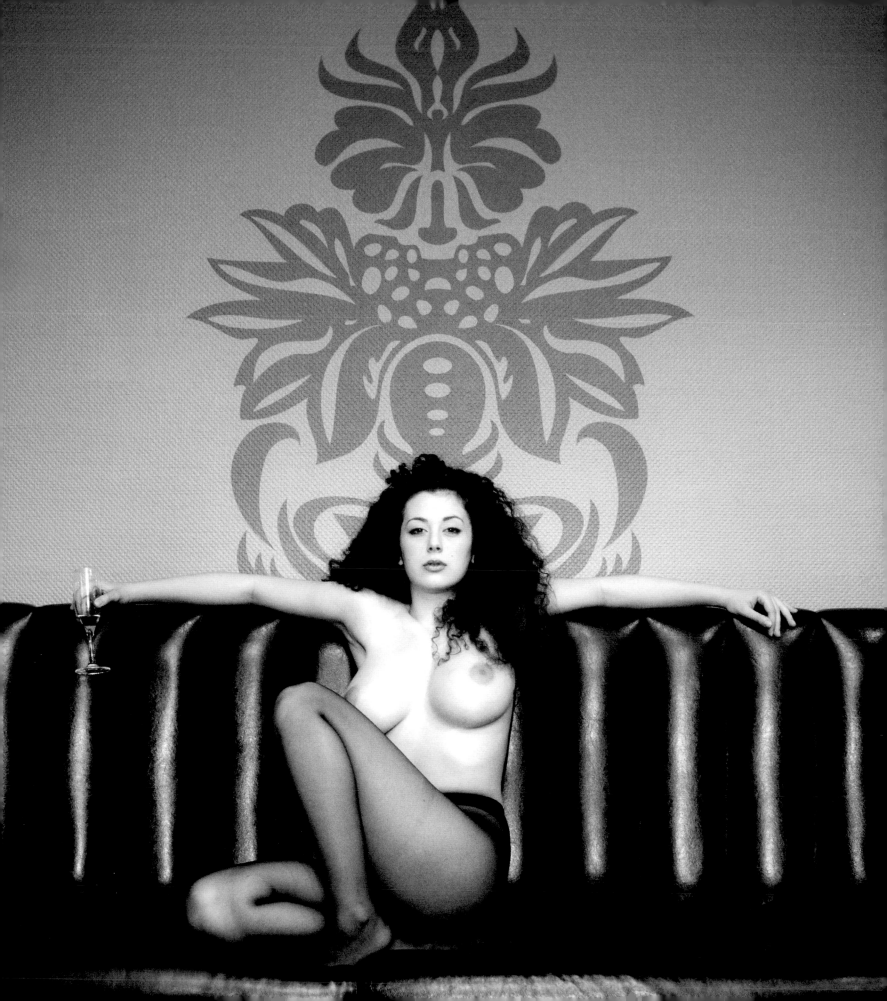

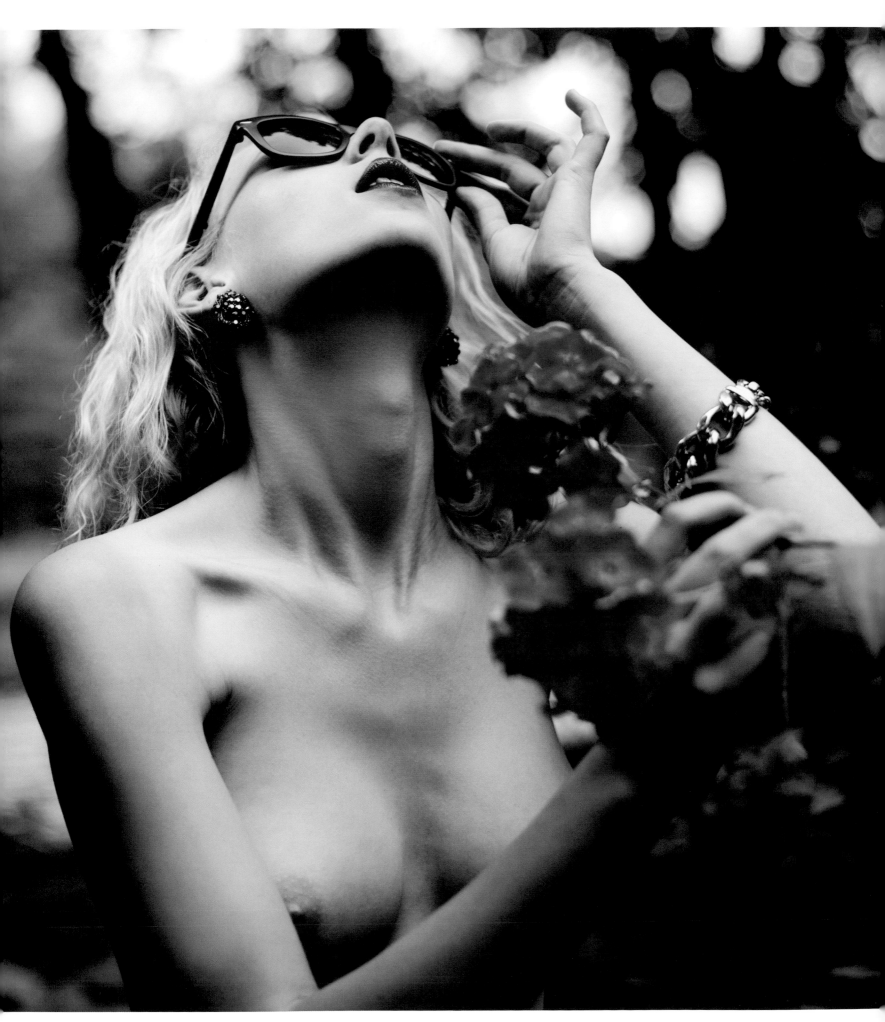

EINE FRAU OHNE GEHEIMNISSE IST WIE EINE BLUME OHNE DUFT A WOMAN WITHOUT SECRETS IS LIKE A FLOWER WITHOUT PERFUME

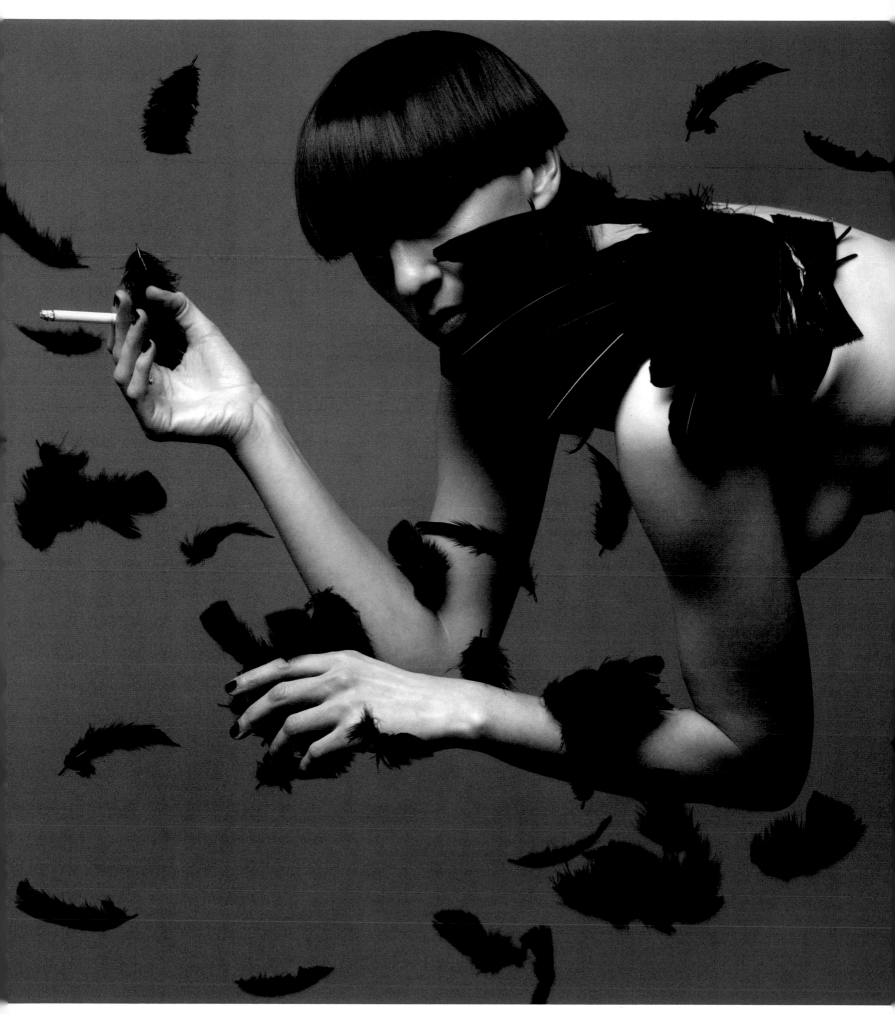

BIRDS FLYING HIGH

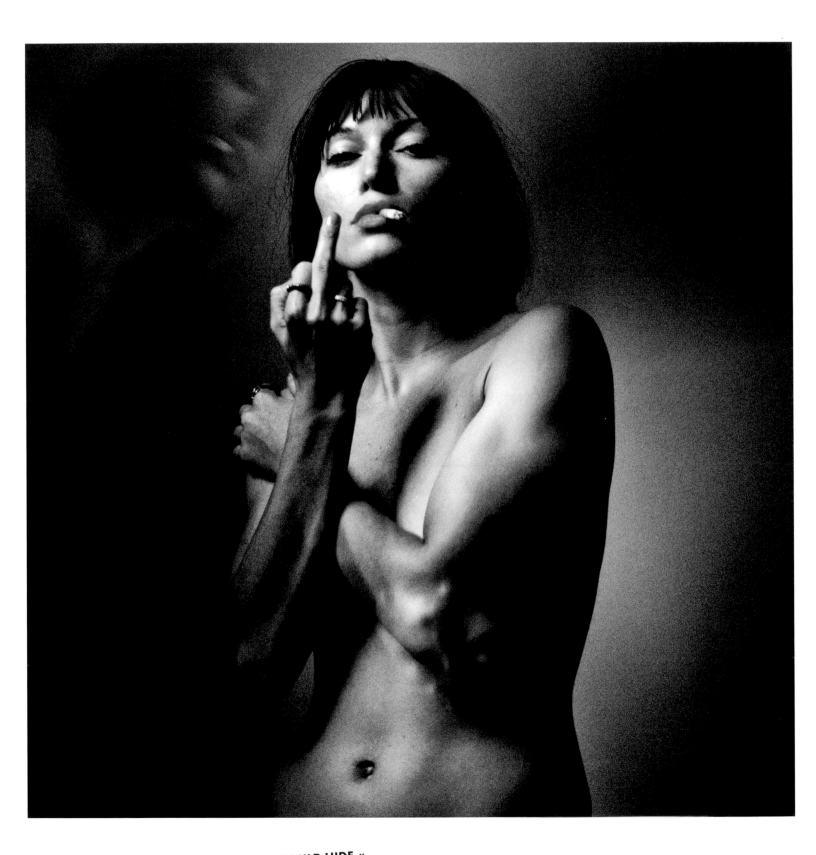

»I GOT NAKED FASTER THAN MY SOUL COULD HIDE.«
SYLTA FEE WEGMANN

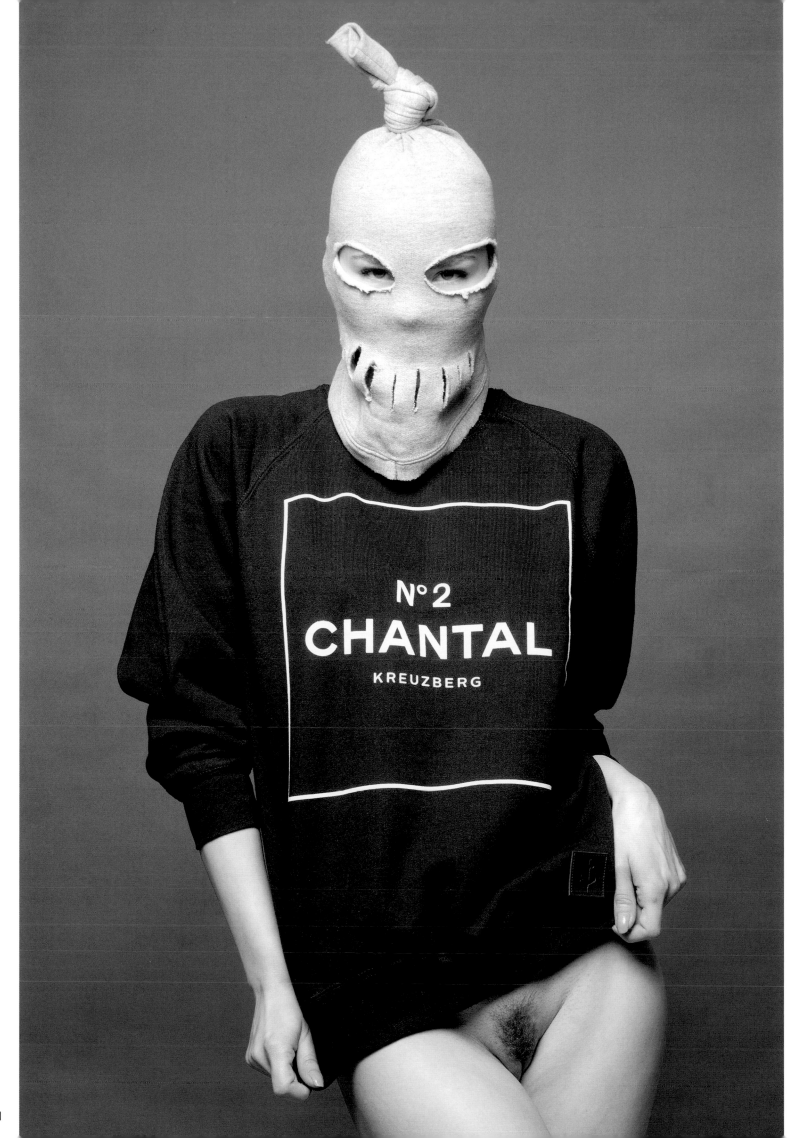

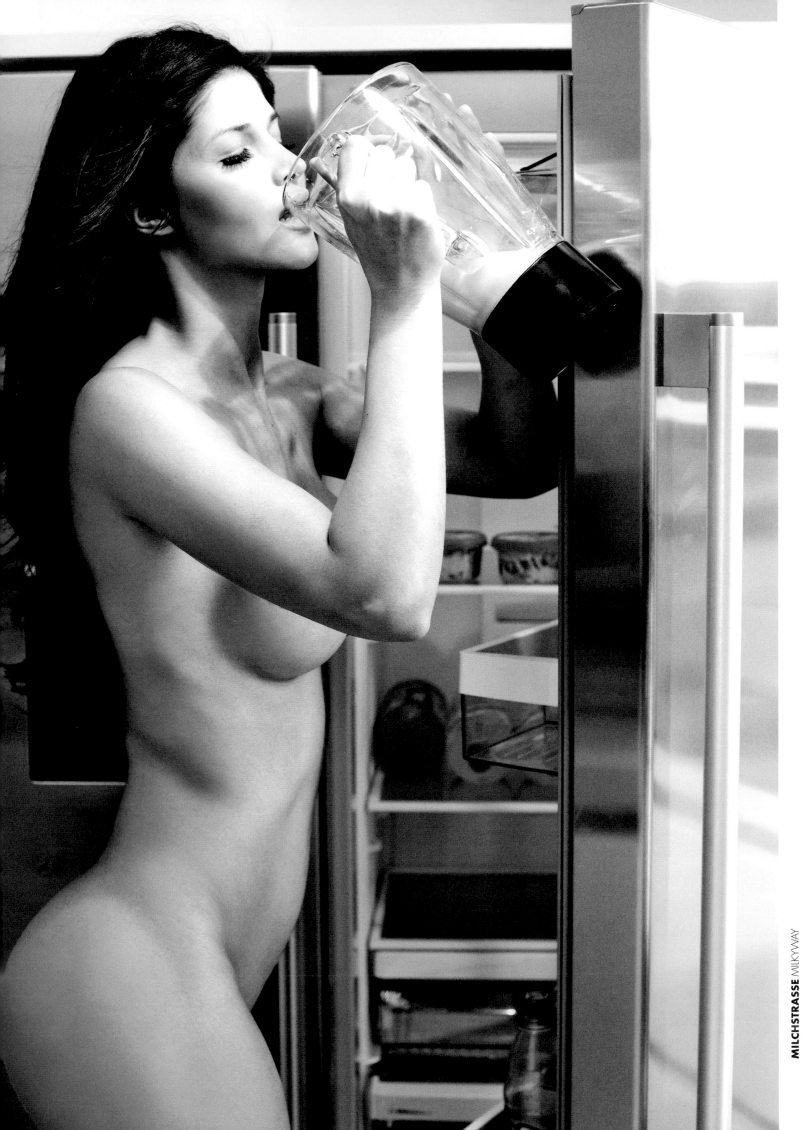

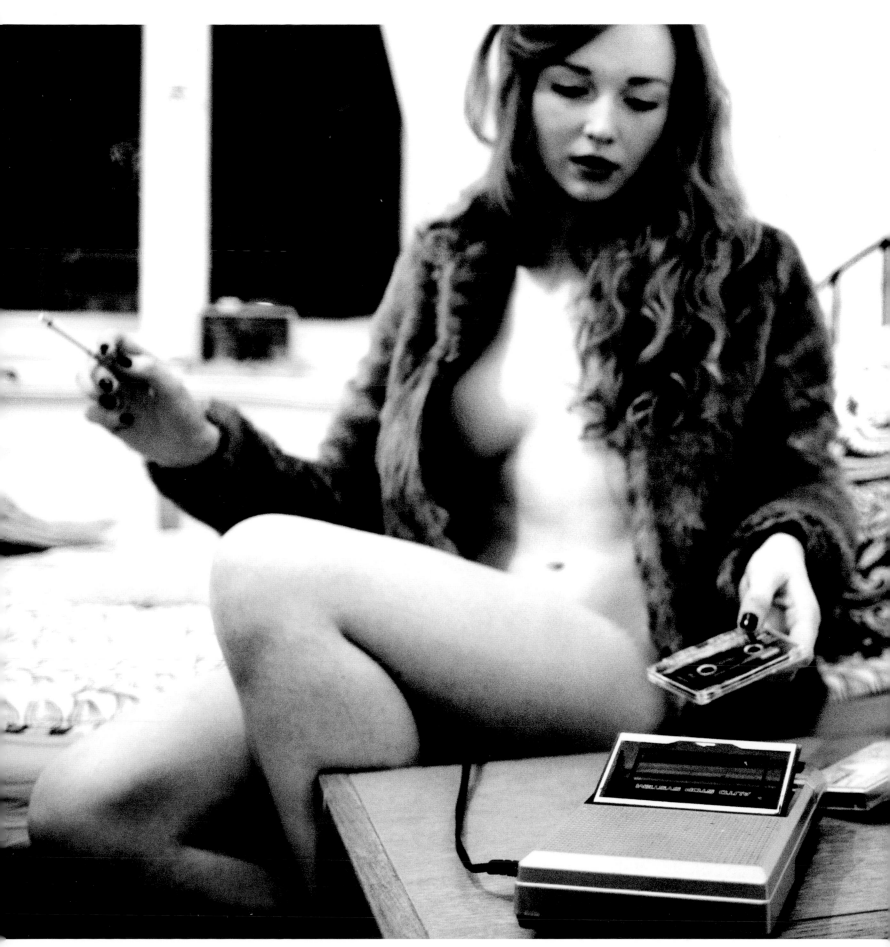

SCHEISS AUF DIGITAL TO HELL WITH DIGITAL

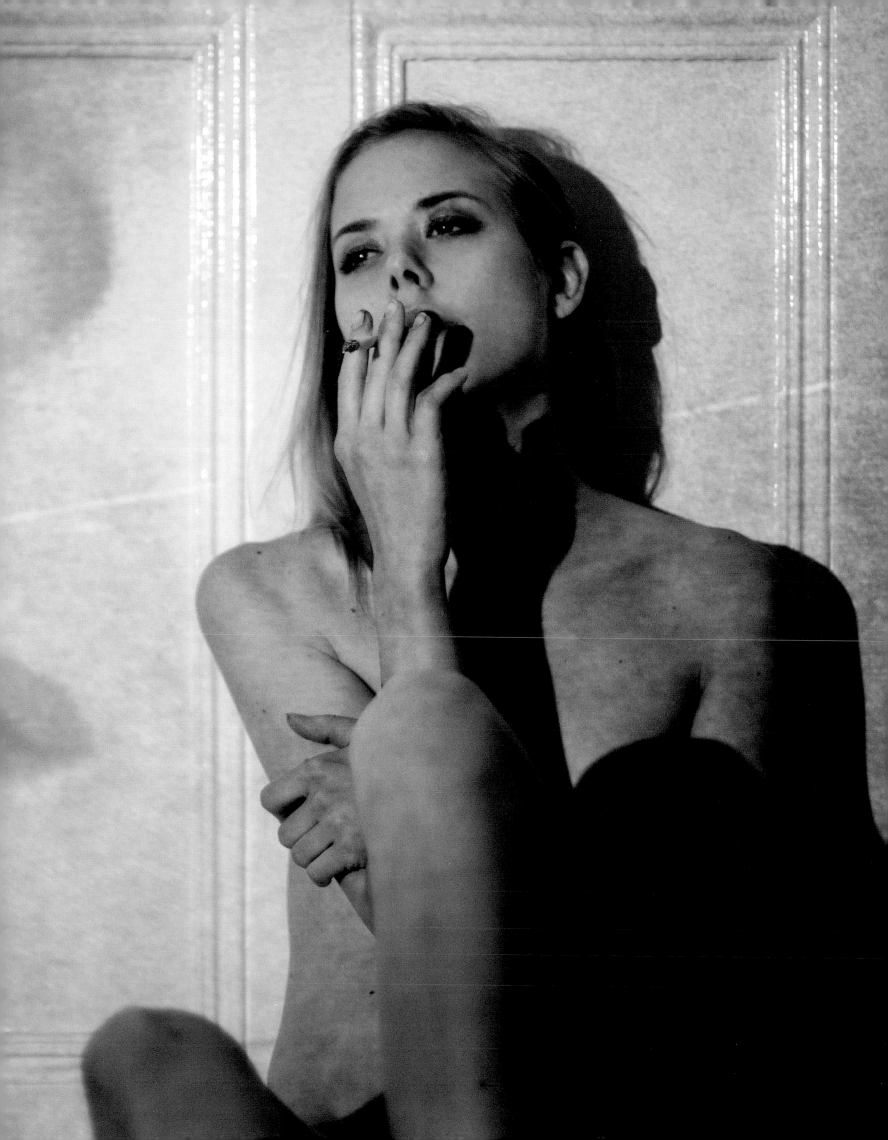

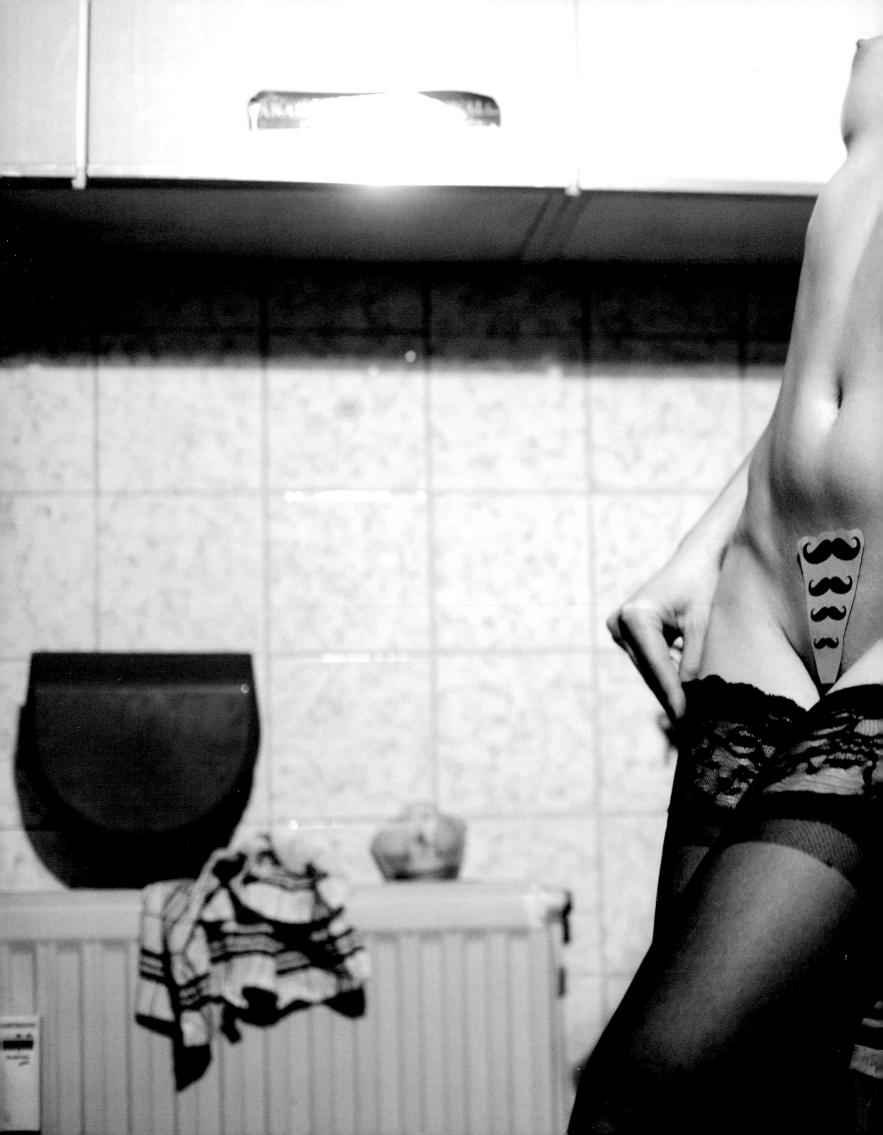

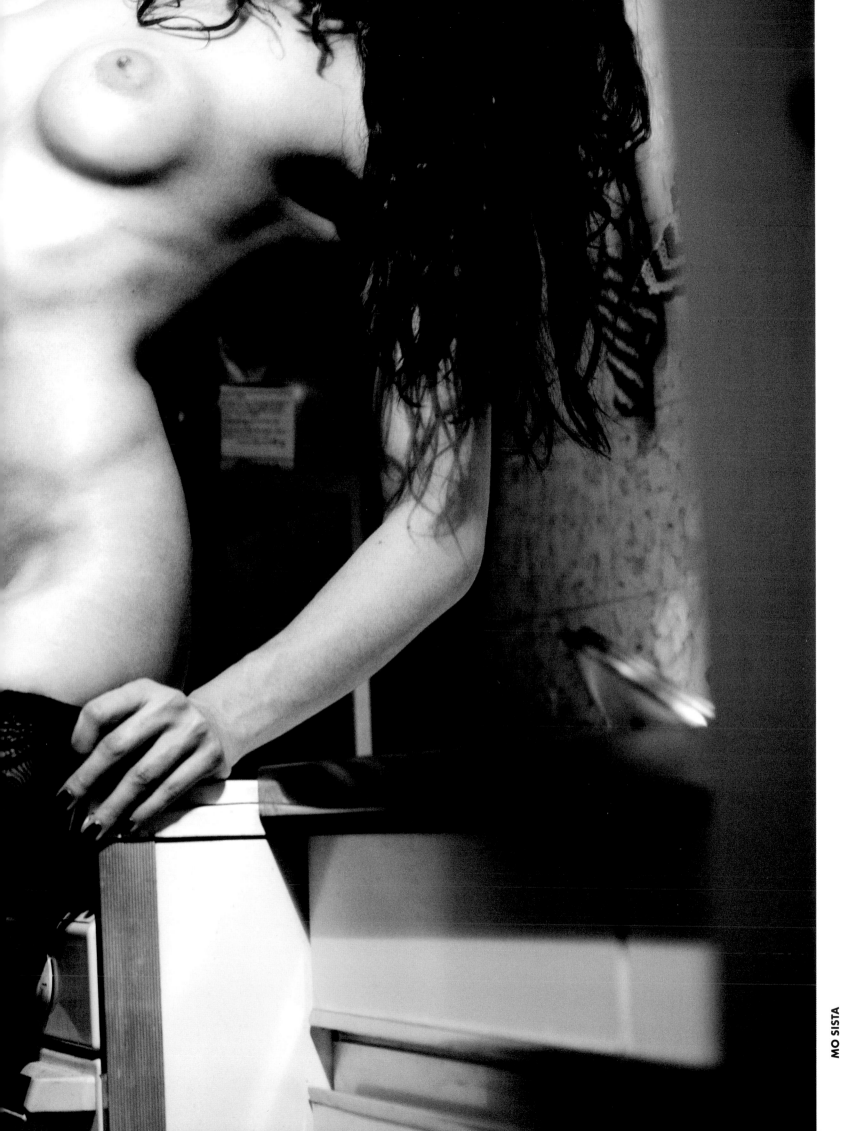

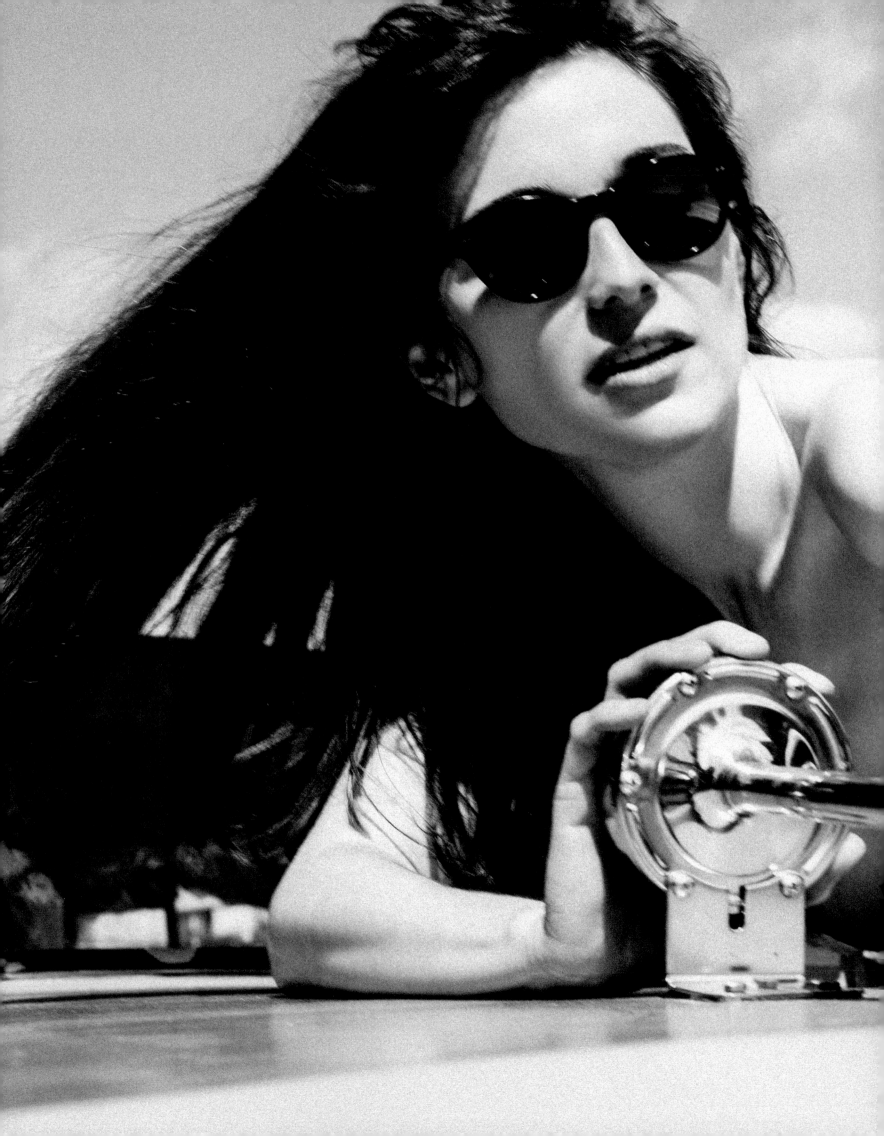

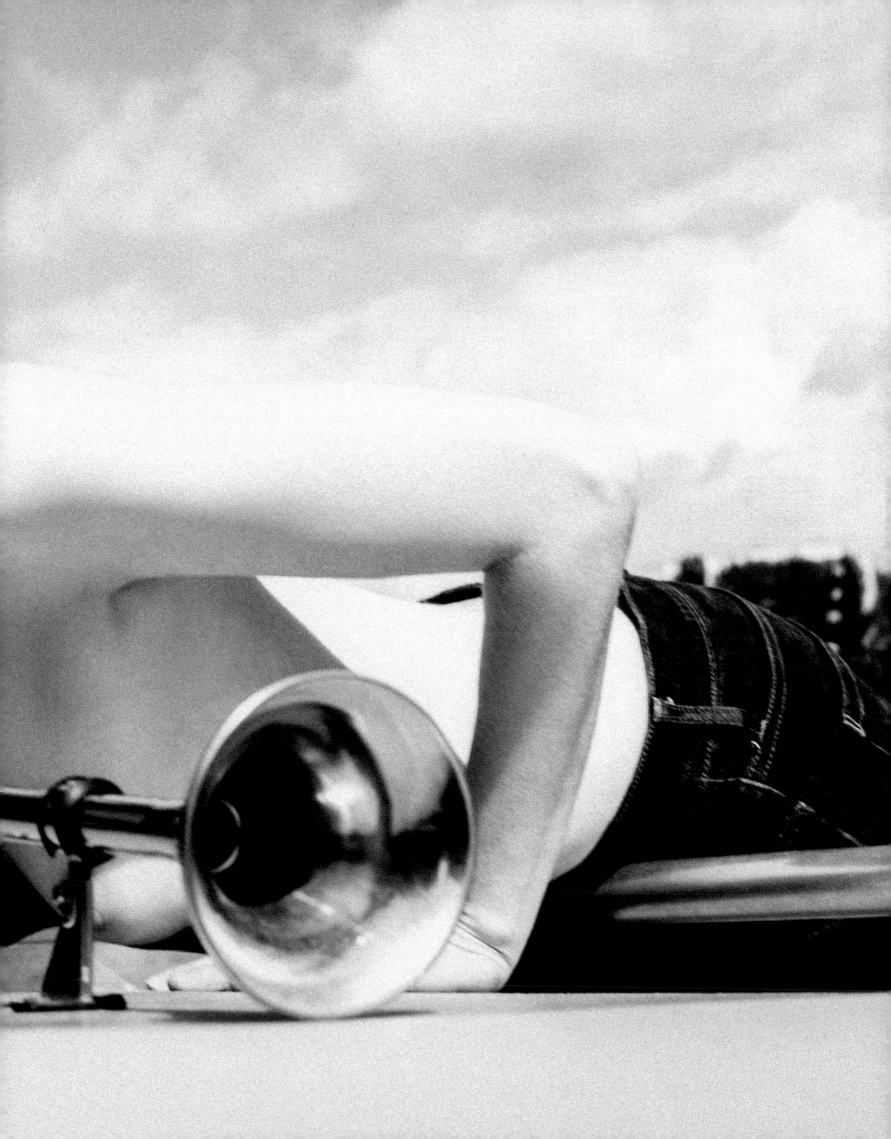

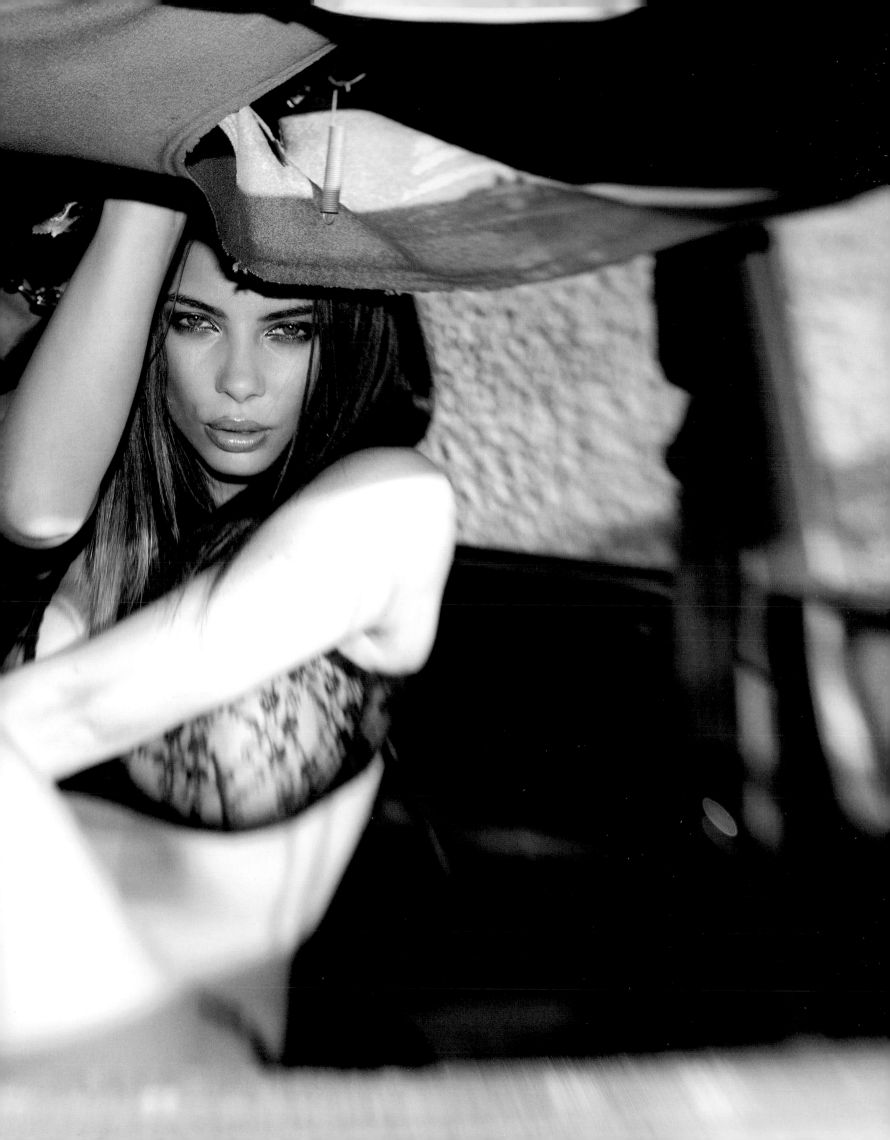

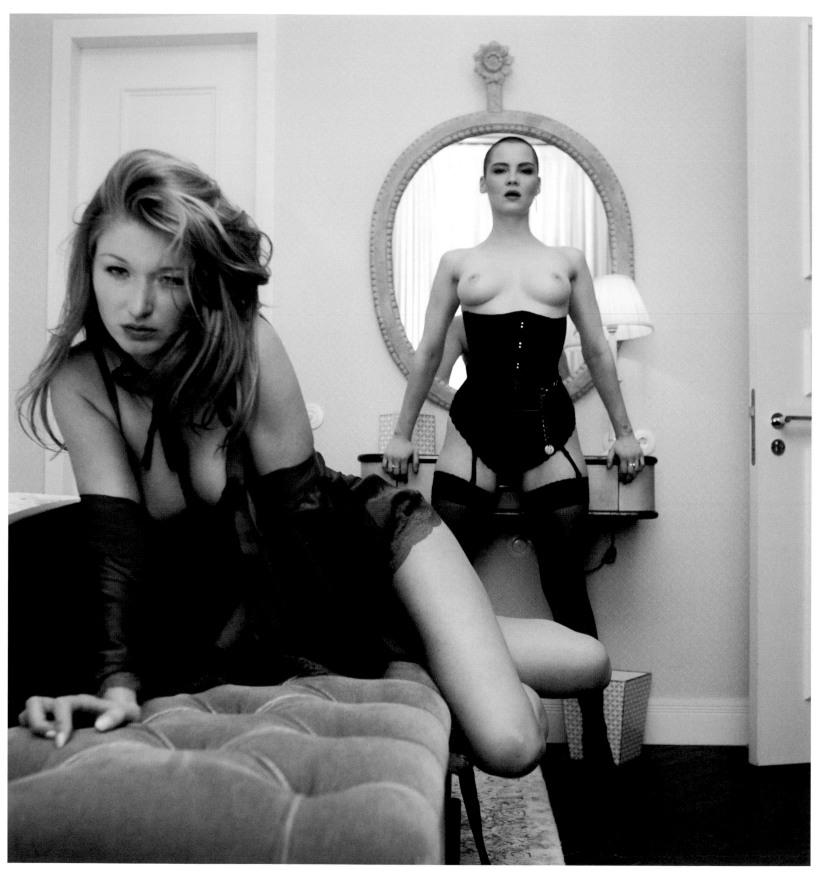

ZWEITEILER TWO-PIECE

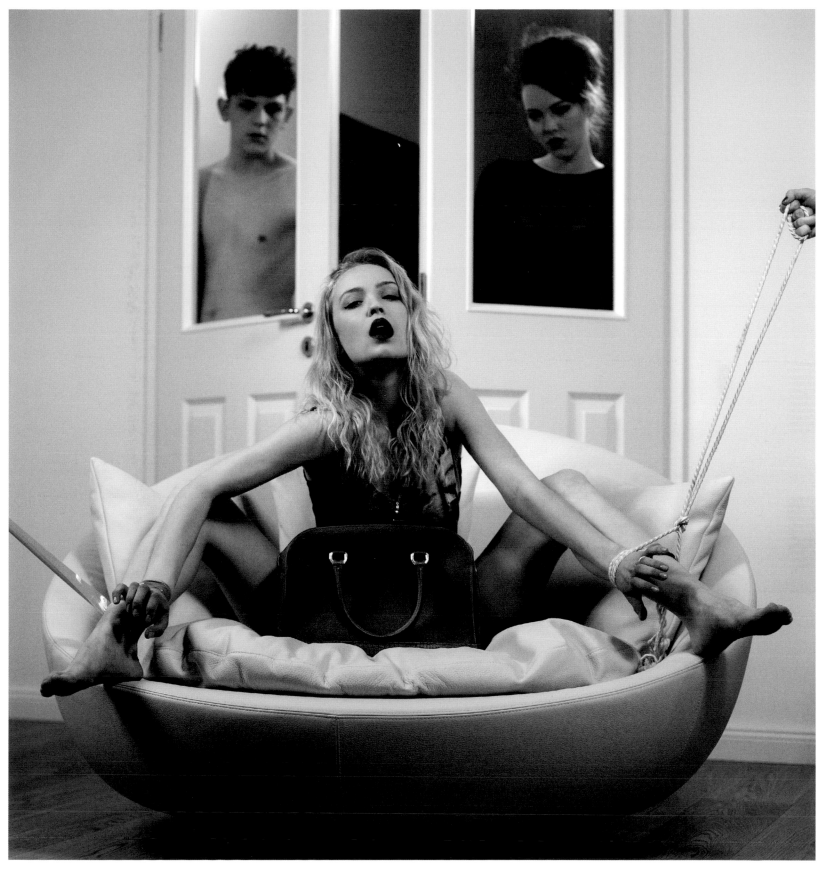

ARRESTED

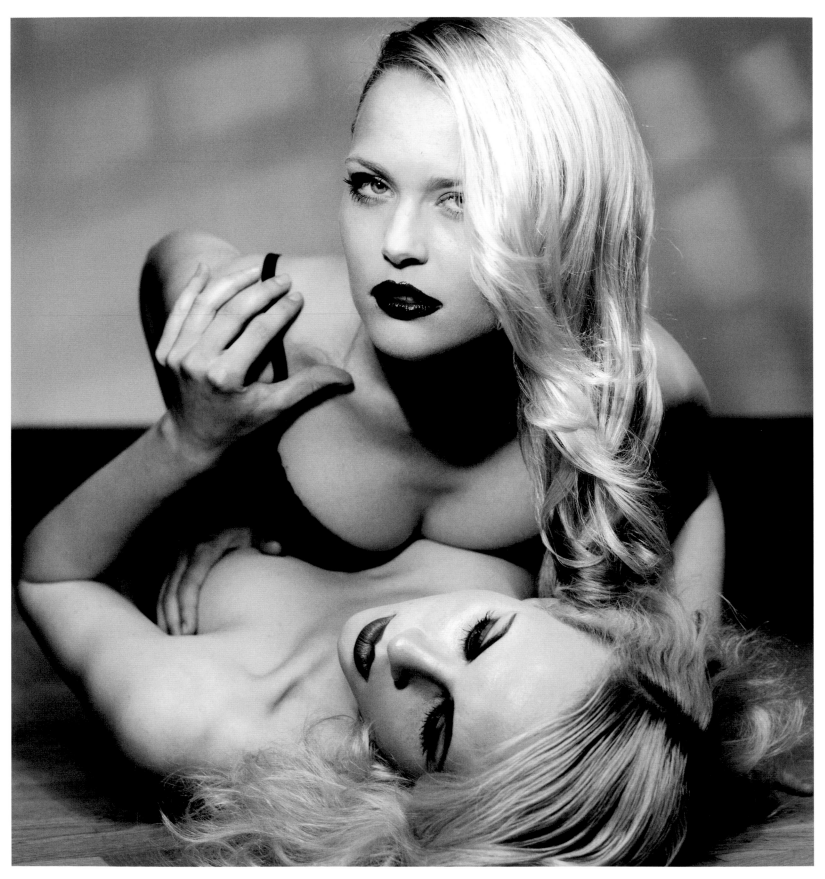

MEINE KLEINE SCHWESTER MY LITTLE SISTER

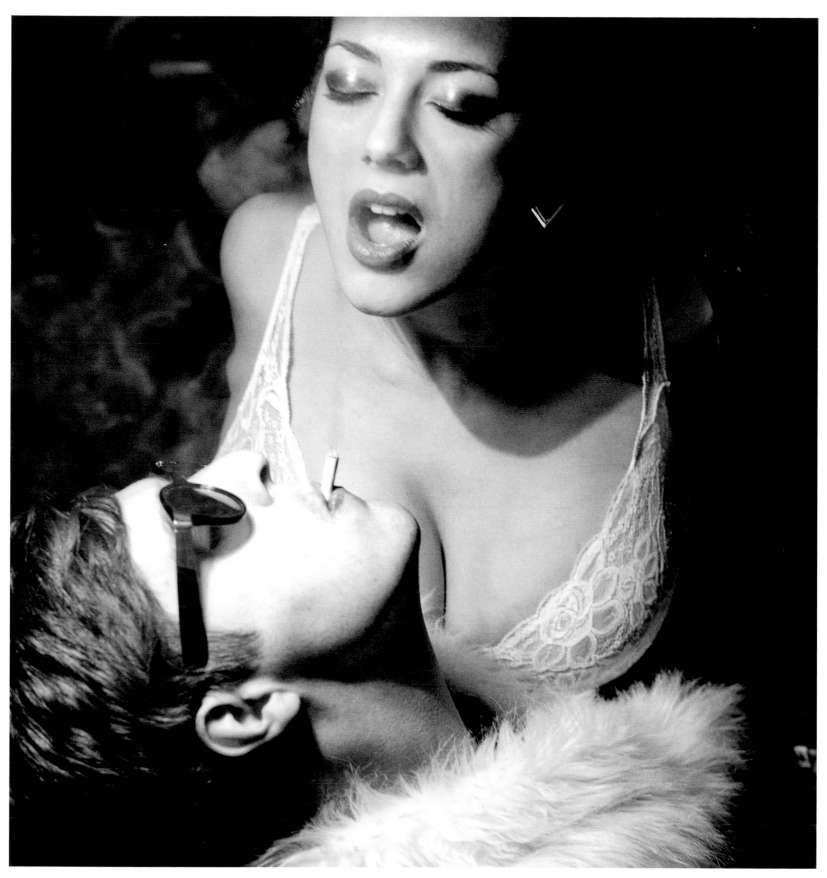

KIFFER PRAKTIKUM POT PRACTICAL

DAS KLEINE KAMASUTRA THE LITTLE KAMASUTRA

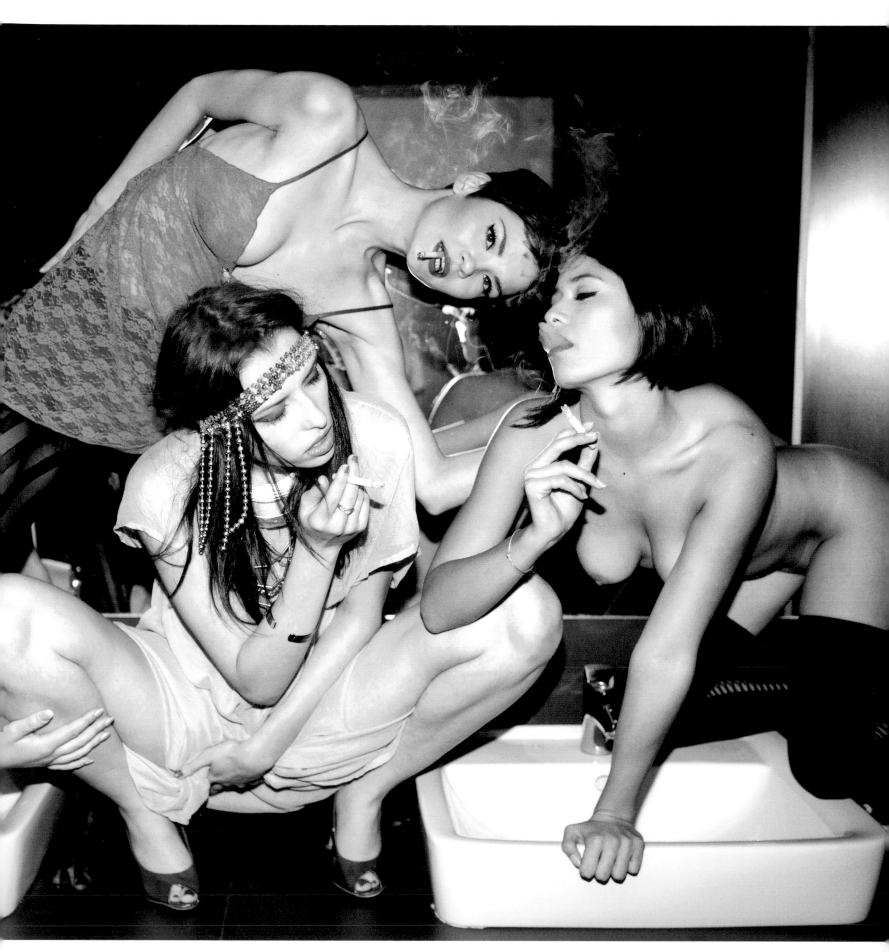

WELTFRAUENTAG WORLD WOMEN'S DAY

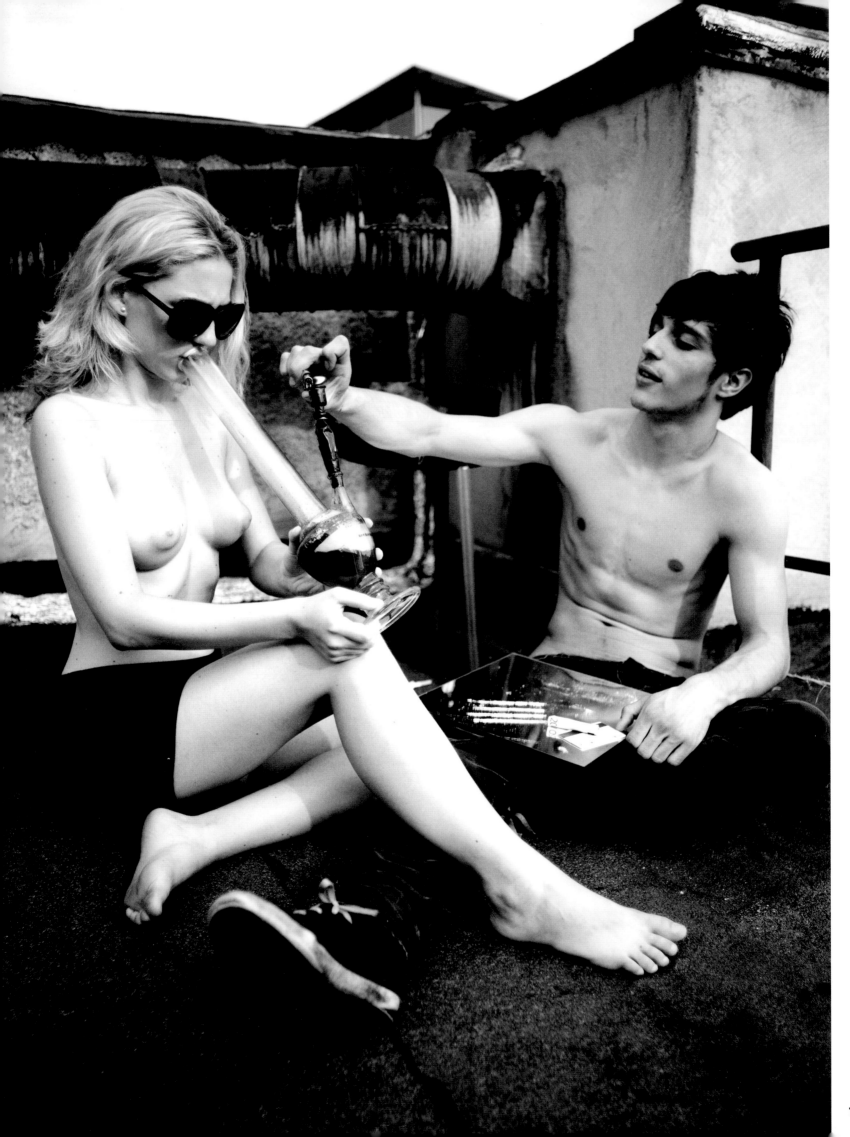

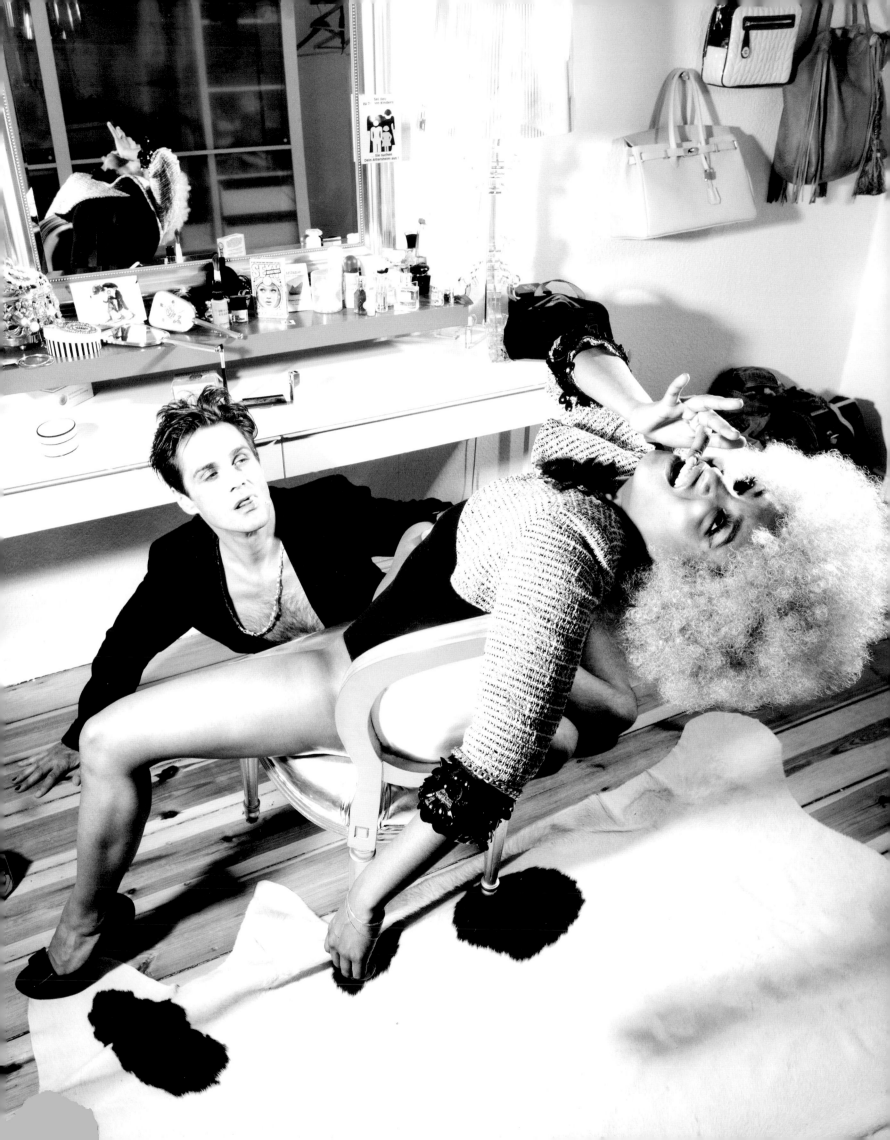

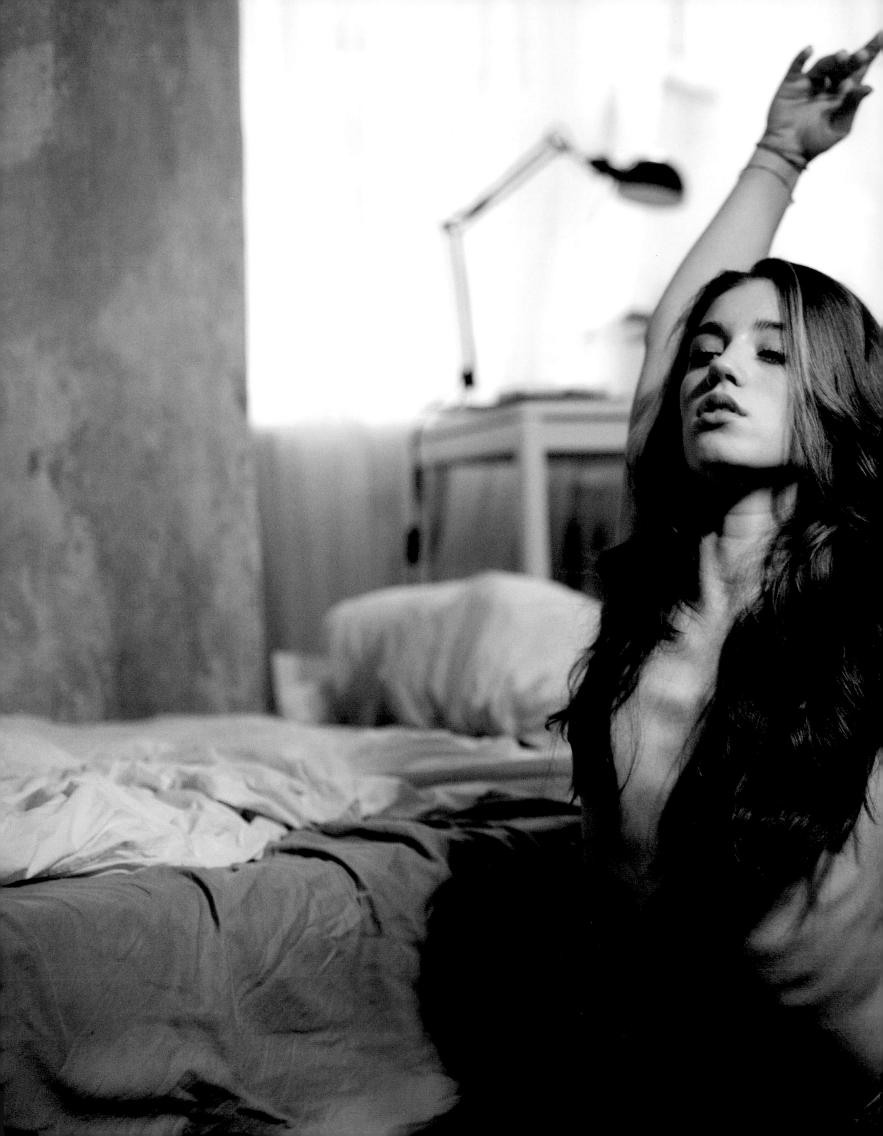

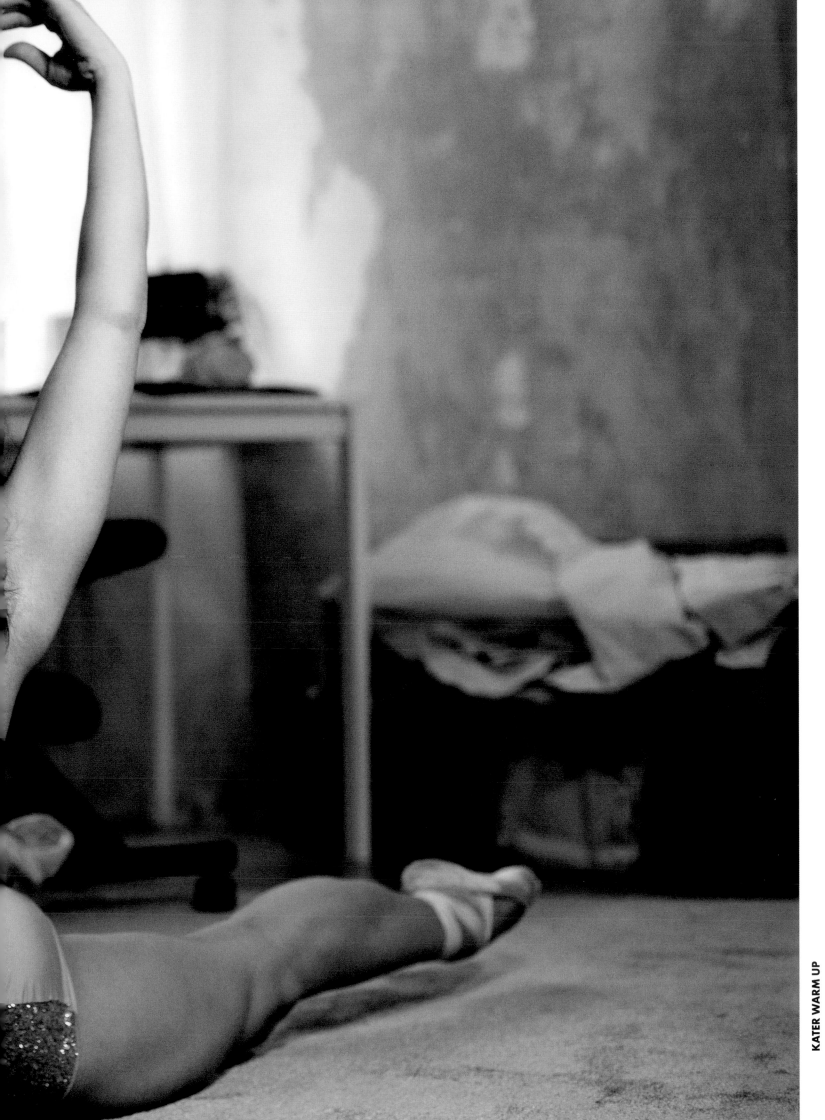

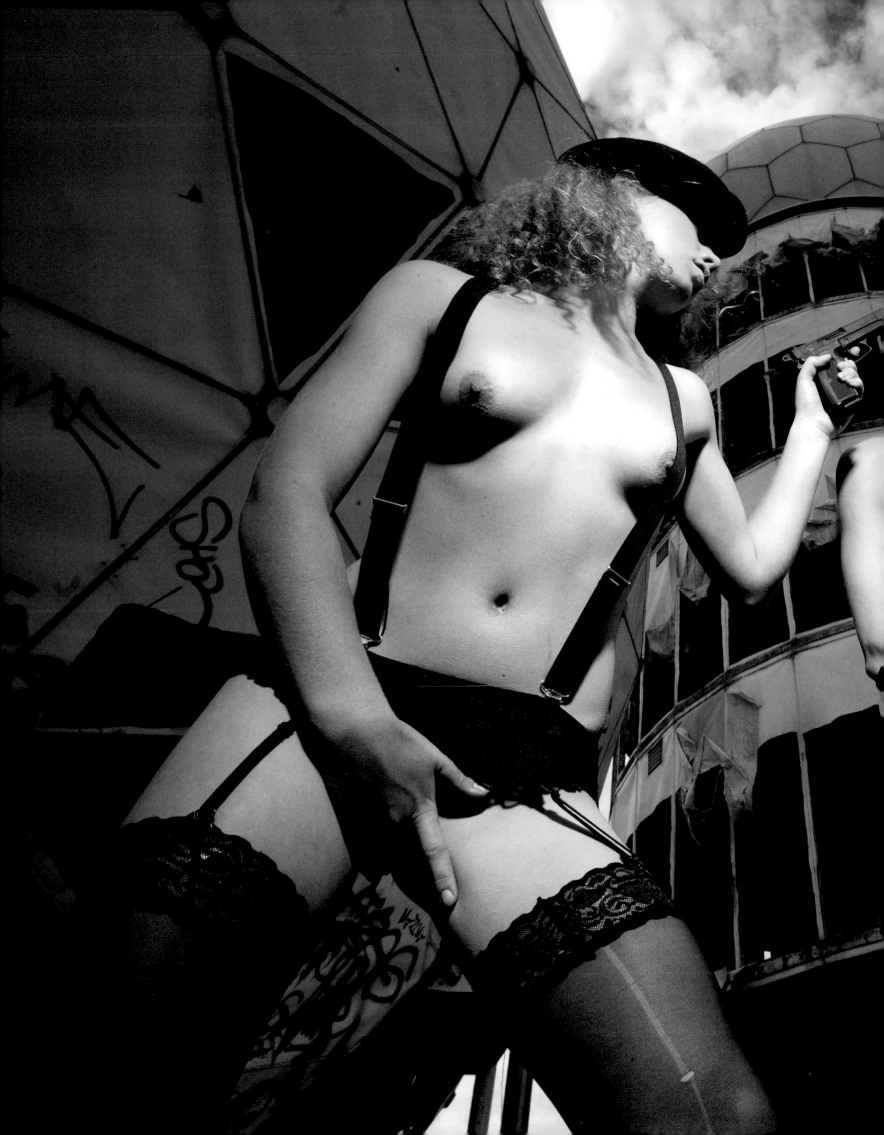

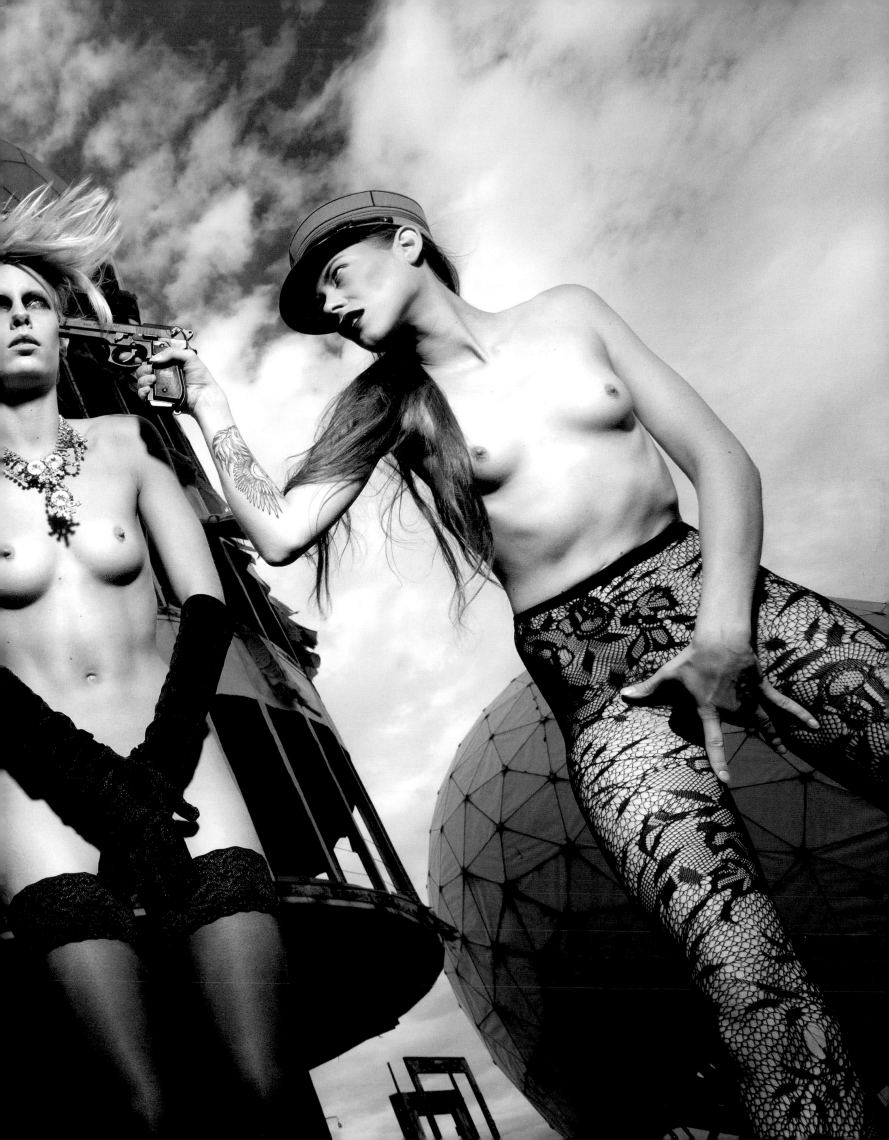

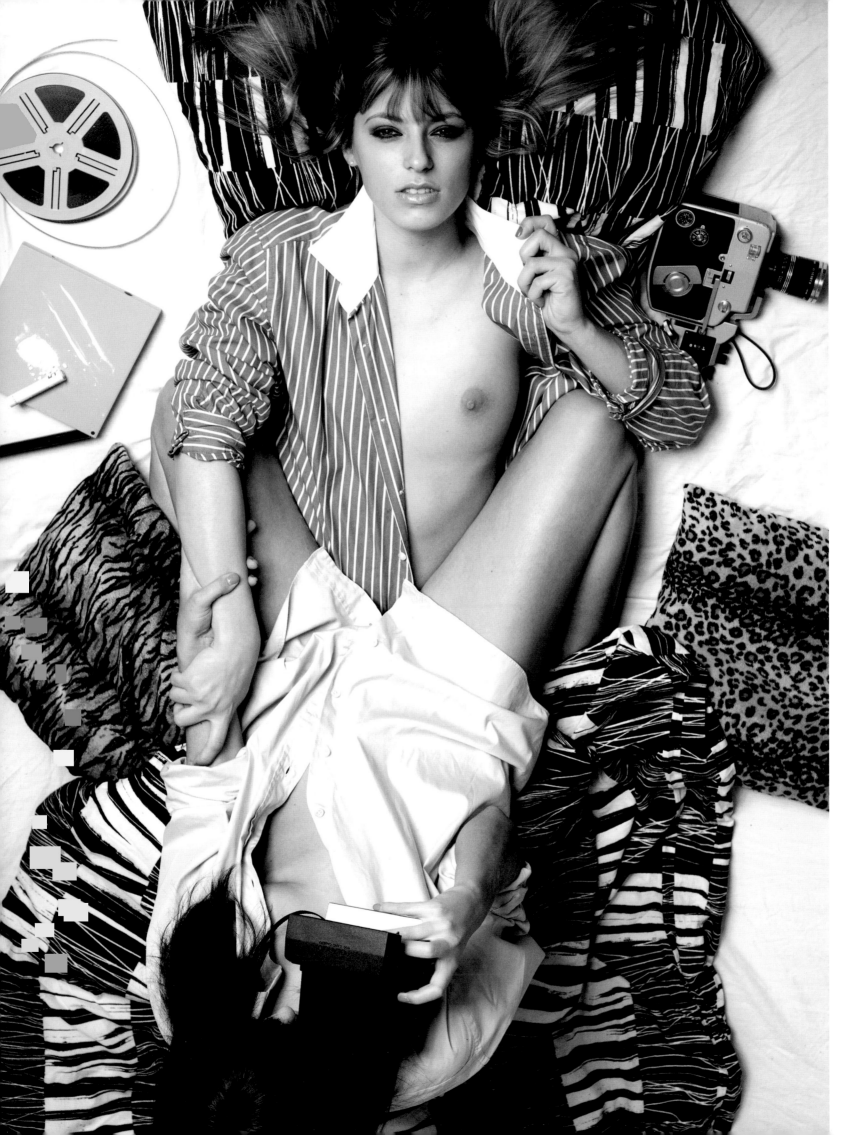

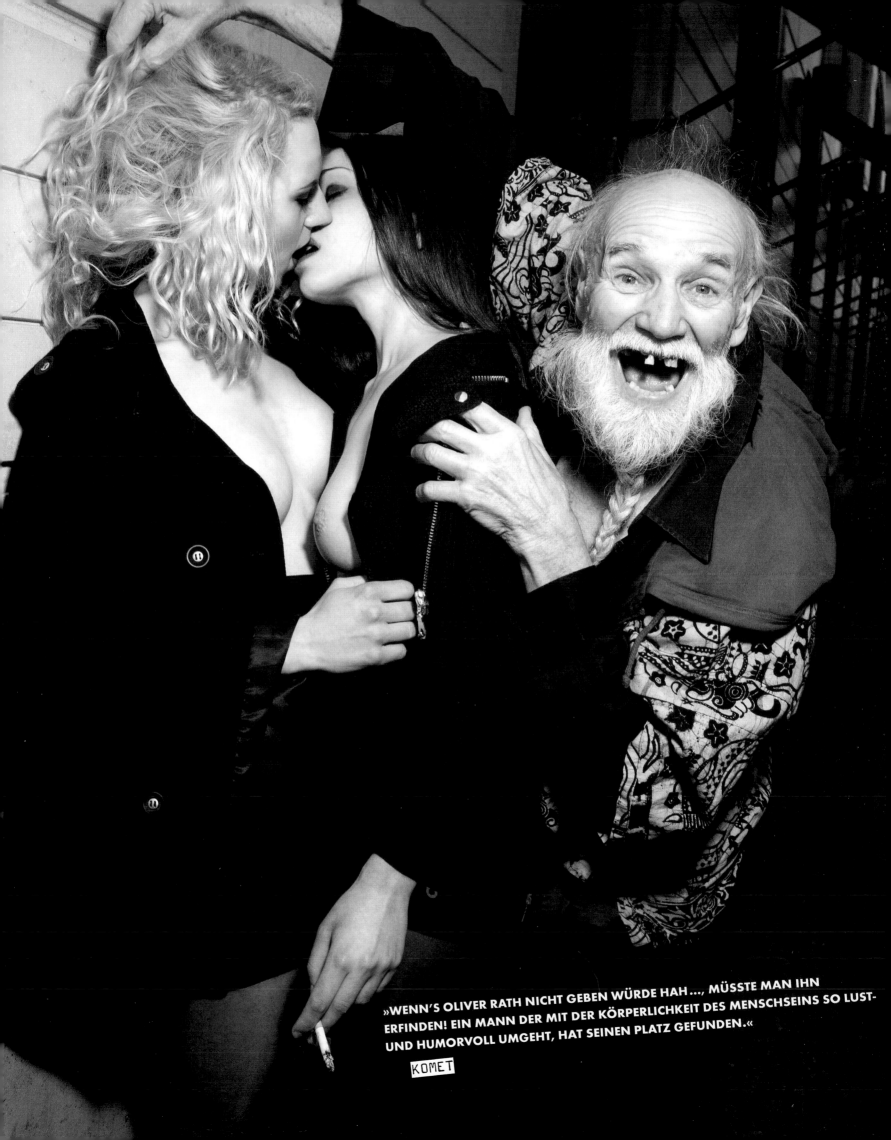

»WENN'S OLIVER RATH NICHT GEBEN WÜRDE HAH ..., MÜSSTE MAN IHN ERFINDEN! EIN MANN DER MIT DER KÖRPERLICHKEIT DES MENSCHSEINS SO LUST- UND HUMORVOLL UMGEHT, HAT SEINEN PLATZ GEFUNDEN.«

KOMET

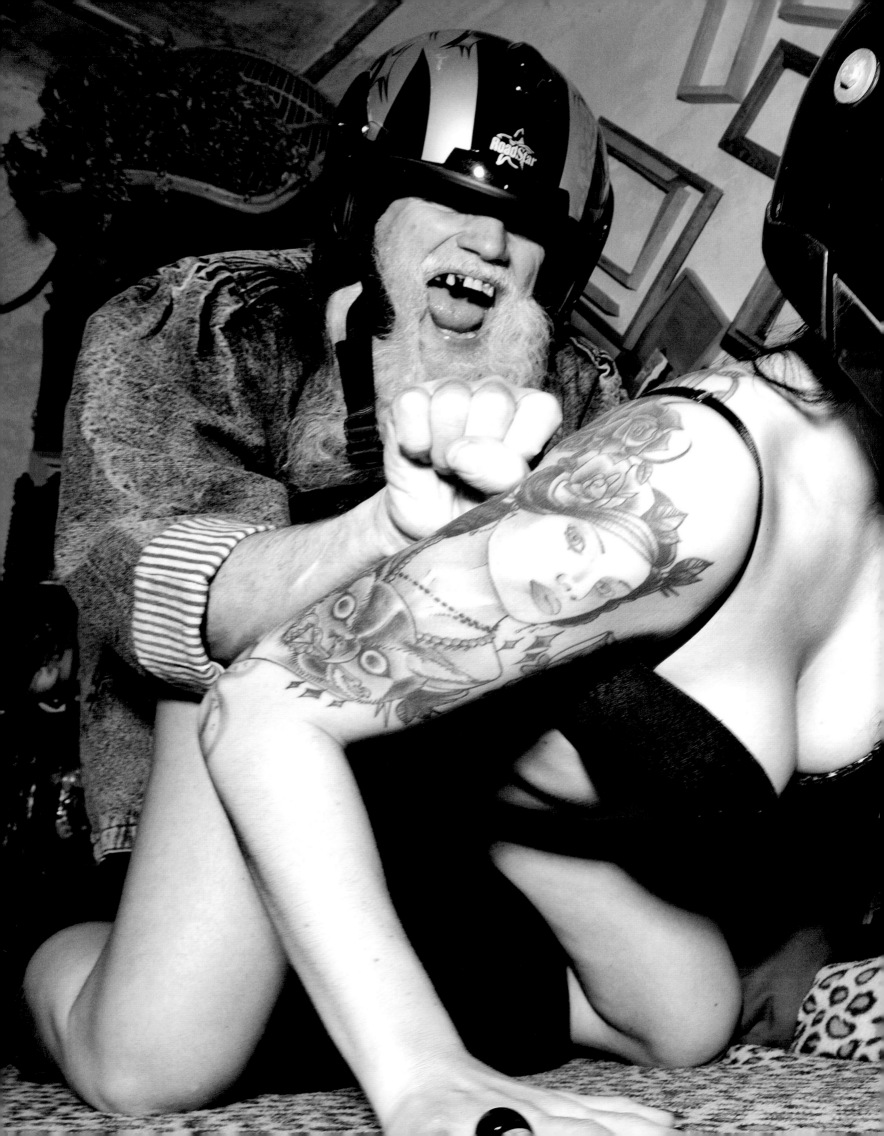

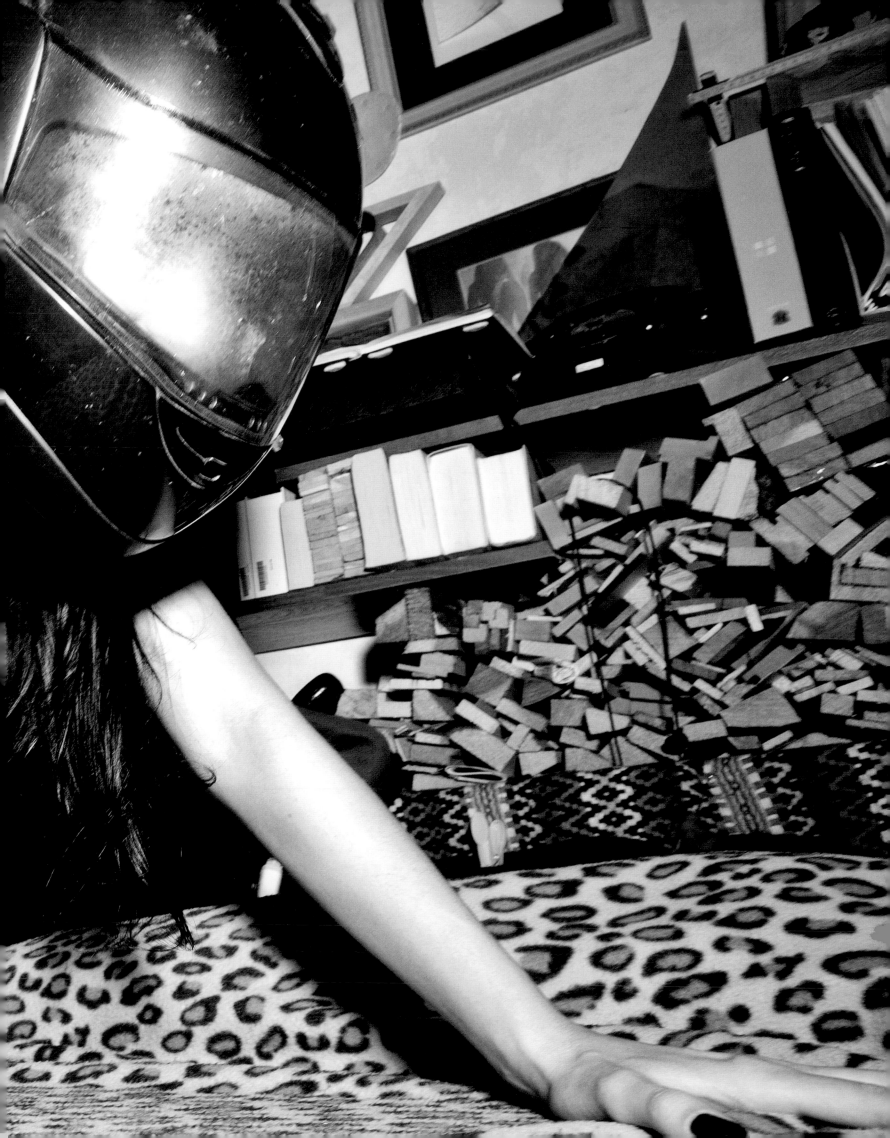

GUTEN TAG HERR RATH, GUTEN TAG HERR SCHULZ! GOOD DAY HERR RATH, GOOD DAY HERR SCHULZ!

130

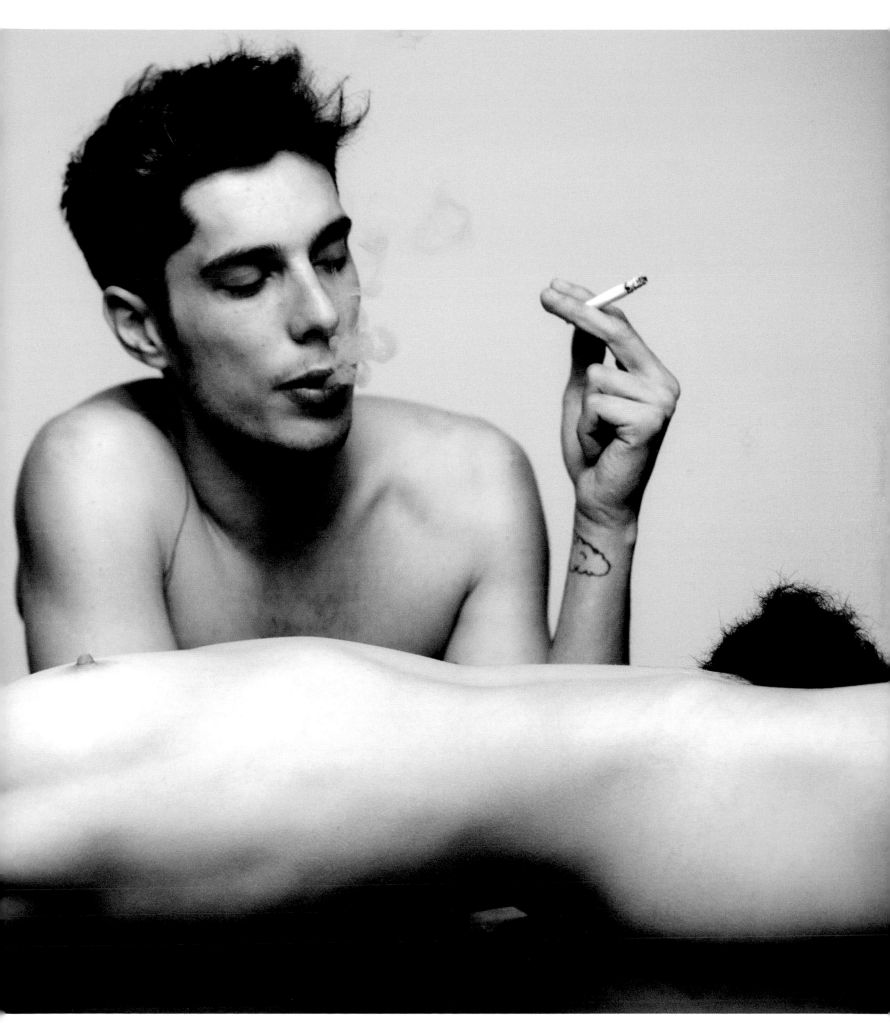

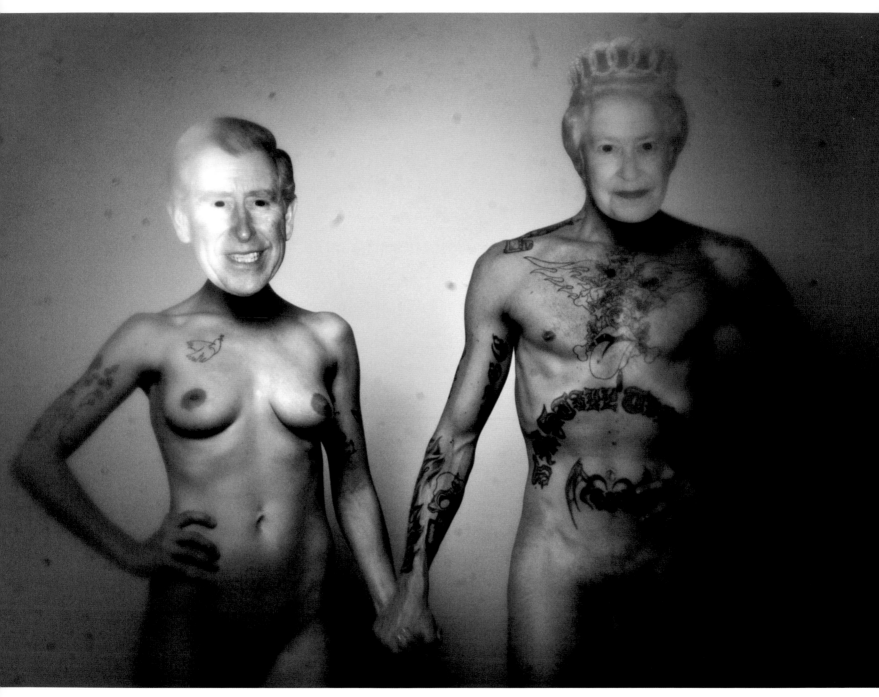

ROYAL LOVE

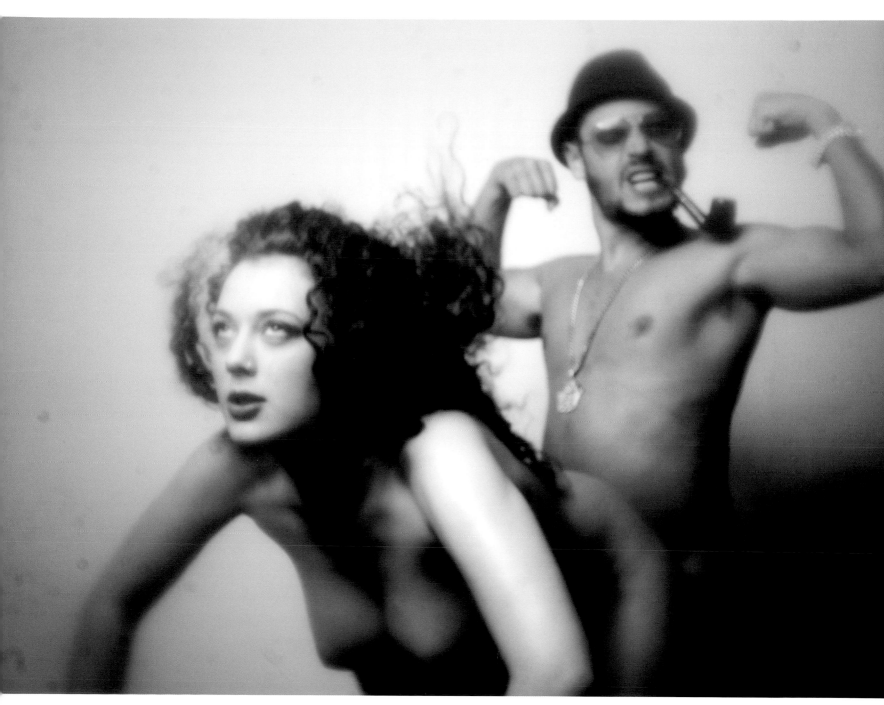

FEAR AND LOATHING IN LAS VEGAS

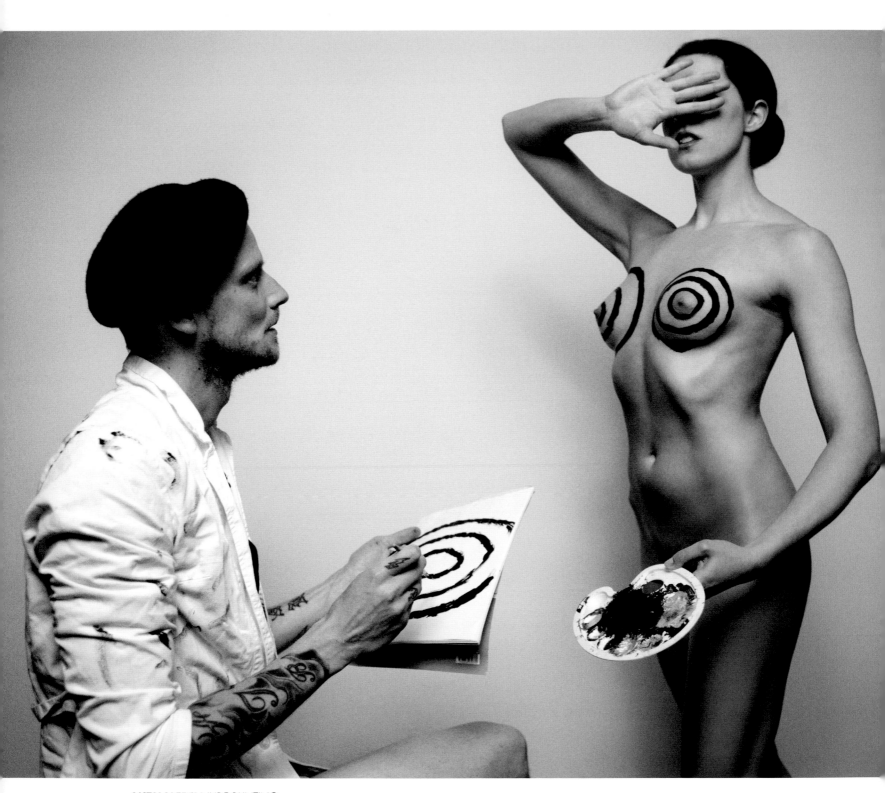

AKTMALEREI NUDE PAINTING

»OLI IST EINE WUNDERBARE SEELE, DIE ICH HOFFENTLICH IN JEDEM LEBEN WIEDER TREFFEN WERDE.« ELIZABETH EHRLICH

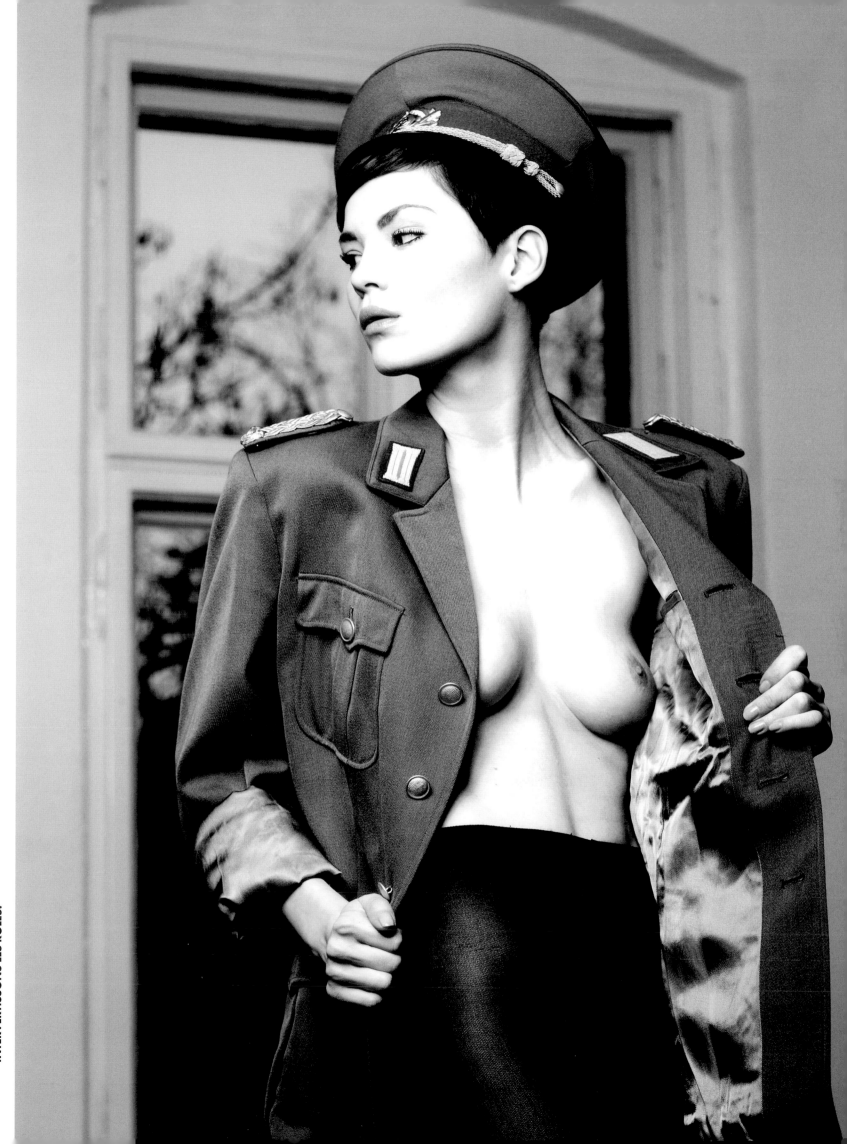

INTERVERTISSONS LES RÔLES!

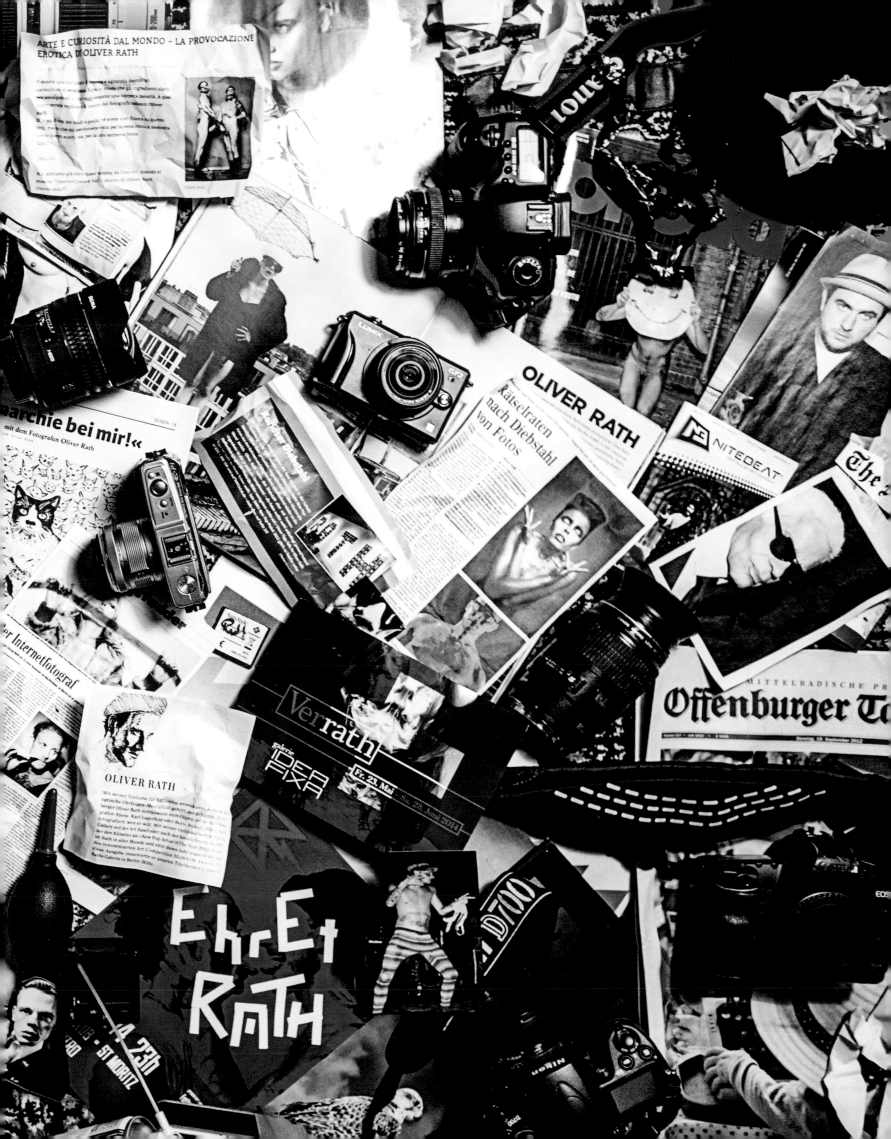

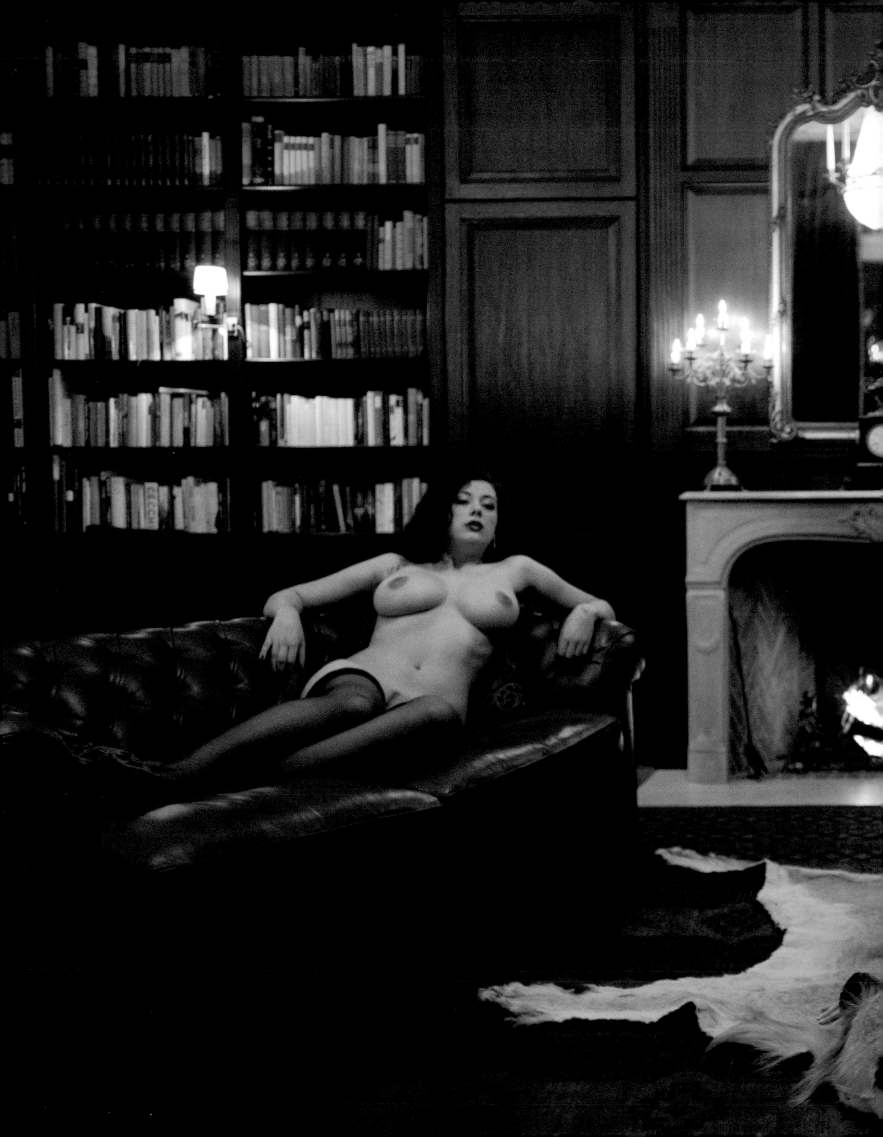

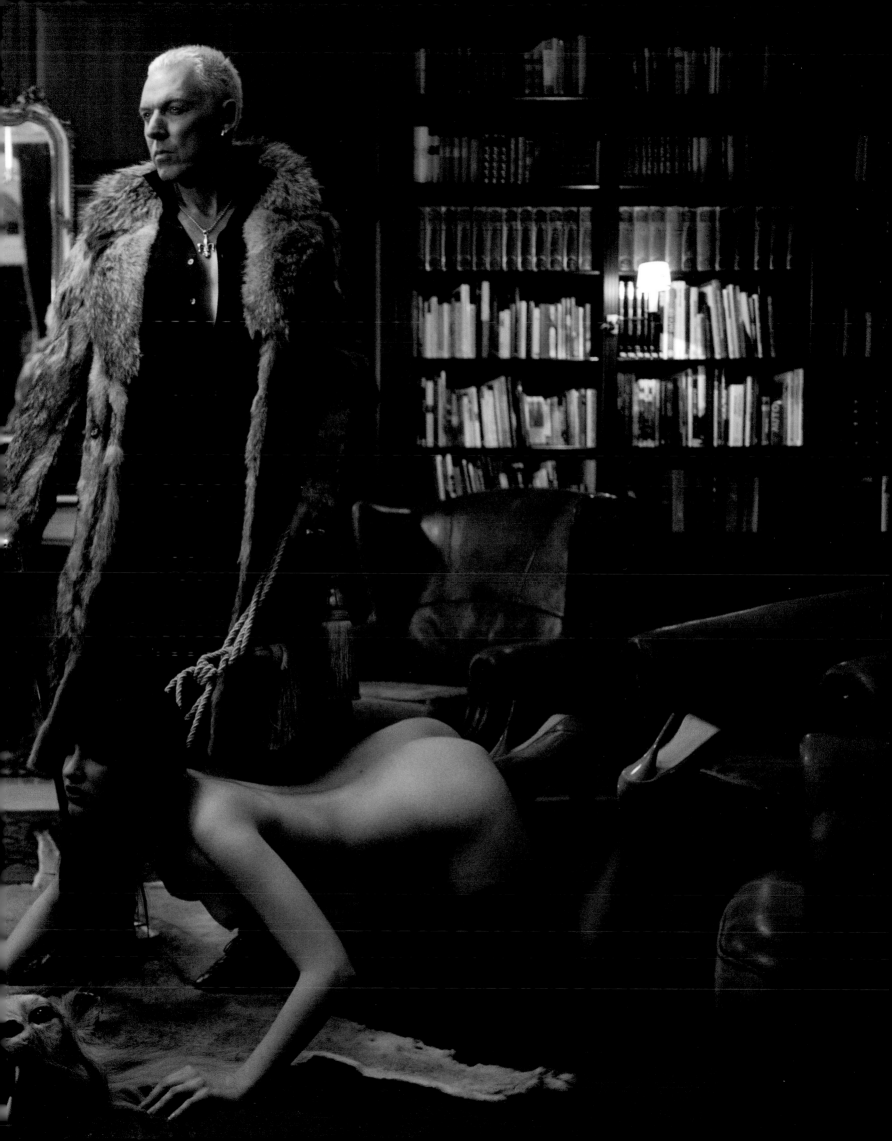

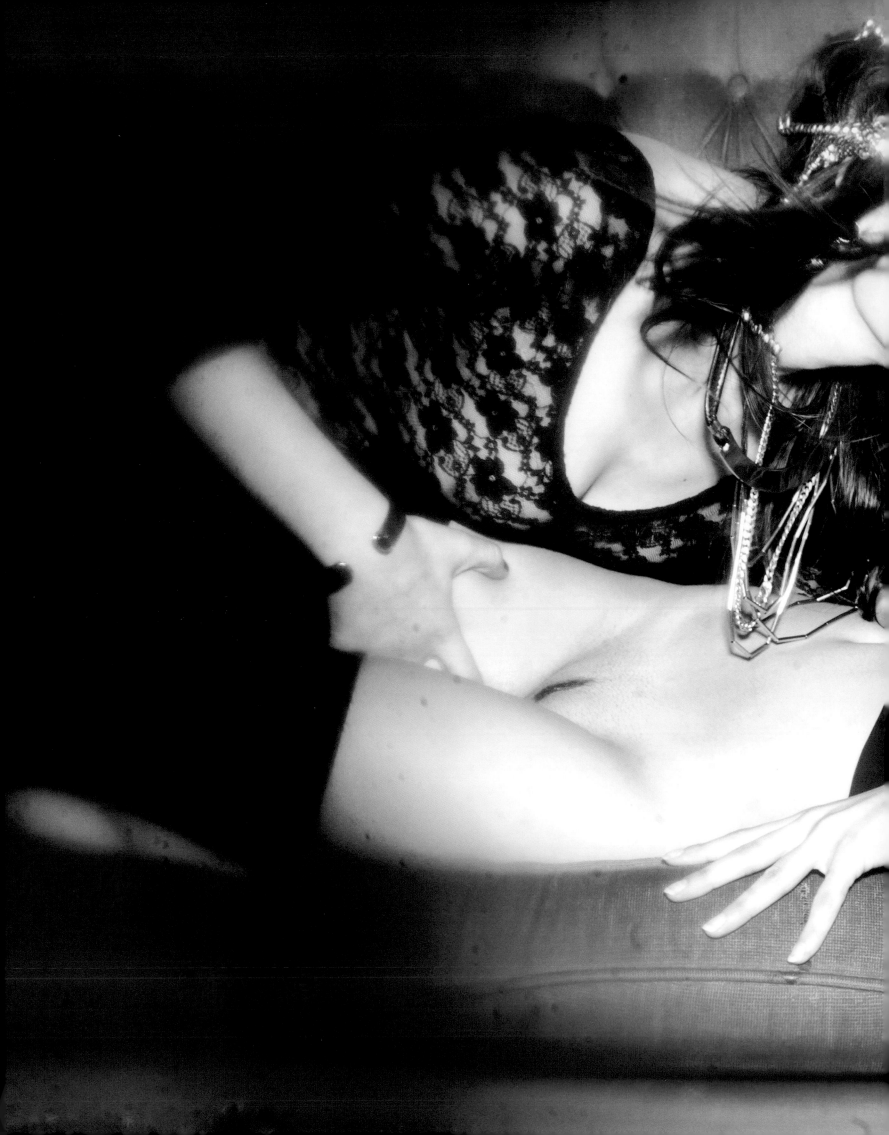

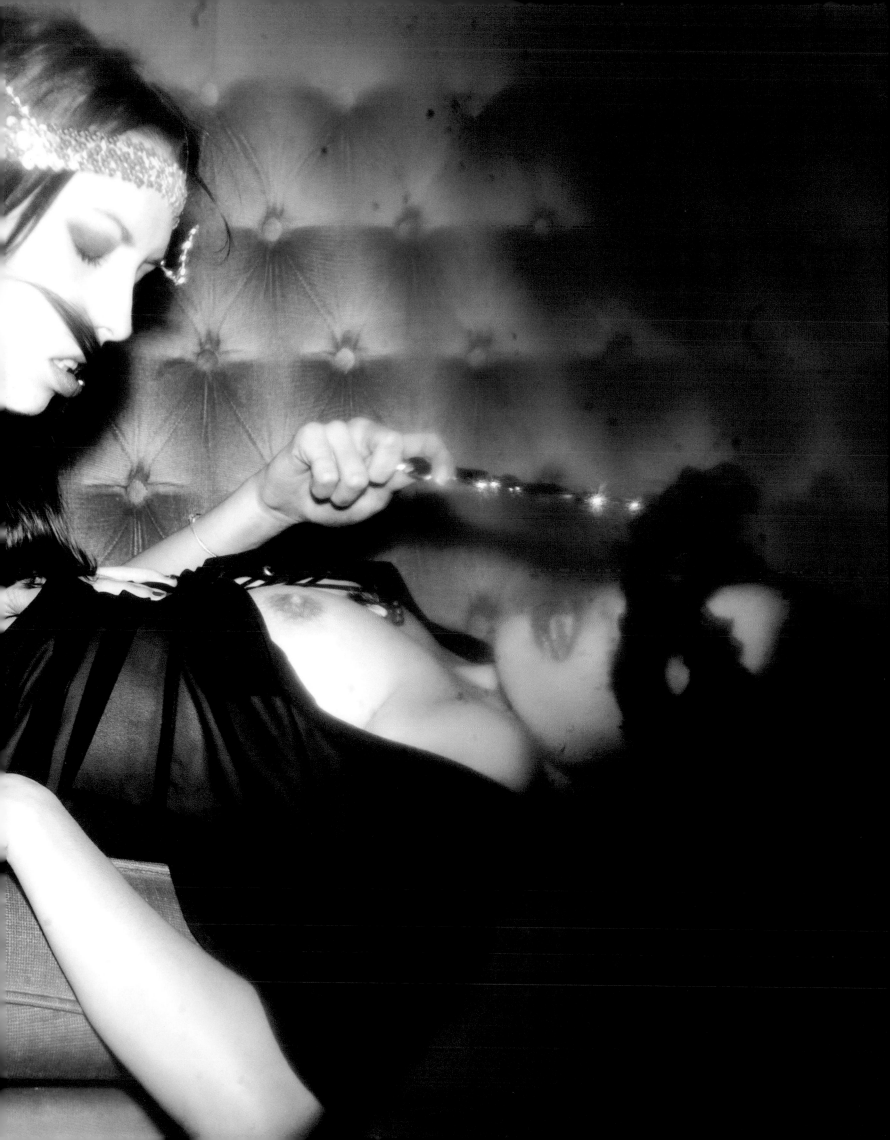

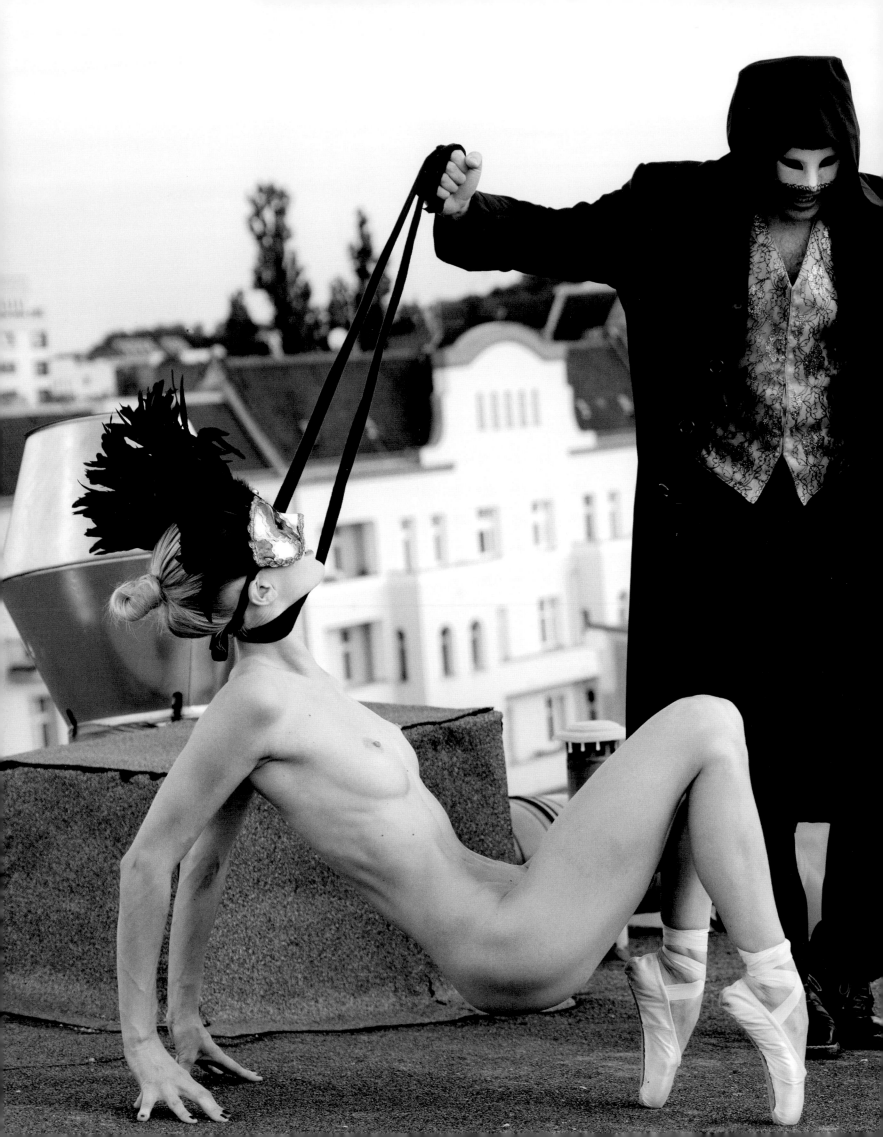

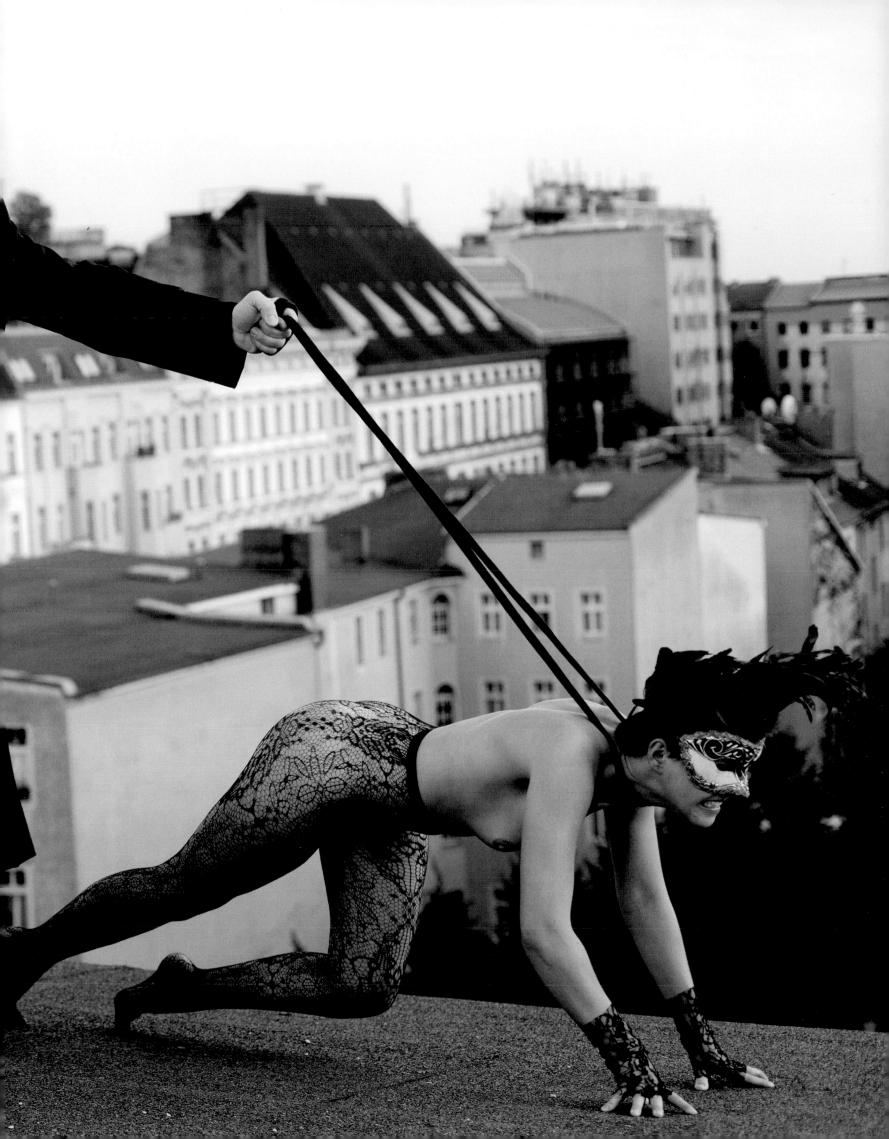

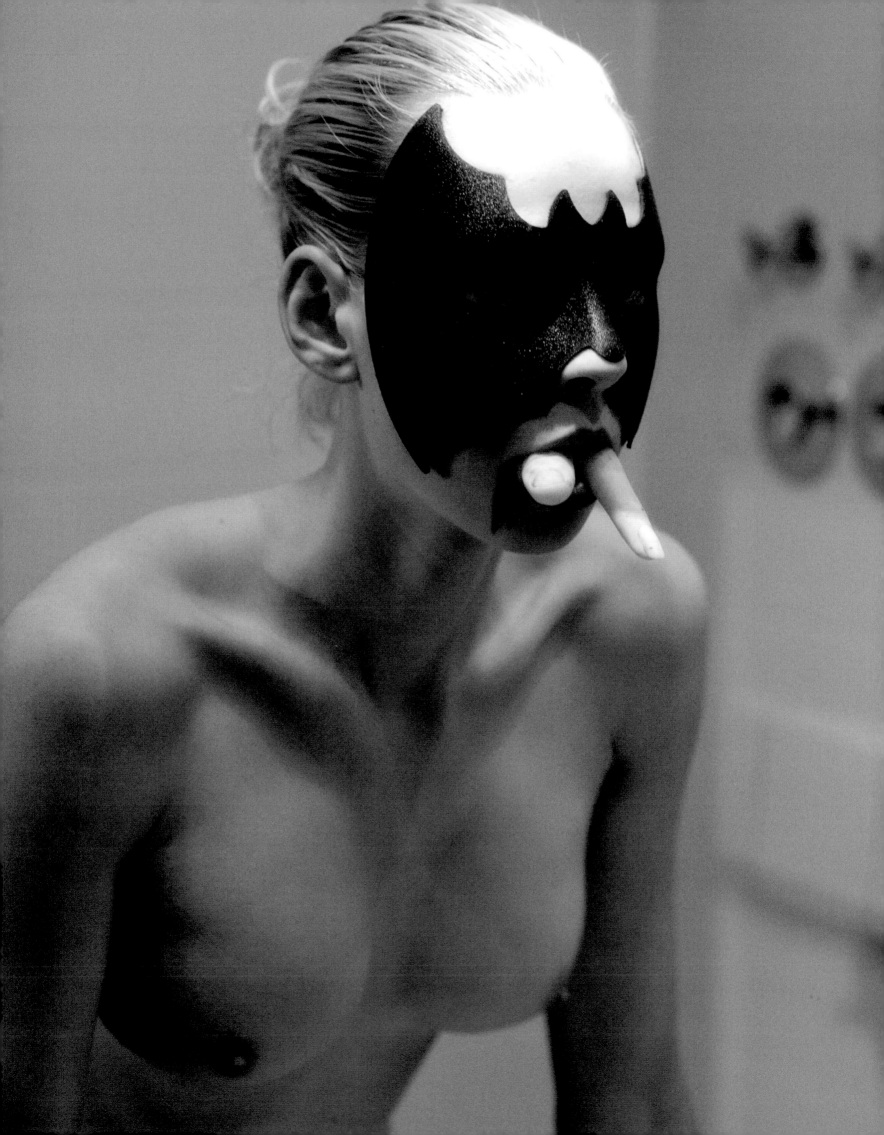

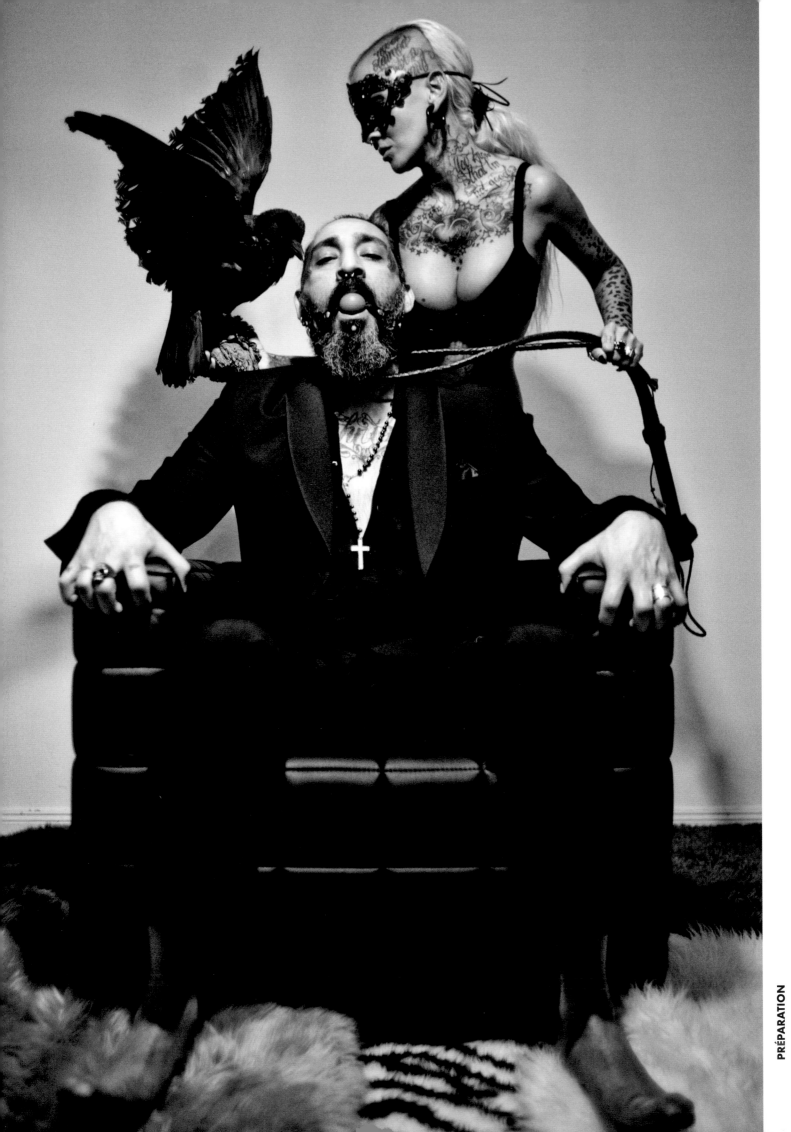

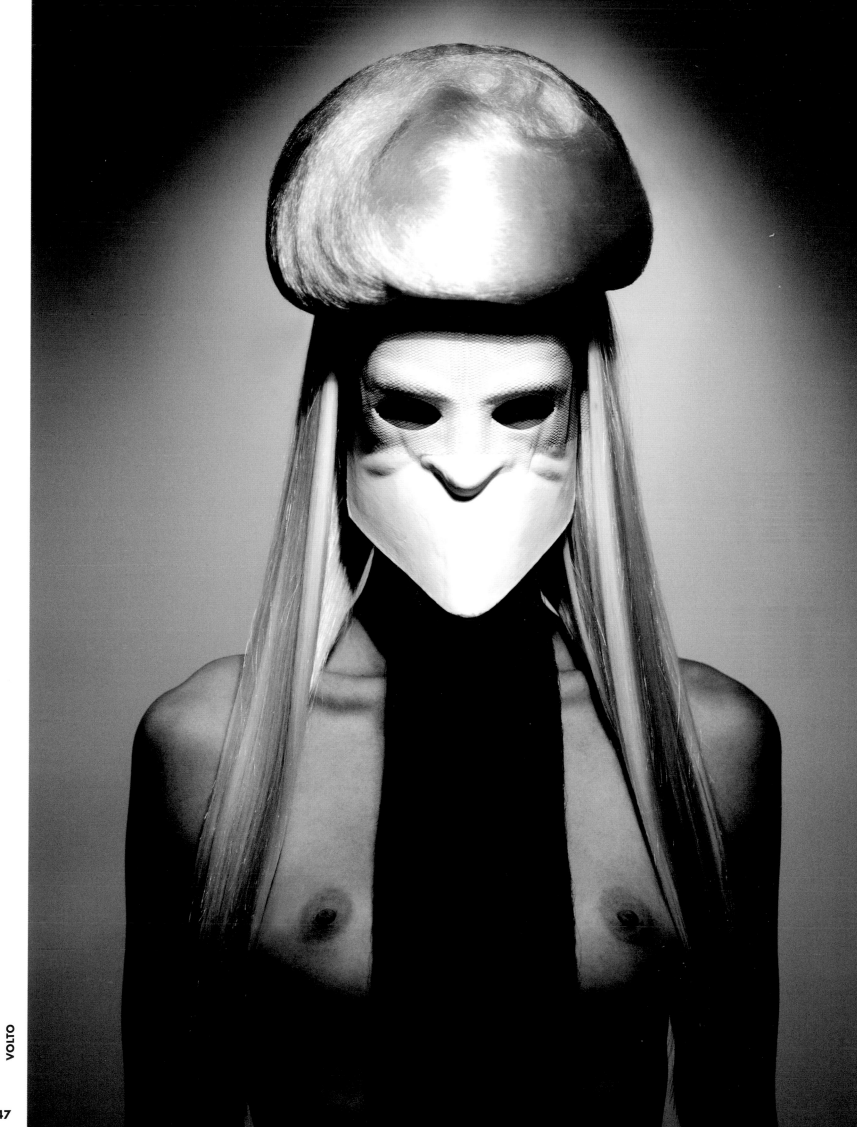

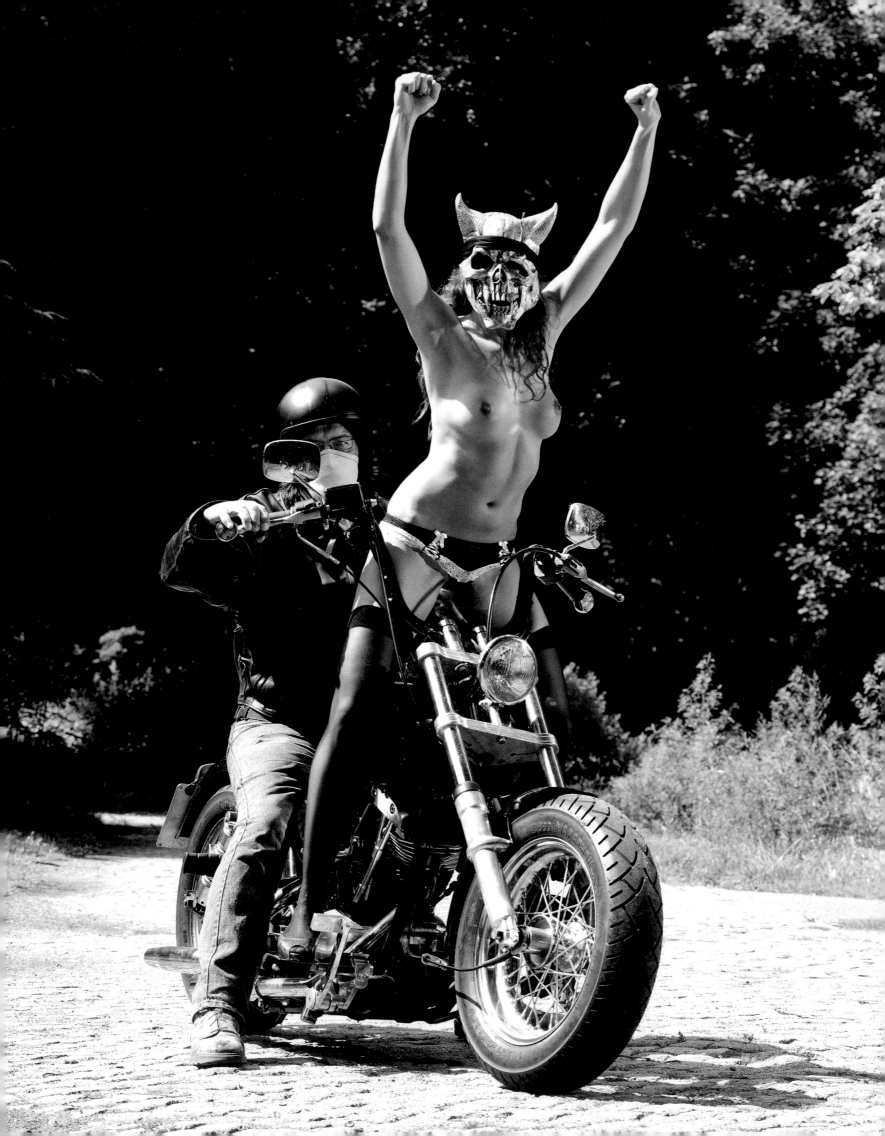

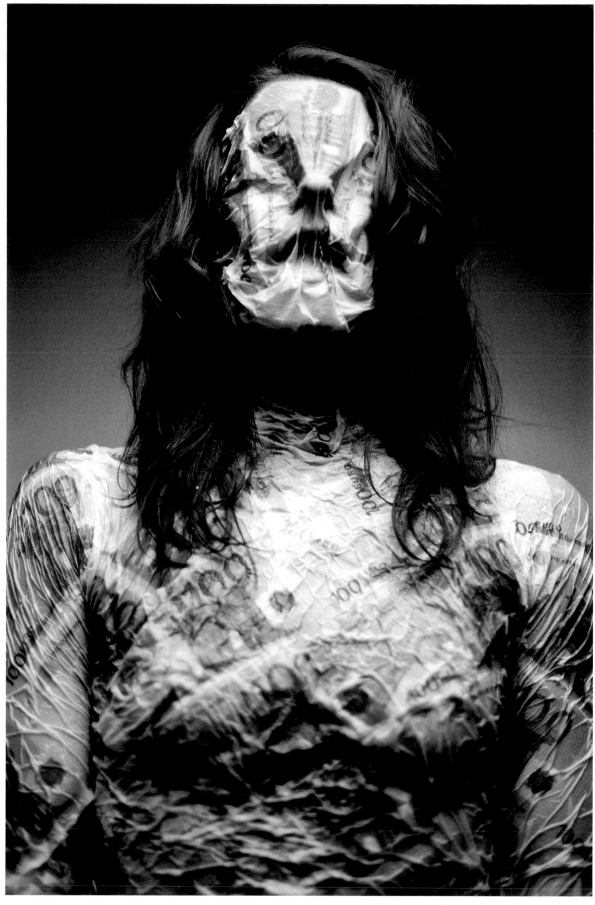

WAS BIN ICH WERT? WHAT AM I WORTH?

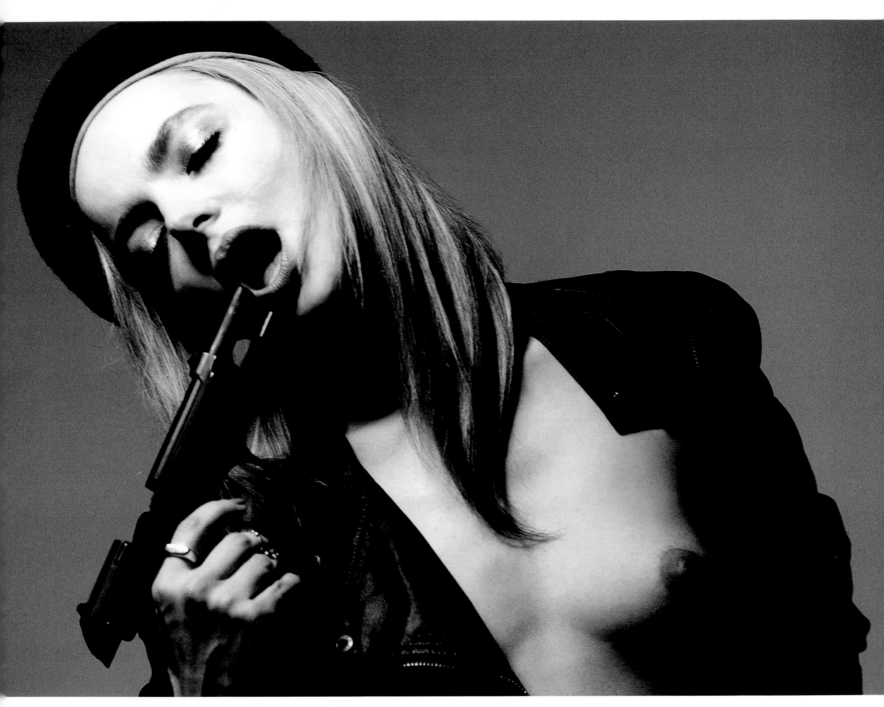

GUNS N'ROSES

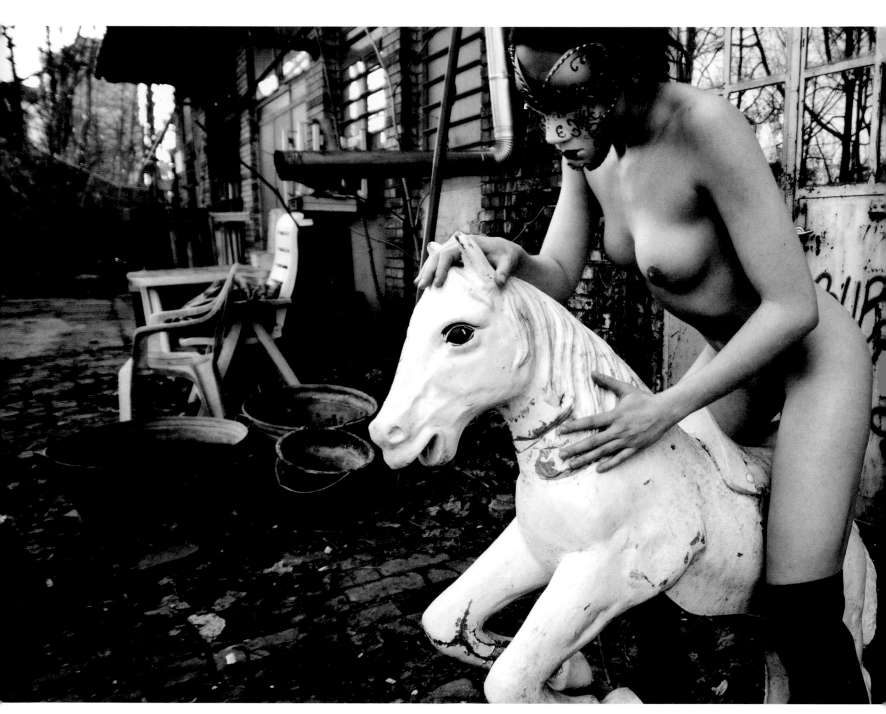

MÄDCHENTRÄUME GIRLS' DREAMS

151

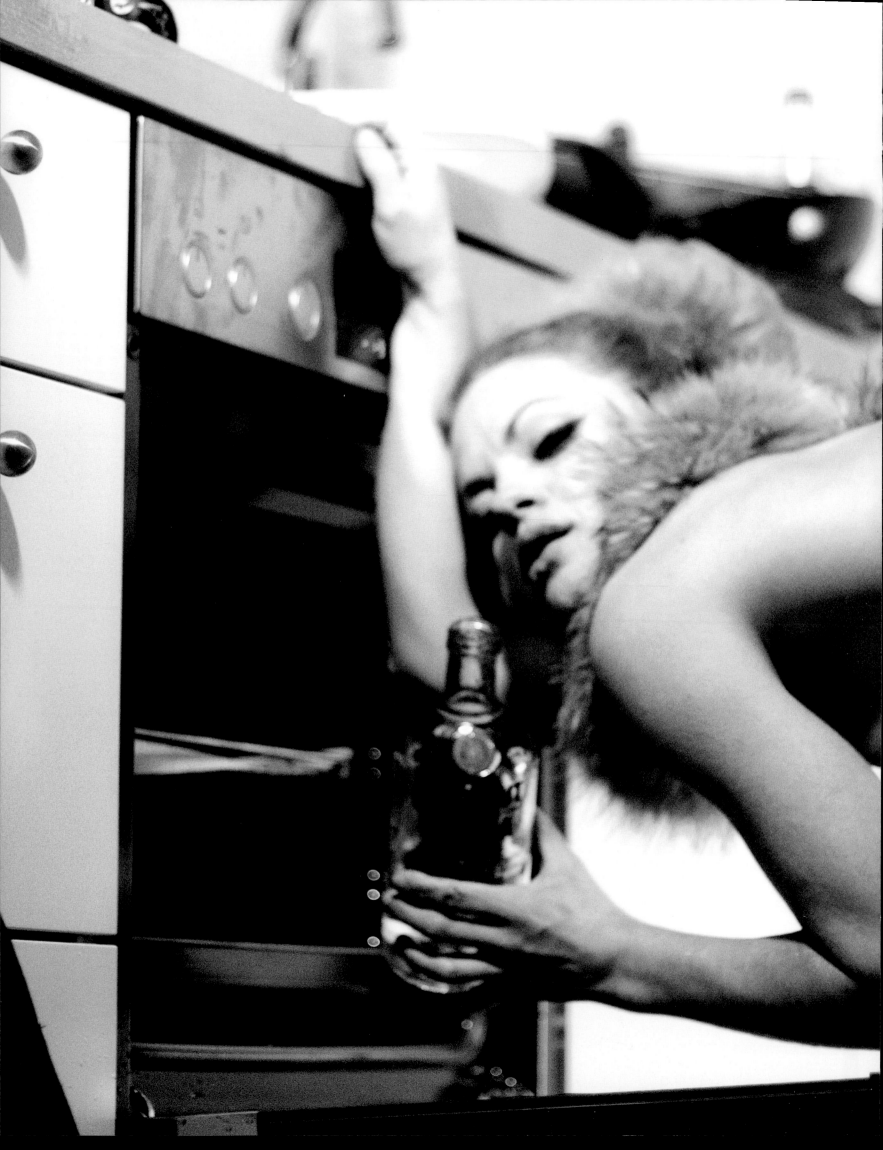

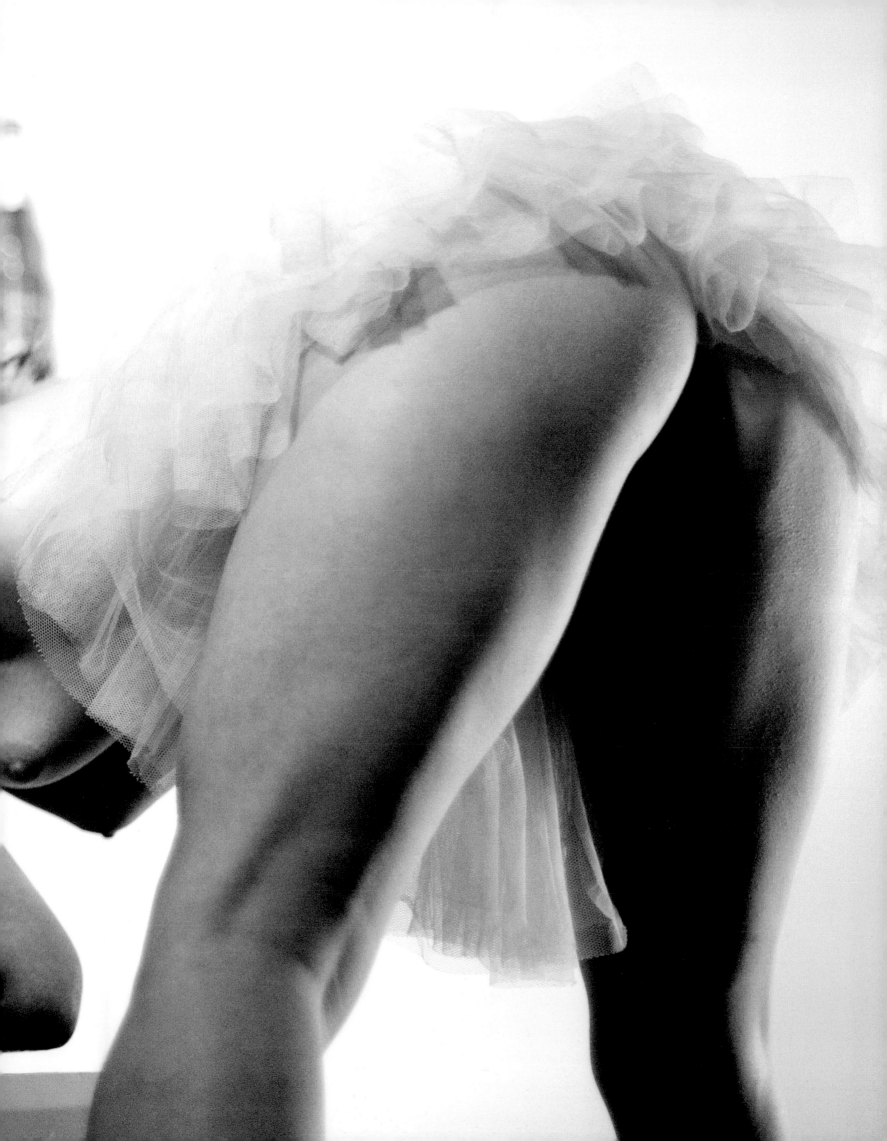

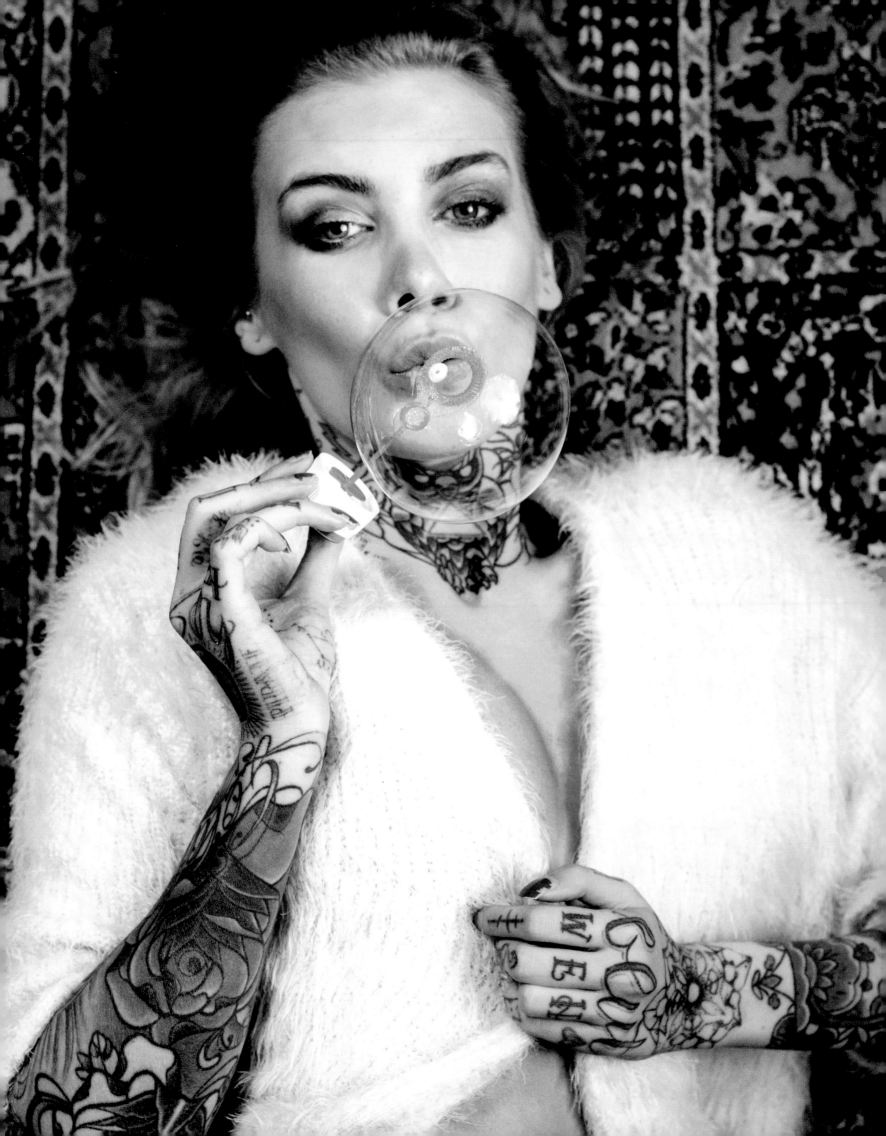

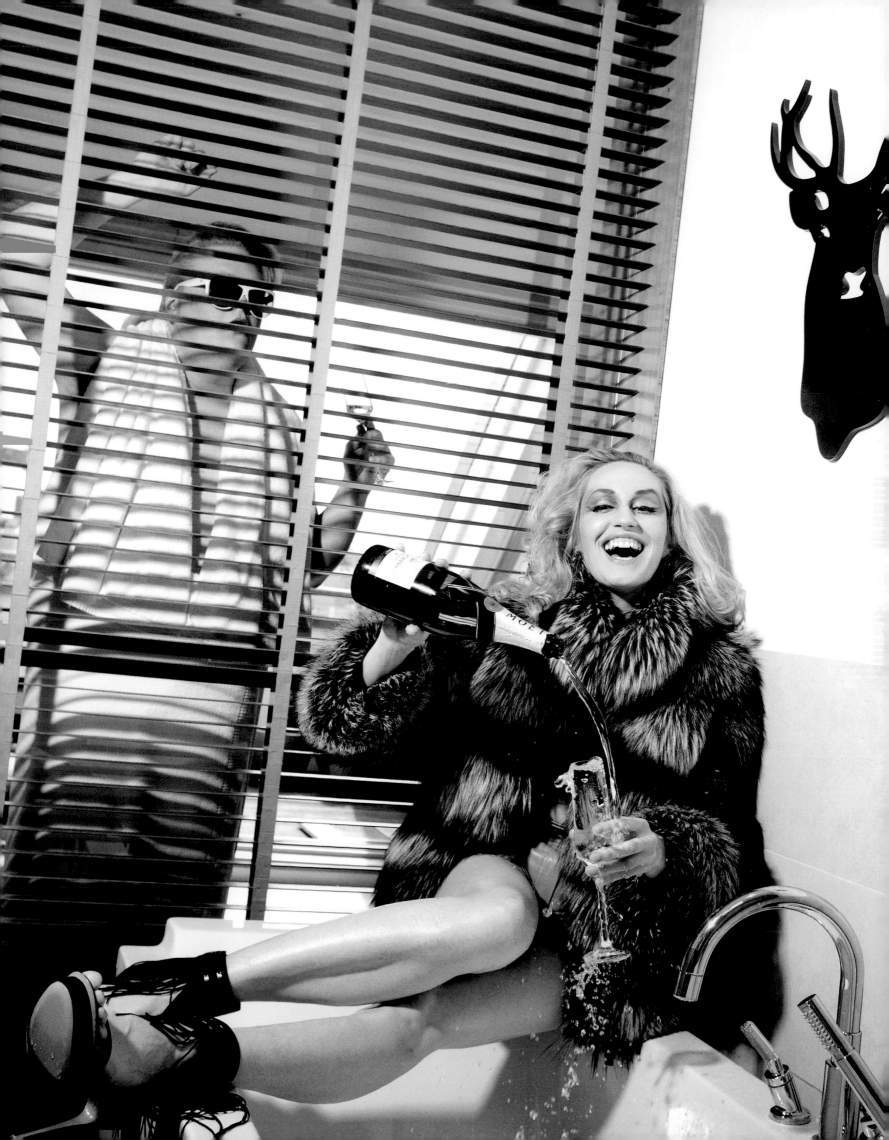

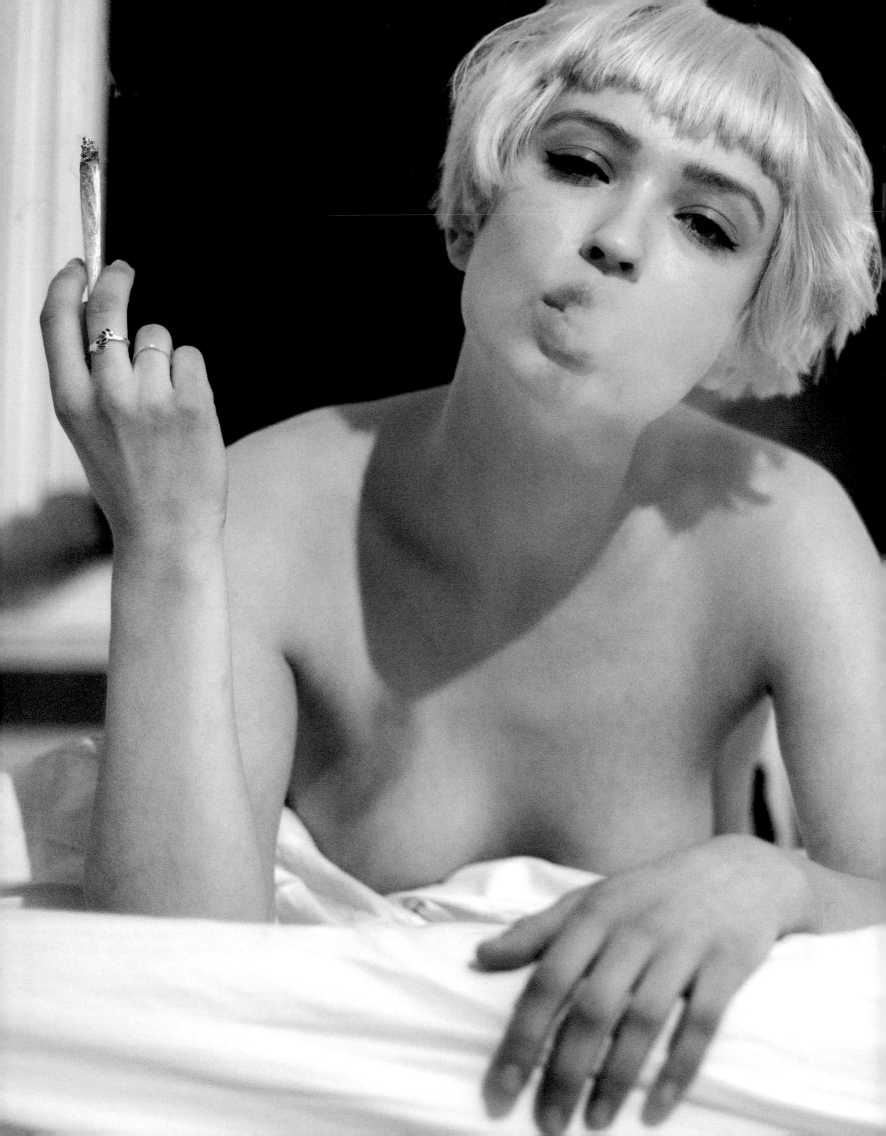

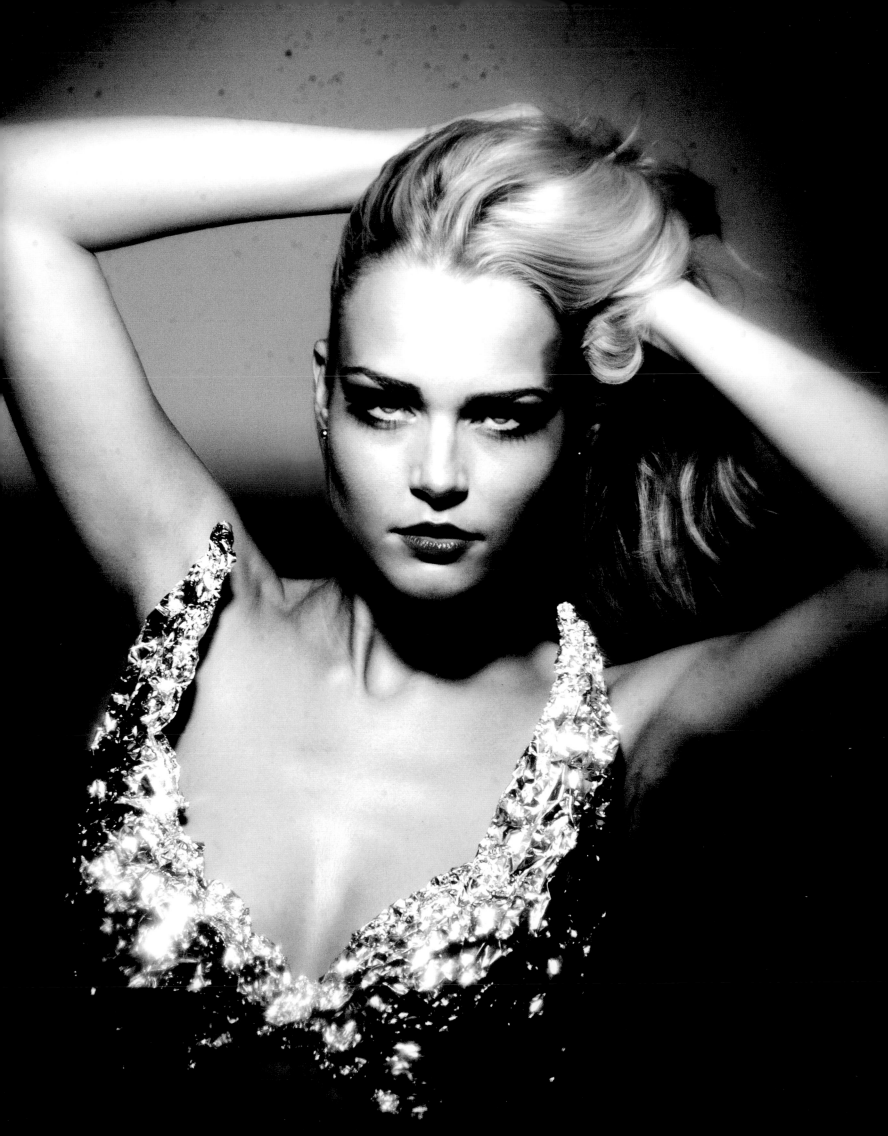

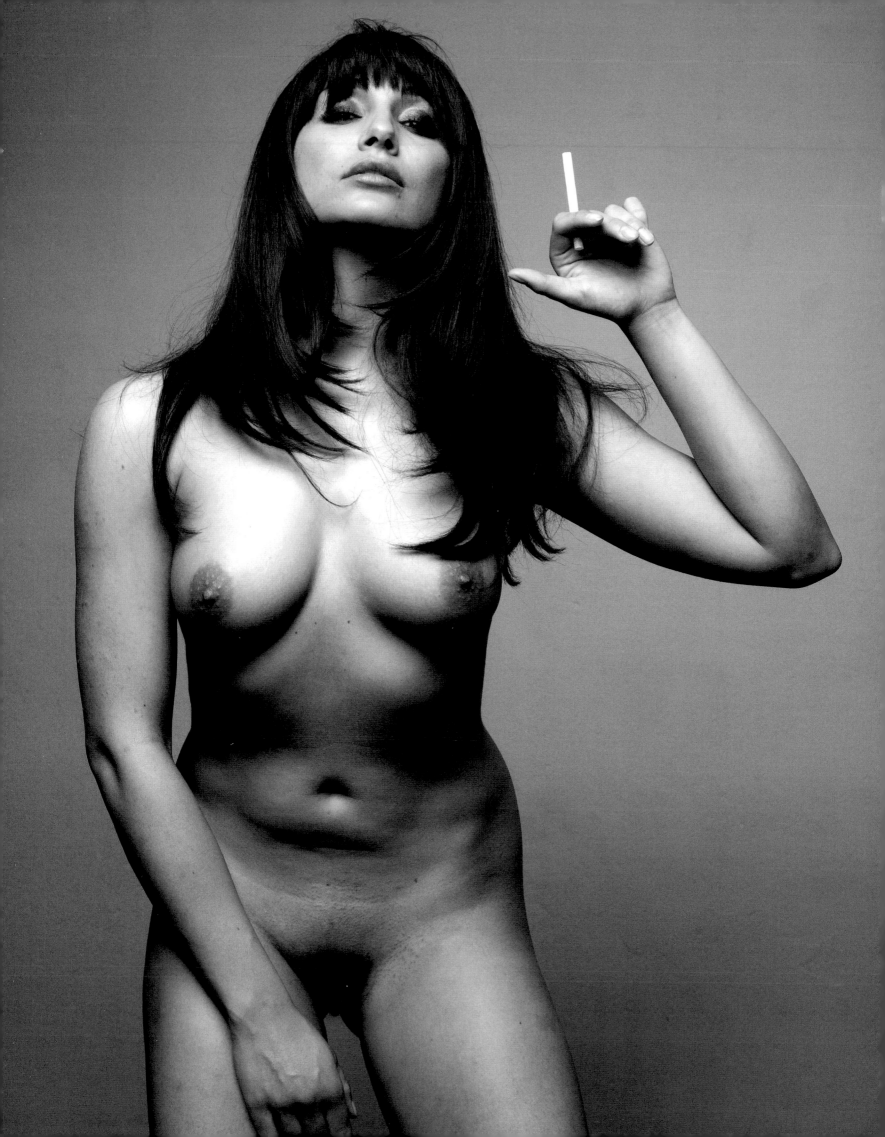

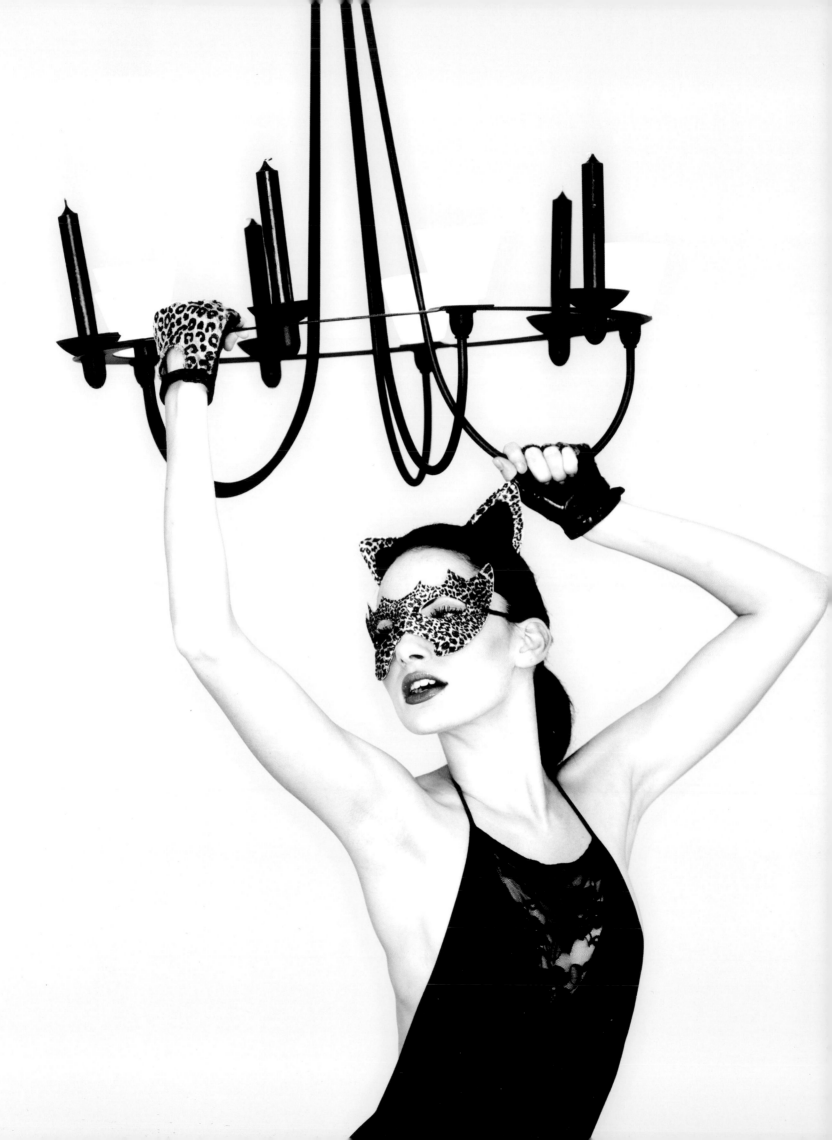

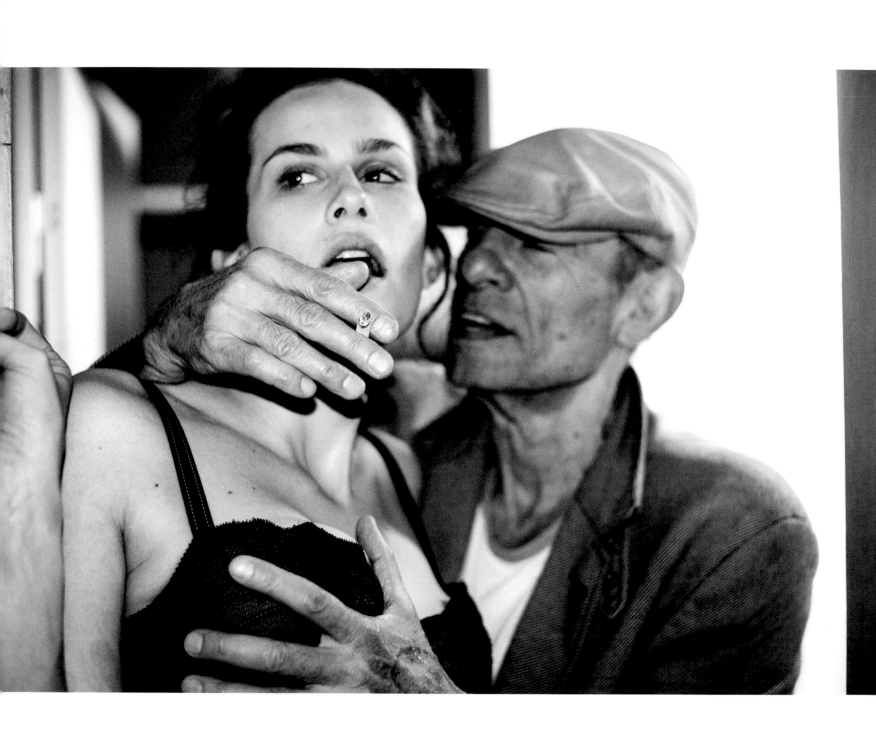

»OLIVER RATH IST EIN SPLITTER VOM PARADIES – ALS MANIACS WIE ER
FOTOS NICHT KLAUTEN: SONDERN FÜR SIE NOCH GEKÄMPFT HABEN«.
KLAUS LEMKE

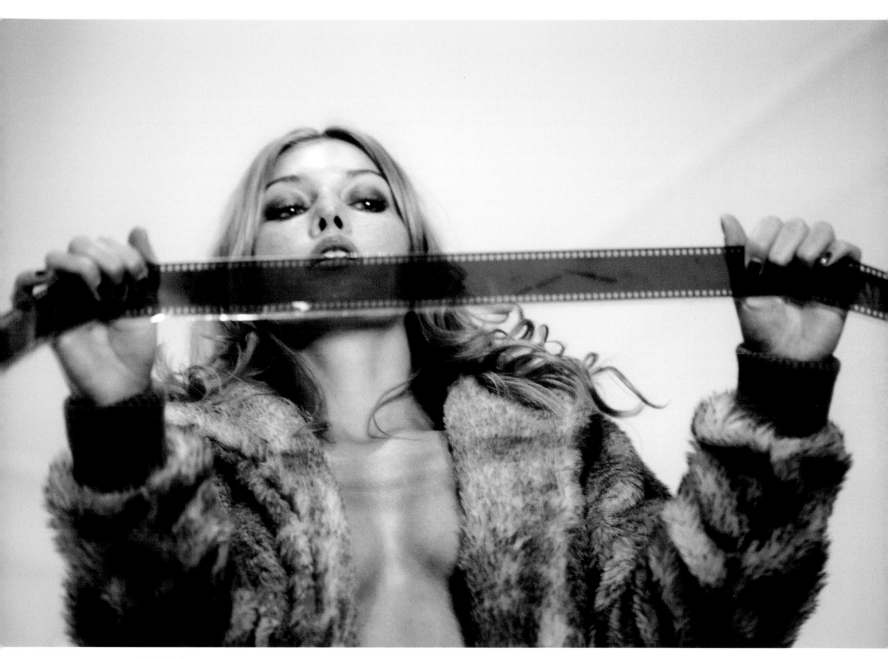

ANNA LOG

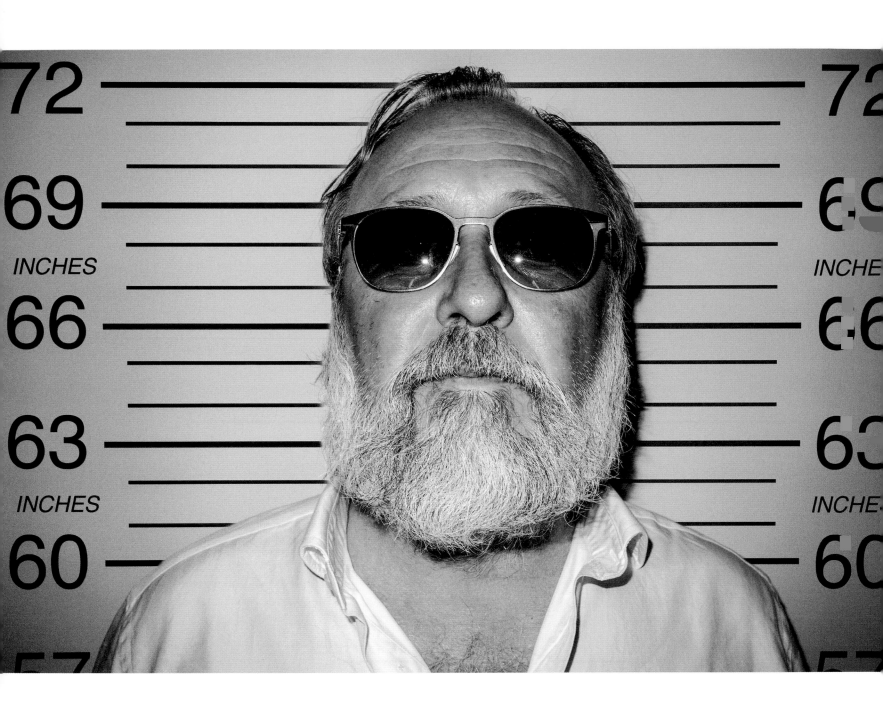

»SEXY.«
FRIEDRICH LIECHTENSTEIN

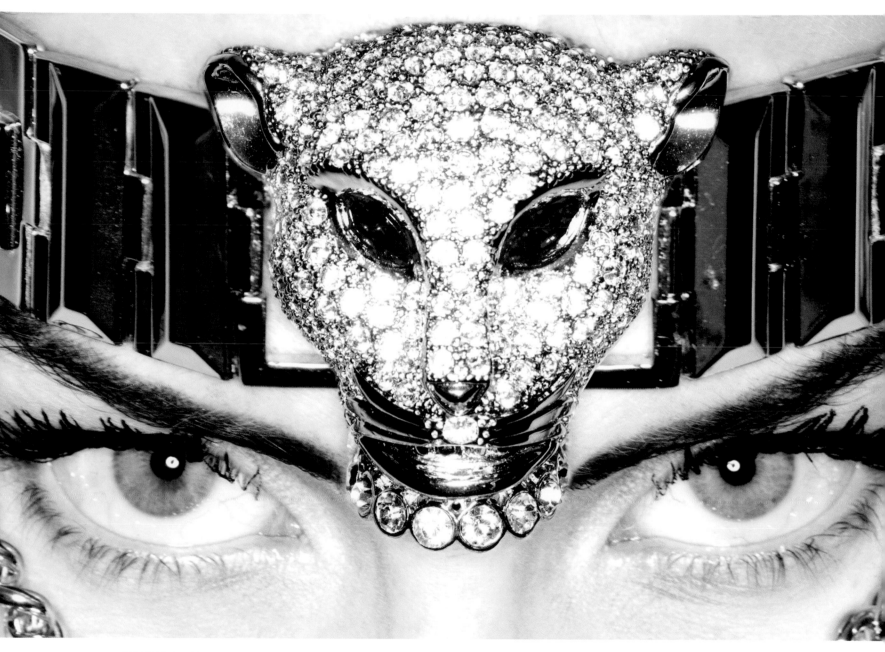

EYE OF THE TIGER

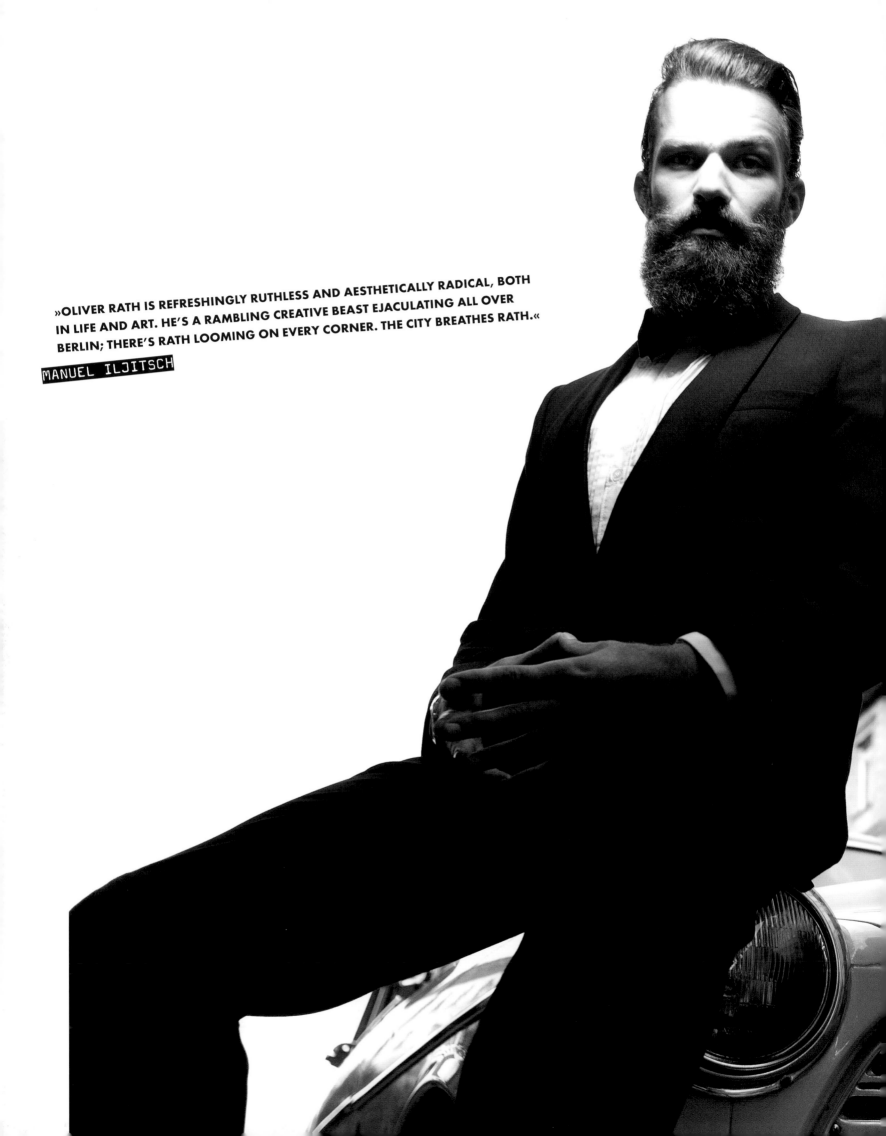

»OLIVER RATH IS REFRESHINGLY RUTHLESS AND AESTHETICALLY RADICAL, BOTH IN LIFE AND ART. HE'S A RAMBLING CREATIVE BEAST EJACULATING ALL OVER BERLIN; THERE'S RATH LOOMING ON EVERY CORNER. THE CITY BREATHES RATH.«

MANUEL ILJITSCH

DU DARFST MAL KURZ LUFT SCHNAPPEN

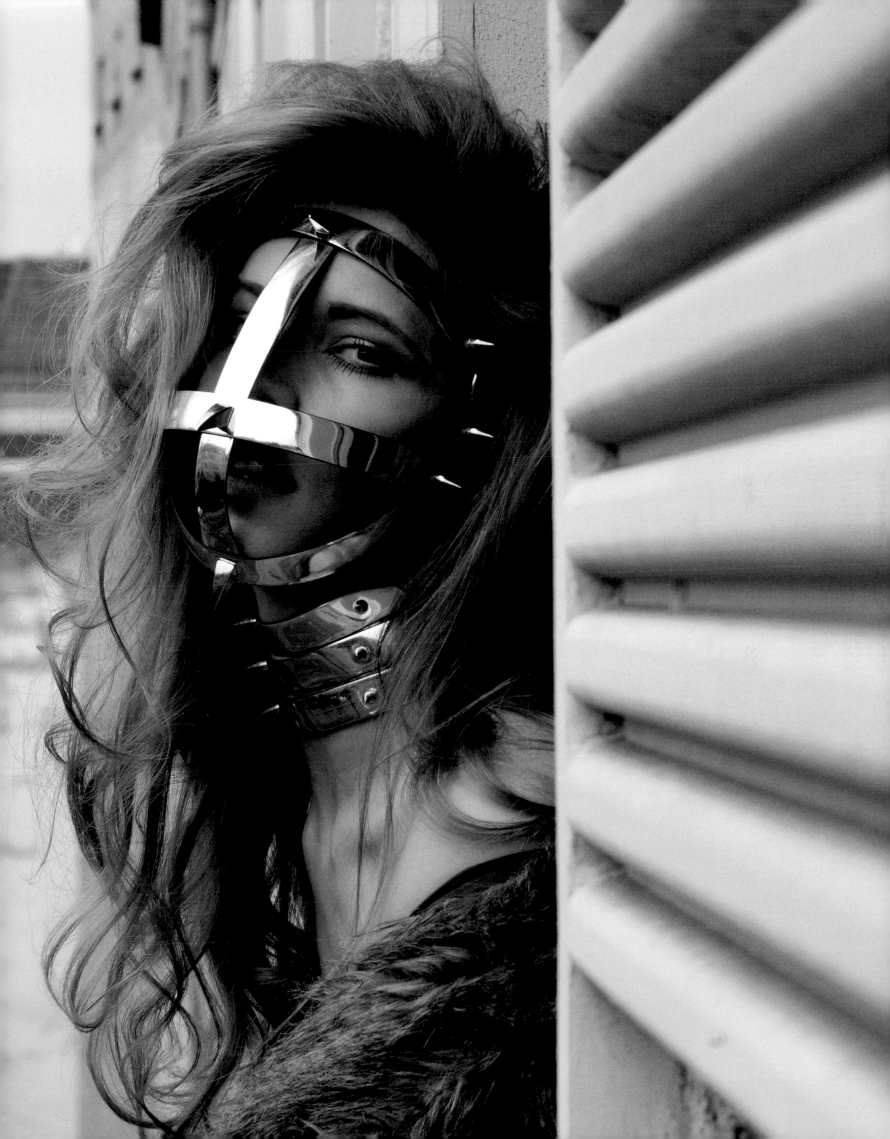

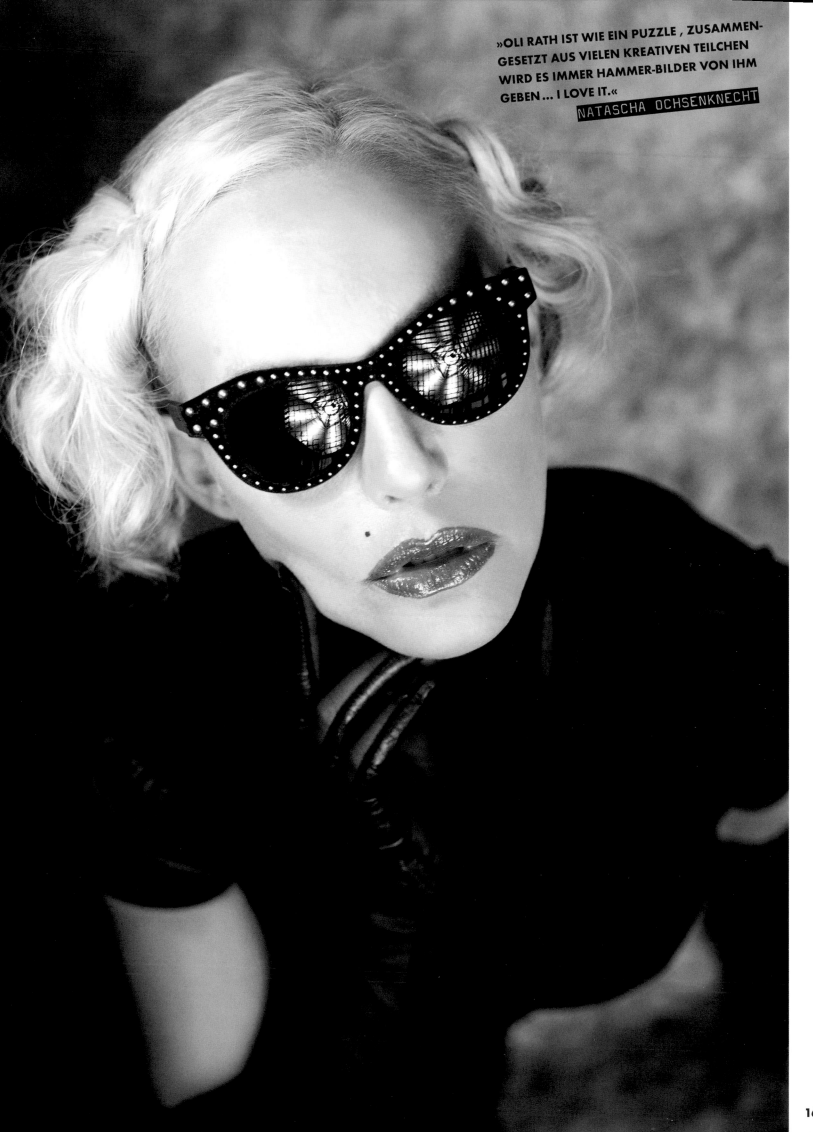

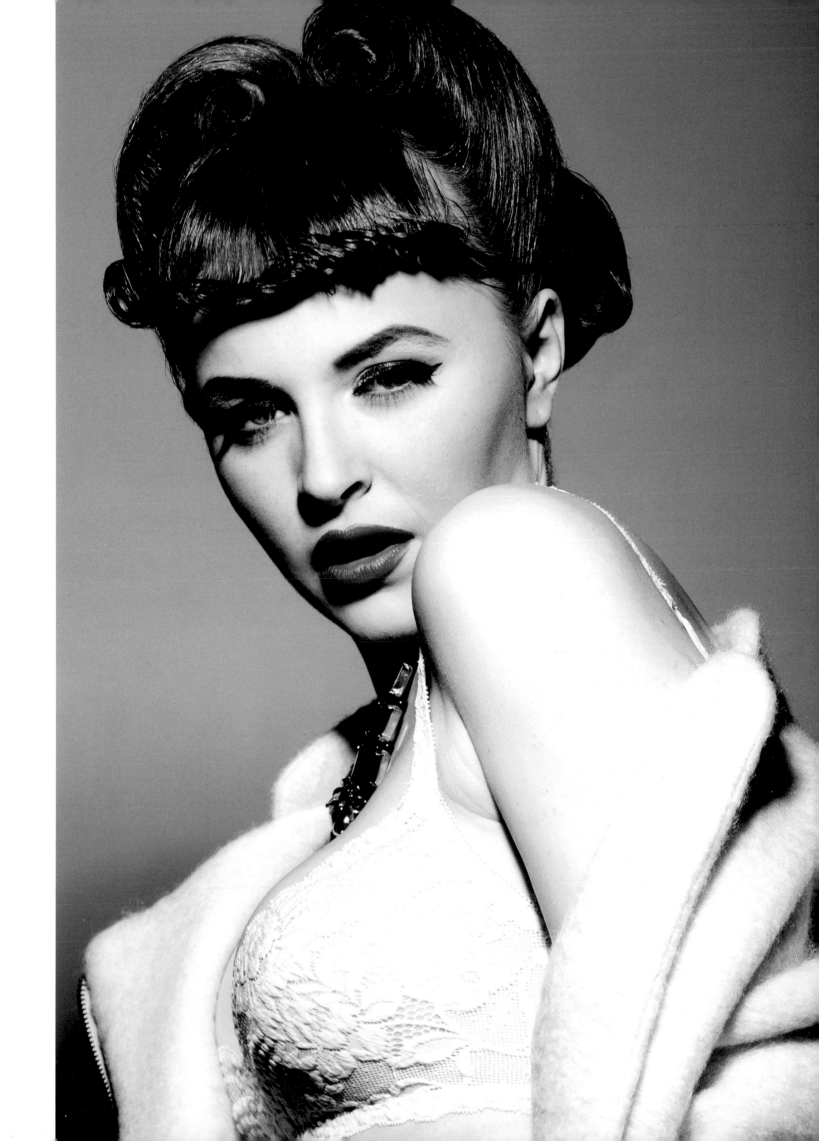

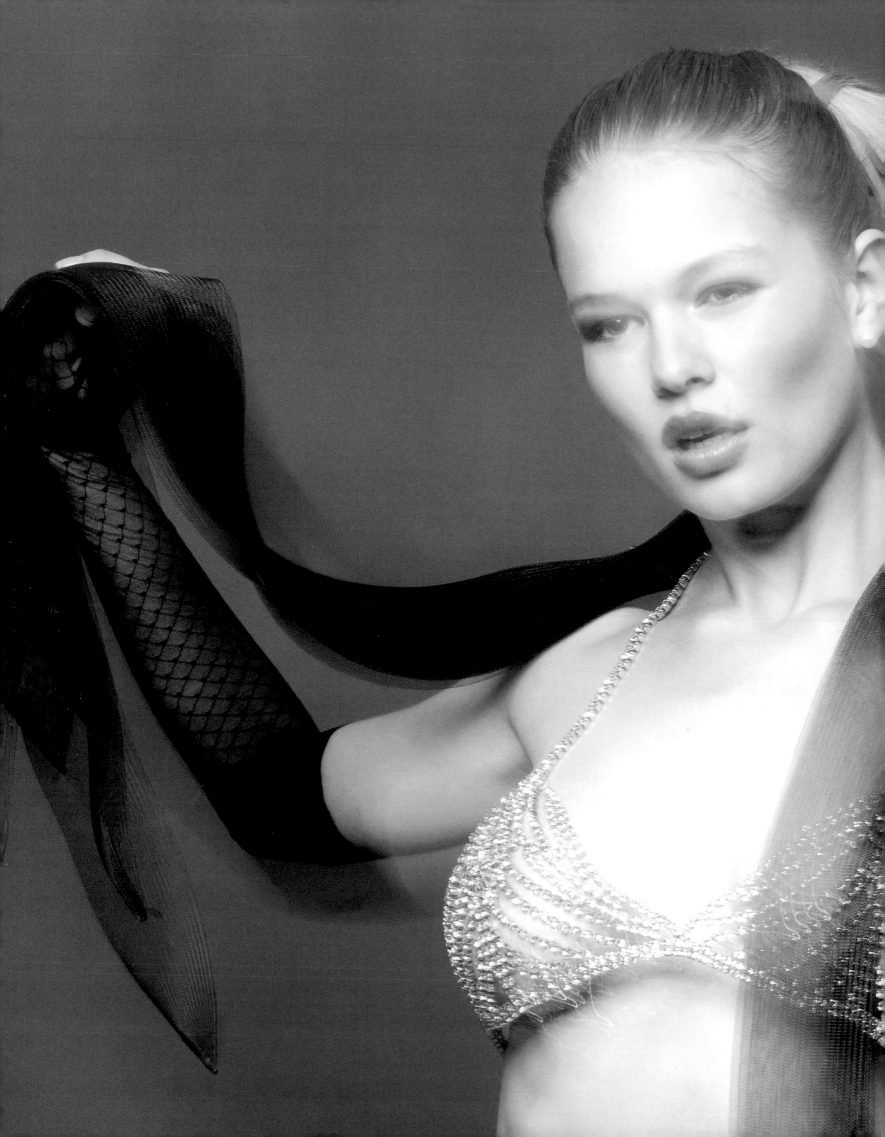

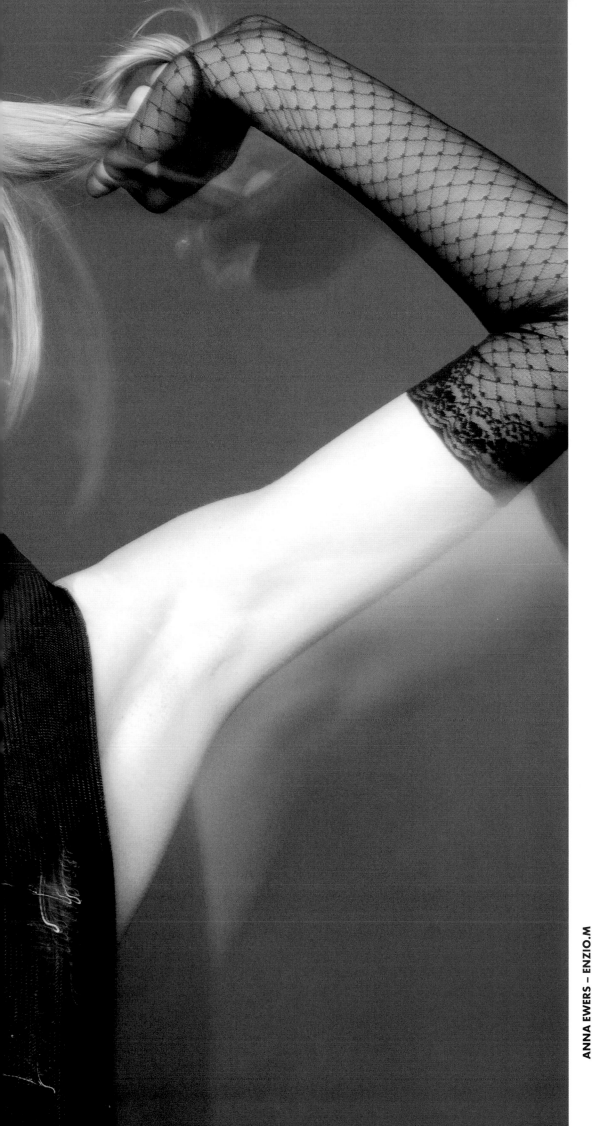

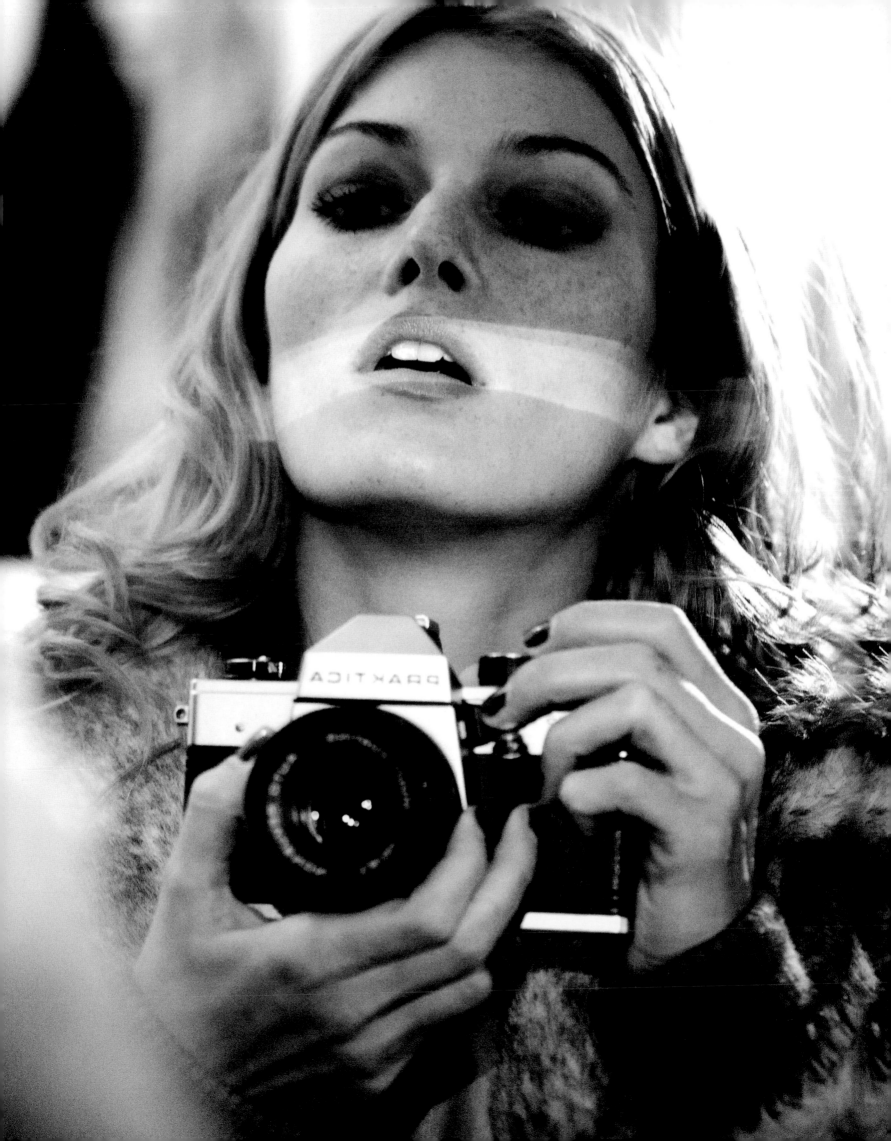

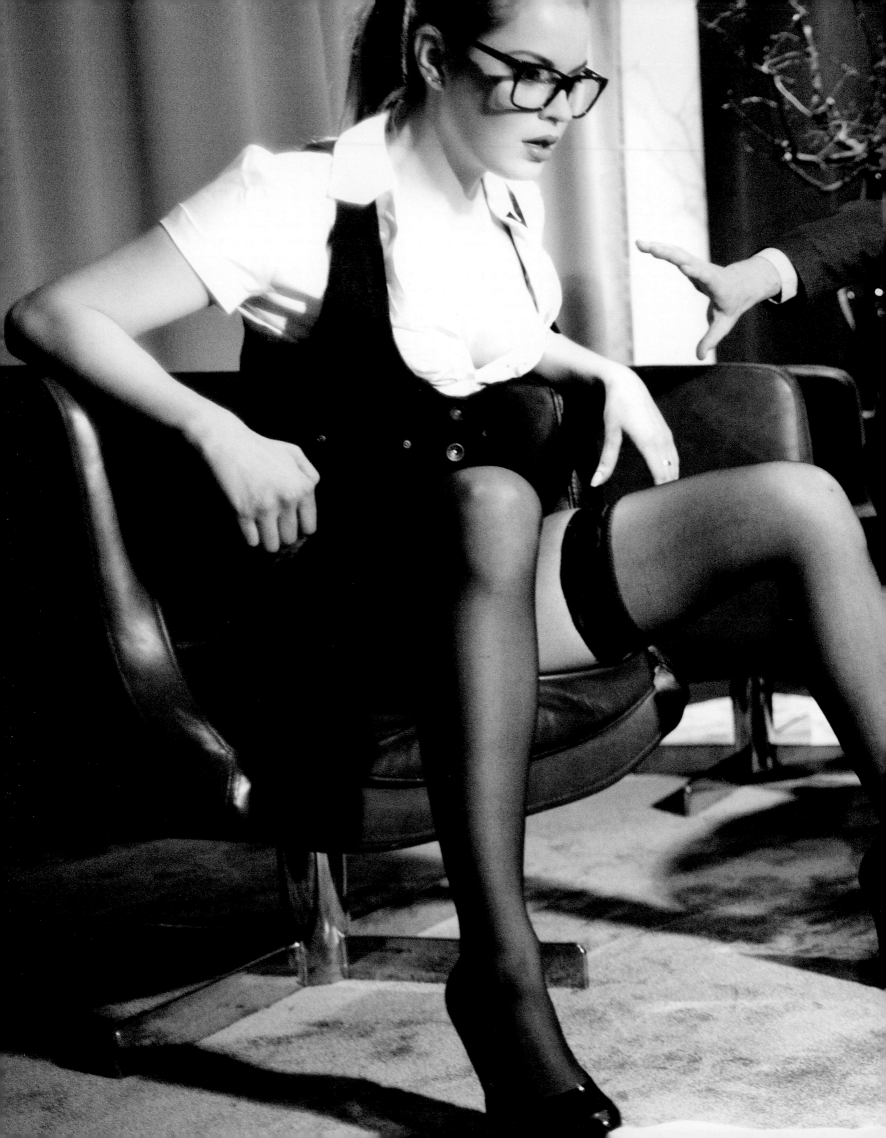

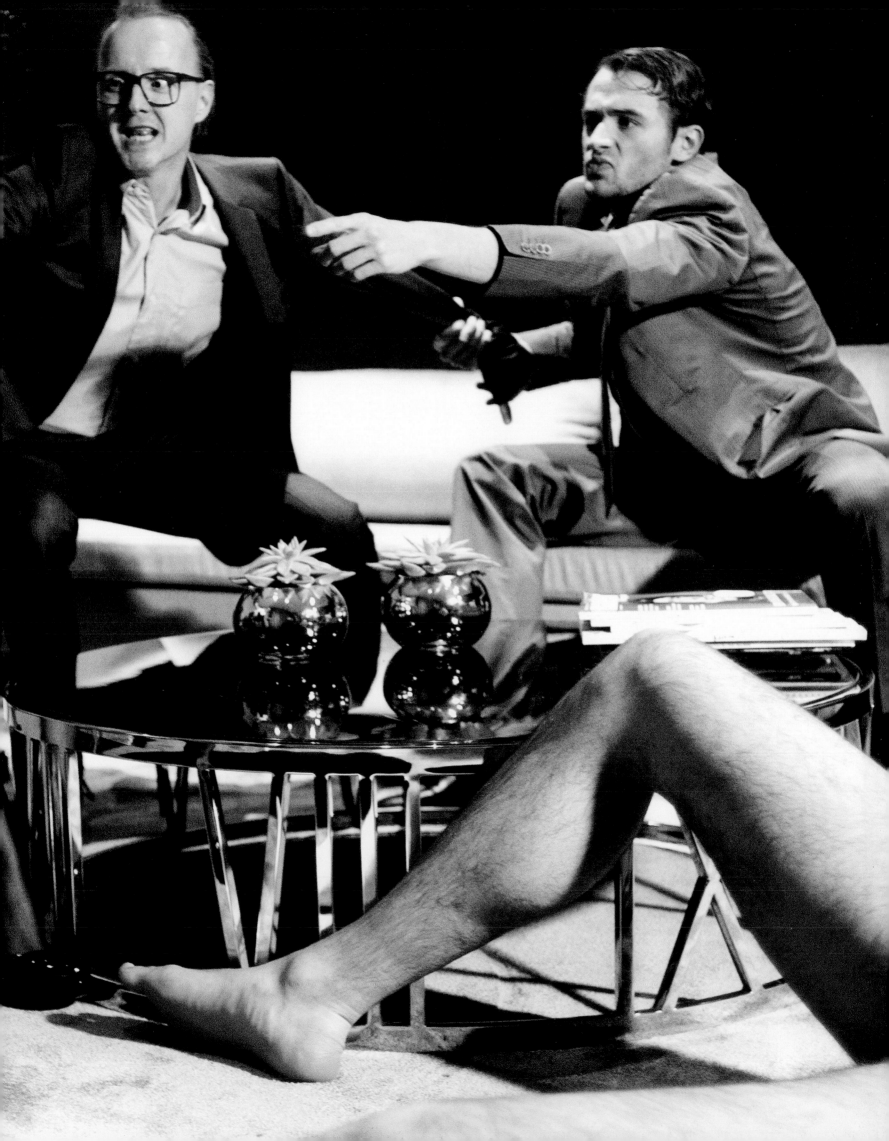

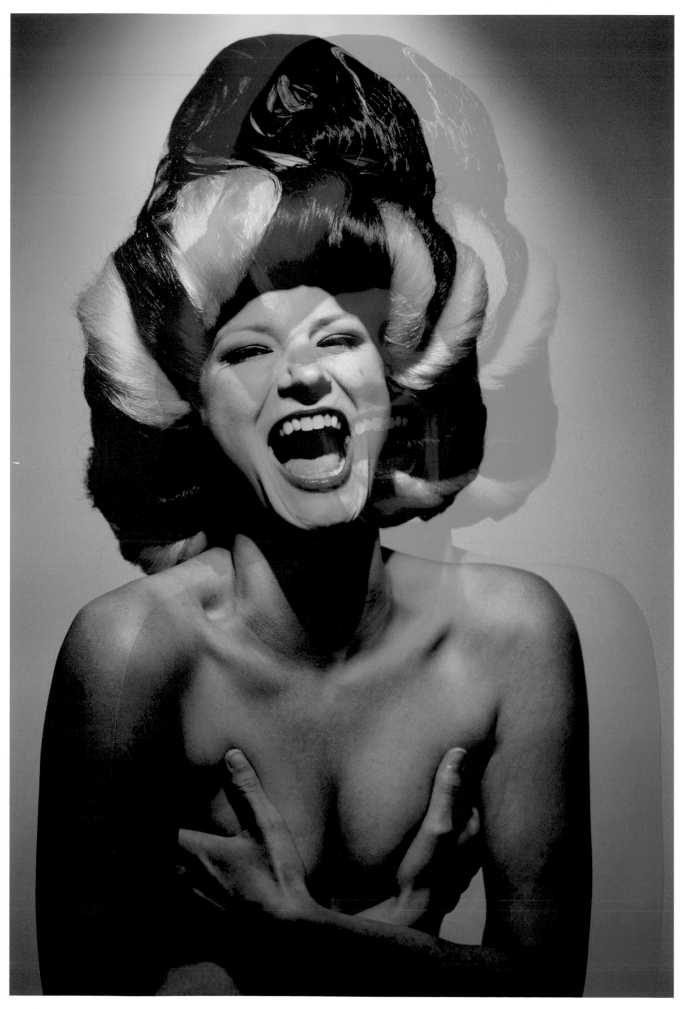

BLASPHEMY

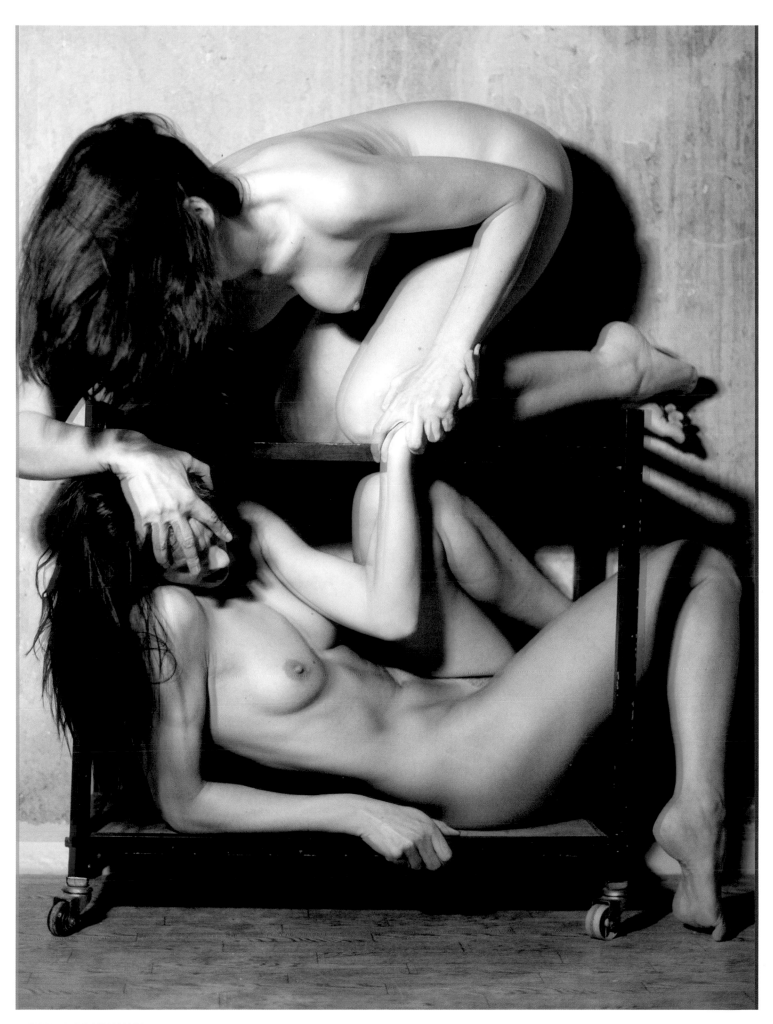

ZICKENKRIEG BITCH WAR

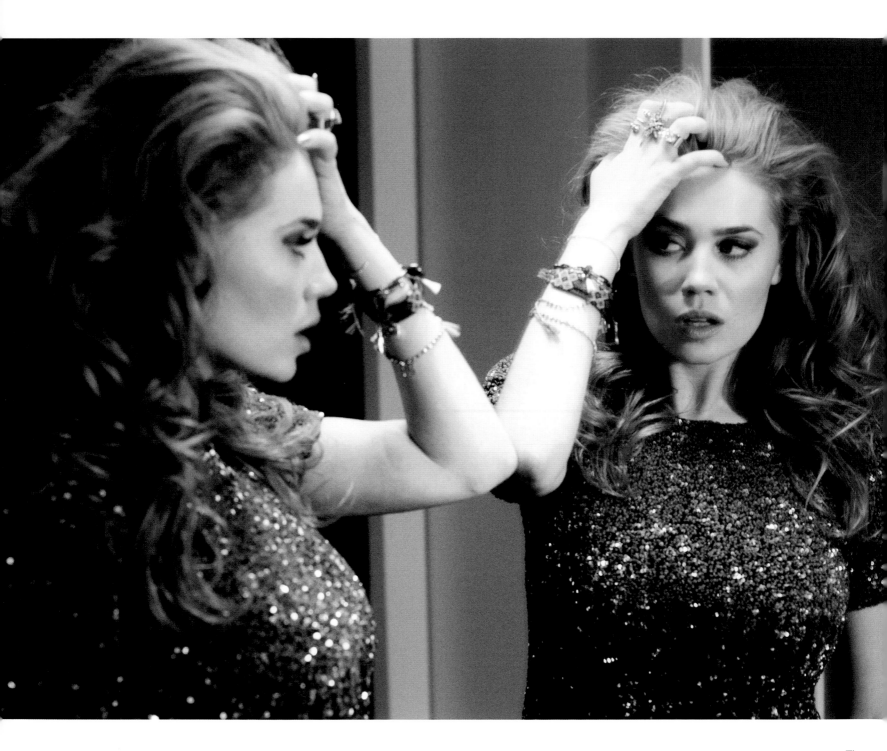

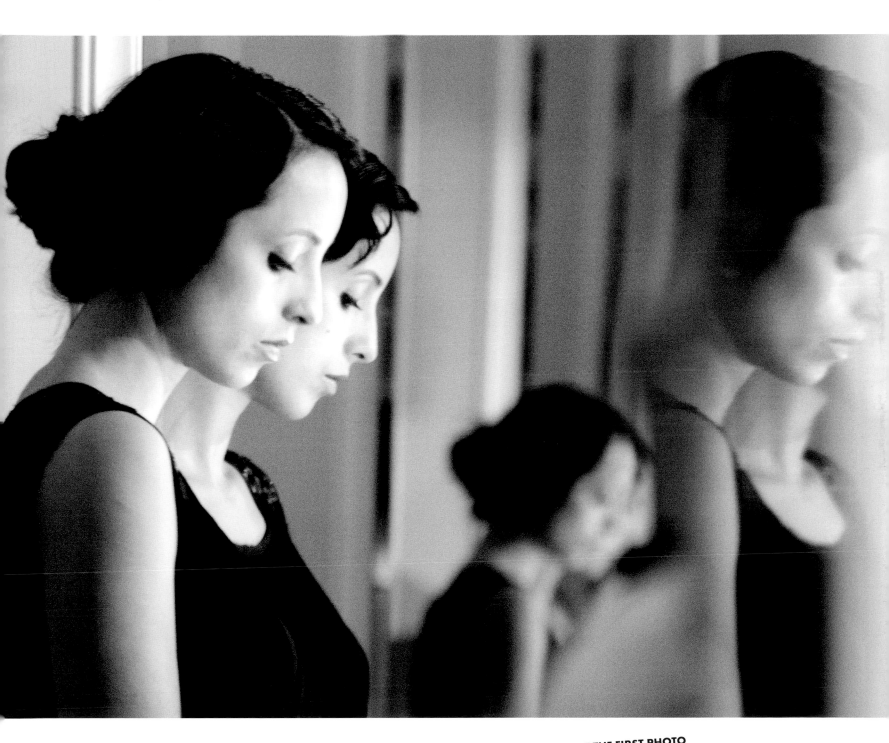

»OLI IS A PHENOMENON. LOOKING AT HIM FROM THE OUTSIDE, YOU MIGHT THINK HE'S CRAZY. AT THE FIRST PHOTO SESSIONS, I WAS THINKING HE'S NEVER GOING TO MAKE IT ON TIME. I WAS WRONG. HE PUNCTUALLY OPENED THE DOOR TO ME EVERY TIME, AND HAD A CLEAR IDEA OF WHAT HE WANTED. YOU CAN RELY ON HIM. ALSO ON HIS TALENT AND OPEN-HEARTED MANNER. IN THE MEANTIME, WORKING WITH OLI IS LIKE COMING HOME.«

STEPHANIE STUMPH

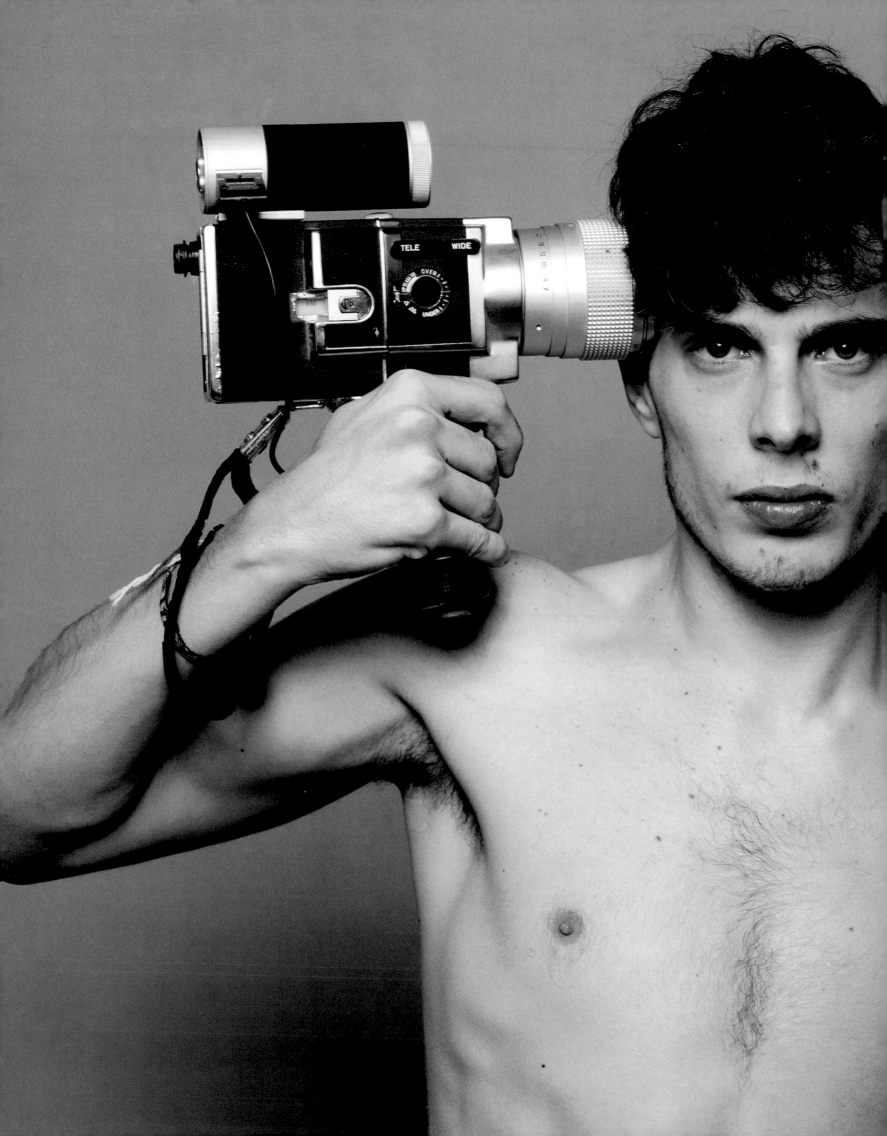

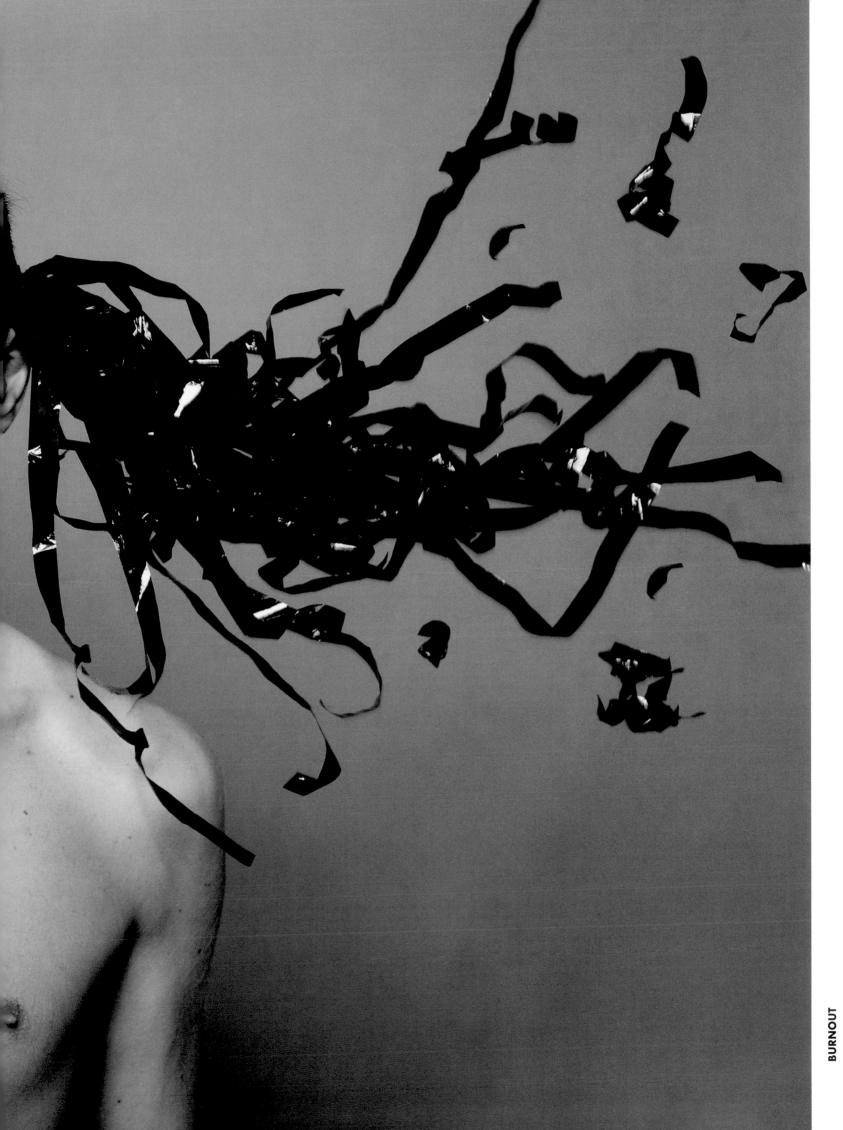

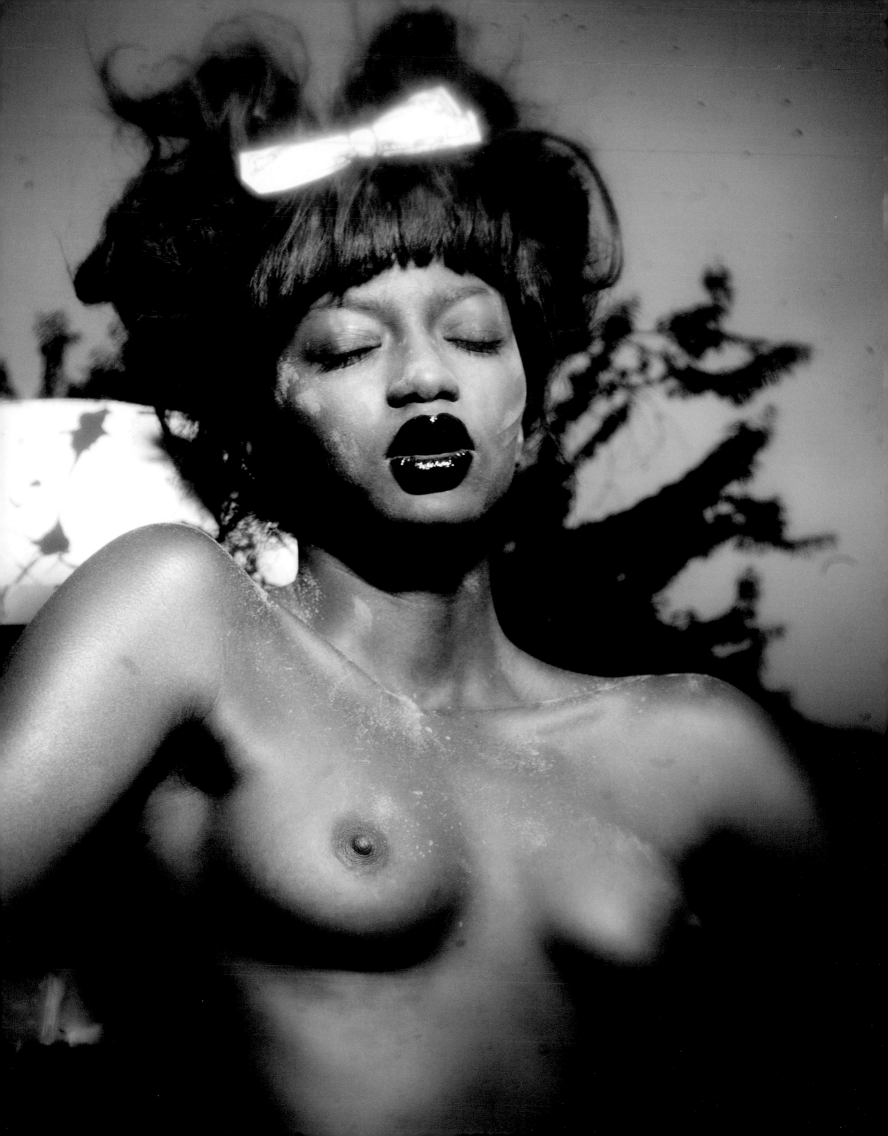

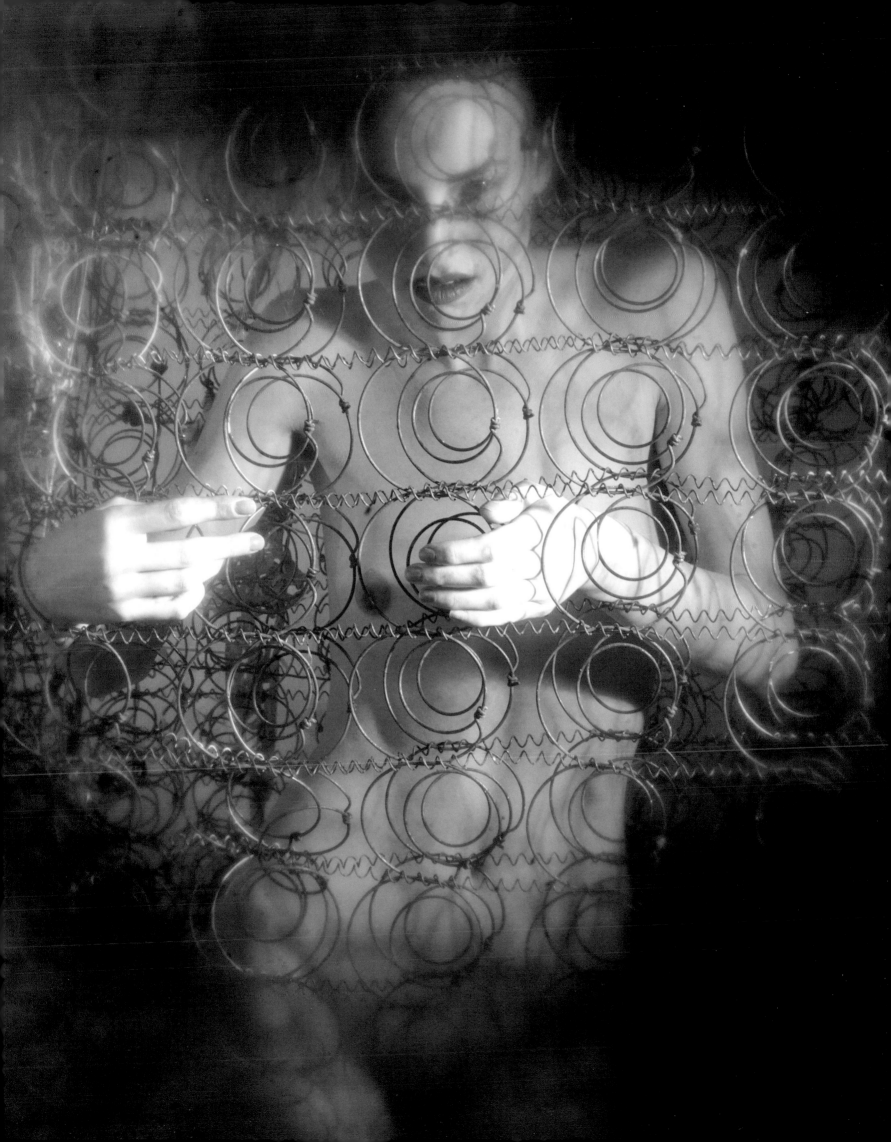

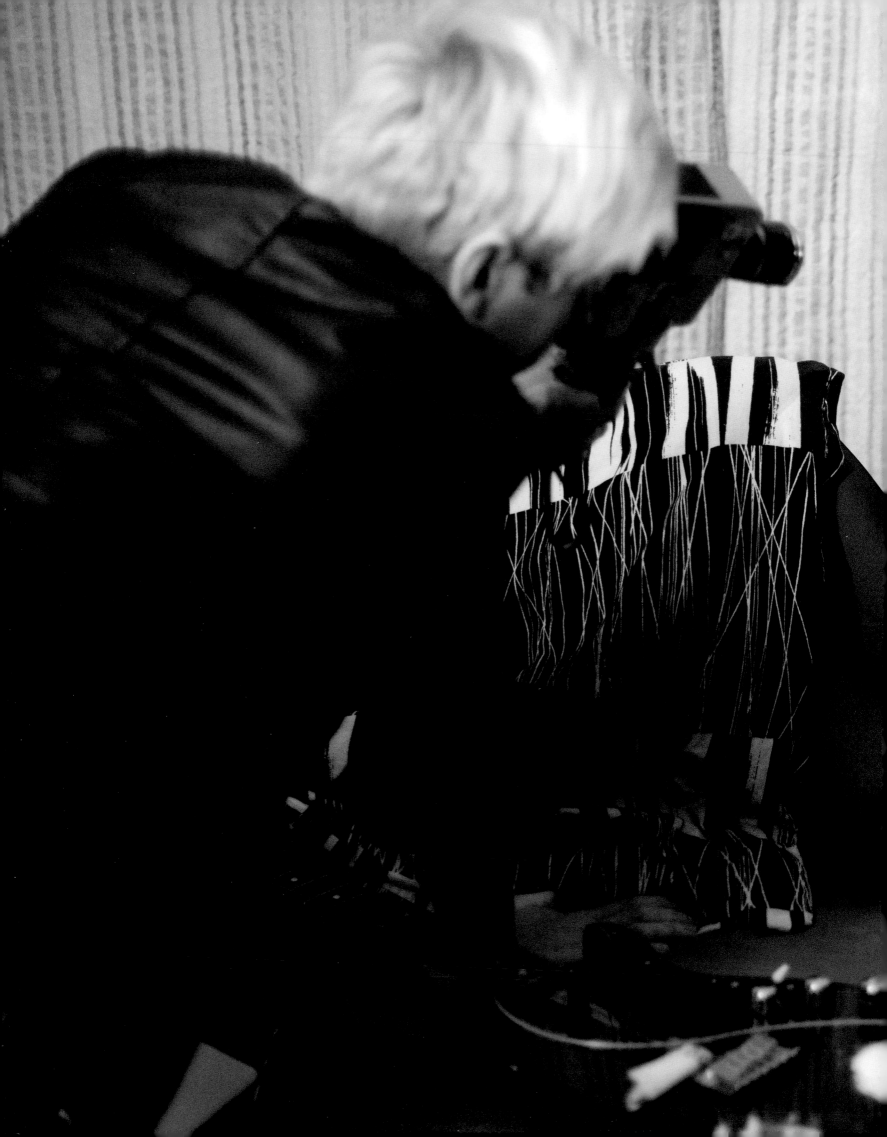

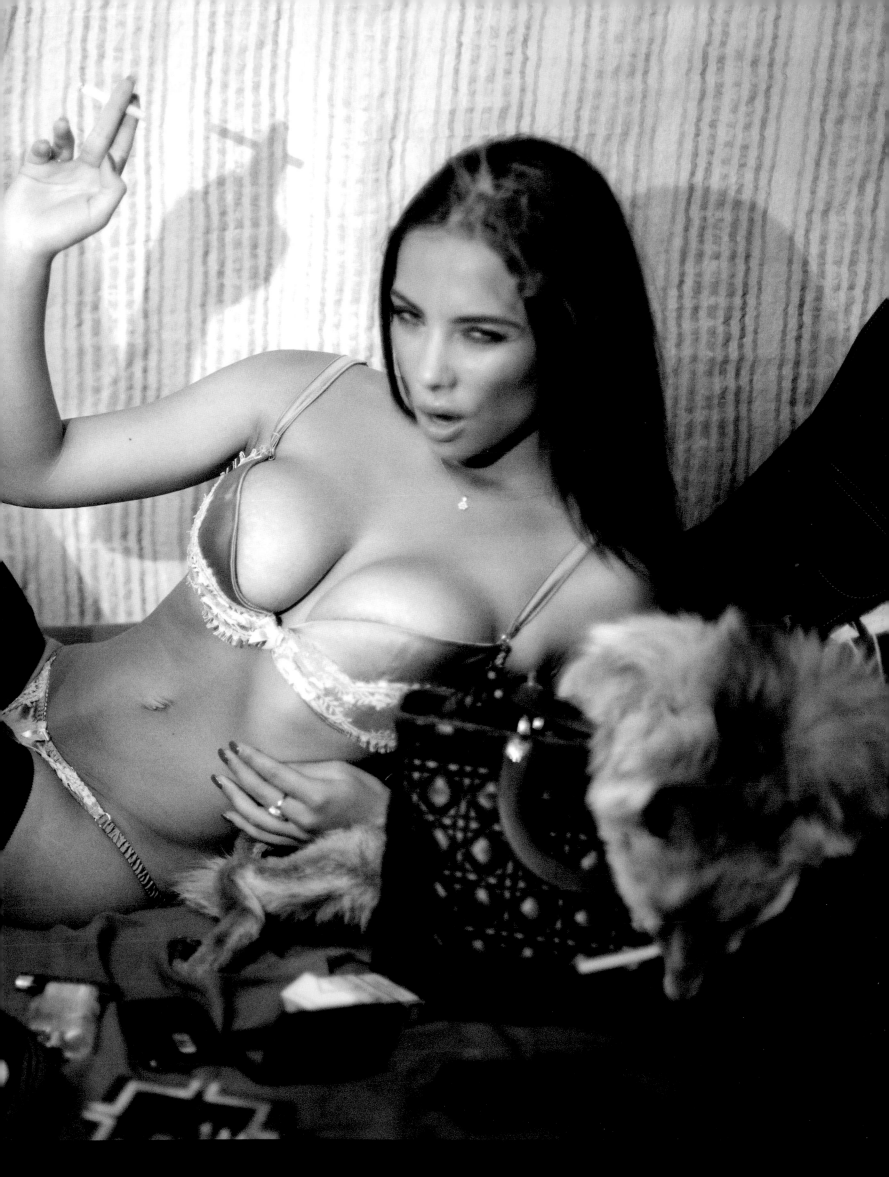

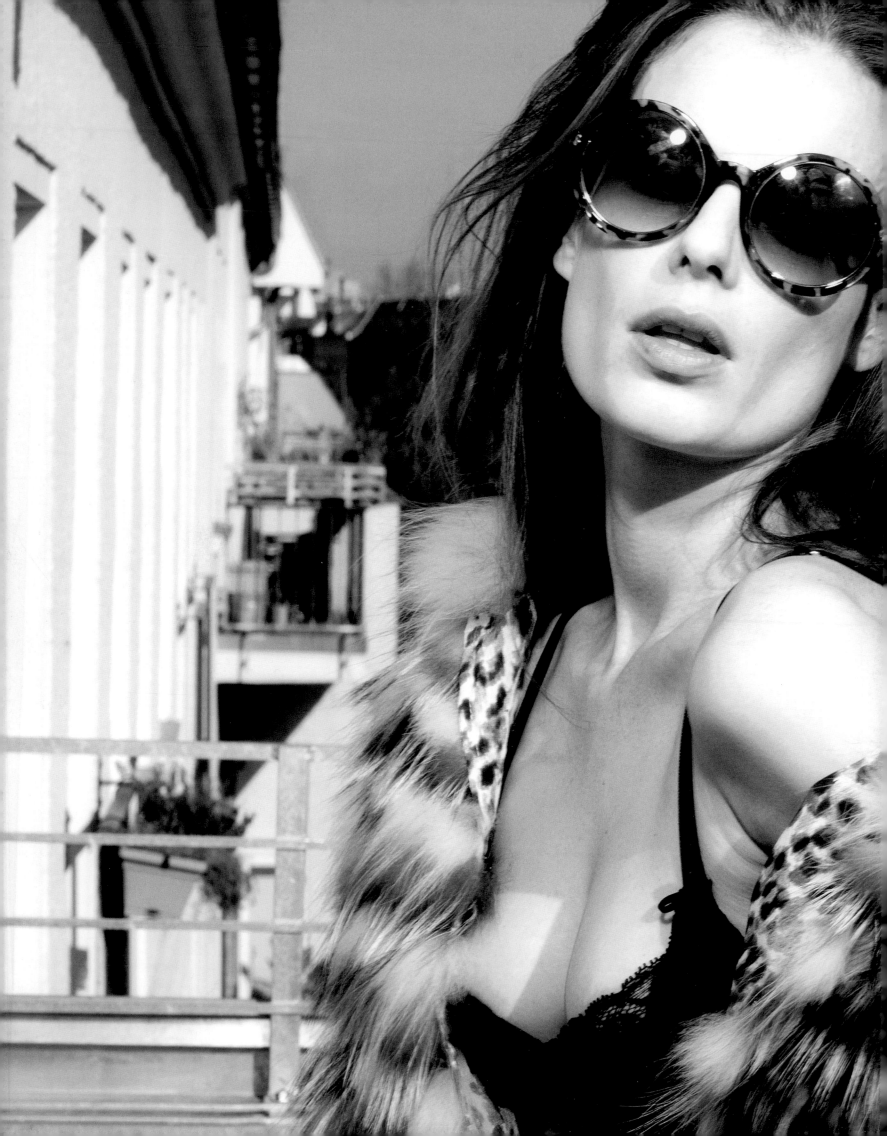

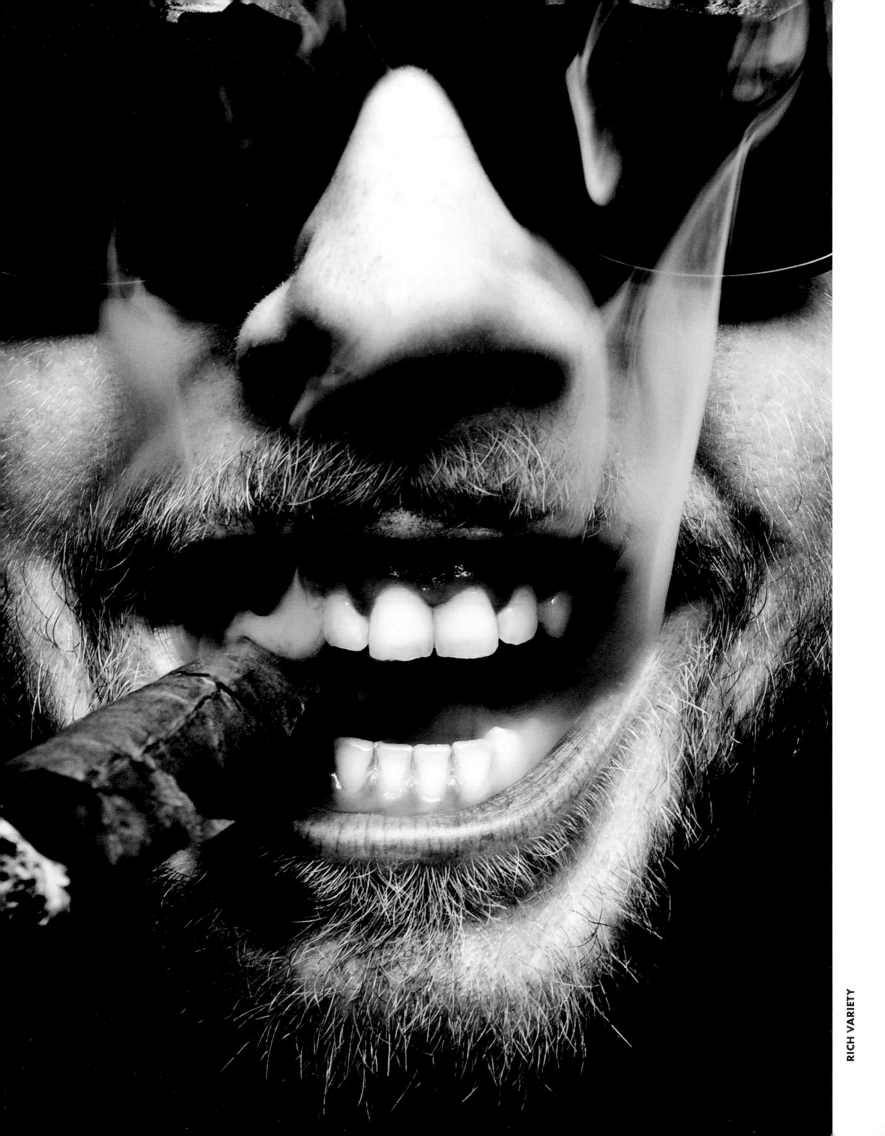